# GET THE MOST FROM YOUR
# DIGITAL HOME MOVIEMAKING

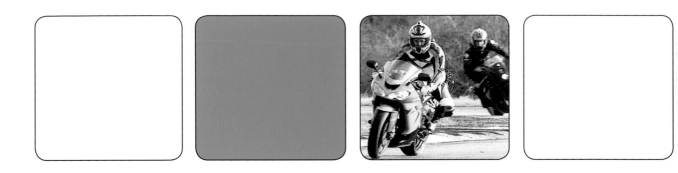

# GET THE MOST FROM YOUR
# DIGITAL HOME MOVIEMAKING

## DESIGN > SHOOT > EDIT PETER COPE

D&C
David and Charles

# CONTENTS

A DAVID & CHARLES BOOK
Copyright © David & Charles Limited 2007

David & Charles is an F+W Publications Inc. company
4700 East Galbraith Road
Cincinnati, OH 45236

First published in 2007

Copyright © Peter Cope 2007

Peter Cope has asserted his right to be identified as author of this work in accordance with the Copyright, Designs and Patents Act, 1988.

All rights reserved. No part of this publication may be reproduced, stored in a retrieval system, or transmitted, in any form or by any means, electronic or mechanical, by photocopying, recording or otherwise, without prior permission in writing from the publisher.

The publisher has endeavoured to contact all contributors of pictures for permission to reproduce.

A catalogue record for this book is available from the British Library.

ISBN-13: 978-0-7153-2639-8 paperback
ISBN-10: 0-7153-2639-2 paperback

Printed in Malaysia by KHL Printing Co Sdn Bhd.
for David & Charles
Brunel House, Newton Abbot, Devon

Commissioning Editor: Freya Dangerfield
Assistant Editor: Louise Clark
Project Editor: Nicola Hodgson
Art Editor: Marieclare Mayne
Production Controller: Beverley Richardson

Visit our website at www.davidandcharles.co.uk

David & Charles books are available from all good bookshops; alternatively you can contact our Orderline on 0870 9908222 or write to us at FREEPOST EX2 110, D&C Direct, Newton Abbot, TQ12 4ZZ (no stamp required UK only); US customers call 800-289-0963 and Canadian customers call 800-840-5220.

Thanks to Gill, David and Sarah for putting up with my moviemaking activities for this book.

Thanks to: Apple Computer, Aquapac, Canon (Europe) Limited, Fujifilm Limited, Griffin, JVC (Europe) Limited, Lastolite, Sony, Transport for London.

Thanks also to everyone involved in the project.

# INTRODUCTION

Anyone can become a moviemaker. Digital video – in all its guises – lets us shoot exciting movies with ease. With video cameras being more affordable than ever (and even included as a feature on many mobile phones), the opportunities to create movies have never been greater.

Let's go back in time to the 1920s: only a few decades after the Lumière brothers launched their cinema to an incredulous audience in France, the movie business has the whole world captivated. But it is not only the major studios that have embraced the technology and the art form. Large numbers of amateur moviemakers, too, are discovering and exploiting the new medium.

In those early days, there was little to distinguish the amateur filmmaker from the professional. This was a rich man's activity (with the occasional lady); only the wealthy could afford both the necessary hardware and the luxury of time to devote to the craft. Indeed, some of the inspired amateurs crossed the divide and became professionals themselves as they realized there was an eager market for films. However, there was a majority for whom moviemaking would always remain a hobby.

The spirit and creativity of these pioneers have carried moviemaking through the decades. From cine photography through early video photography and on into the digital world of today, creating movies – whether that movie is a mini-blockbuster or a record of a once-in-a-lifetime trip – has never been so simple and accessible.

The medium of digital video can be enjoyed by anyone. Camcorders of all shapes and sizes are capable of delivering recordings of unparalleled technical quality and diversity. As high-definition television (HDTV) comes to dominate broadcast television, we can also create high-definition home movies. And while one part of the market concentrates on quality, another makes the medium available to all: mobile phones are proving increasingly adept at video recording.

Once you have created your movies, the choice of how to view them is also wide. Traditional viewing on a television is

only one option. You can choose to deliver and view movies on computers, the Internet, DVD and on portable devices such as iPods and PlayStation Portables.

In this book we will examine all aspects of digital moviemaking, from setting up your studio, planning your masterpiece, and getting it out to an audience. Digital video cameras today are extremely powerful, versatile, and easy to use. We will look at how to get the best from yours and, should you be planning to purchase a new model, what features are key to delivering the movie footage you want.

A video camera, however, is only a tool. Along with other tools, such as computers and editing software (which we will also examine), these are just the means to an end. That end – great movies – will quickly fall within your grasp as you discover all the skills, tricks and tips for great moviemaking. Let's get underway!

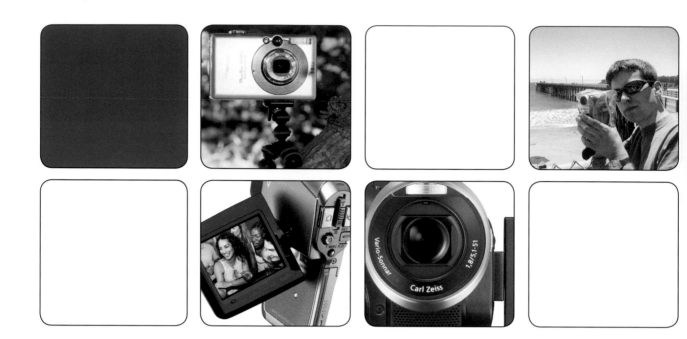

# PART ONE:
# GETTING STARTED

Digital video cameras are a must-have device for many people. They can be seen in use at every sporting event, social occasion and children's party. Today's cameras are not only easy to use, but offer movie quality that only a few years ago was the preserve of the professional cameraman.

In this section we look at what today's cameras offer, and what all the controls that adorn your camera – whether it is a simple point-and-shoot version or something more like a professional model – actually do. We also discuss how your computer can become the heart of a desktop movie studio.

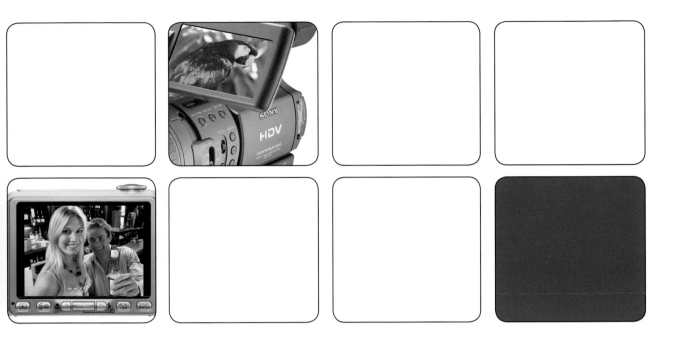

# THE DIGITAL VIDEO HUB

>> Once it was so simple. You shot your movie footage and plugged the camera into your TV to watch the results. In the digital age, you can still do this (albeit in higher quality), but your options are much broader. You can edit movies and embellish them; you can add sound and photos and then output your modest blockbusters to television, the Internet, mobile phones, iPods and other portable devices.

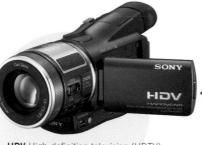

**INTERNET** Scan the Internet for images, sounds and even video clips that you can use to enliven your edited movies.

**HDV** High-definition television (HDTV) allows recordings of stunning quality, and cameras exploiting the format are increasingly available.

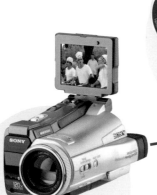

**DV** Great quality and easy to use, digital video cameras come in all shapes and sizes, and suited to all budgets.

**MOBILE PHONE** The quality is poor, but mobile phone video cameras let you grab footage whenever you are out and about.

**DIGITAL CAMERA** Images from digital stills cameras can be incorporated into movies in dynamic ways. Most cameras allow movie recording (of modest quality), too.

**VHS VIDEO** Most of us have a collection of video materials from the pre-digital age. These can be incorporated into your productions using a converter.

**CONVERTER** A converter allows you to digitize old analogue material and import it to your computer.

Final Cut Express HD

**SOFTWARE PACK** Software turns your raw footage into a movie masterpiece.

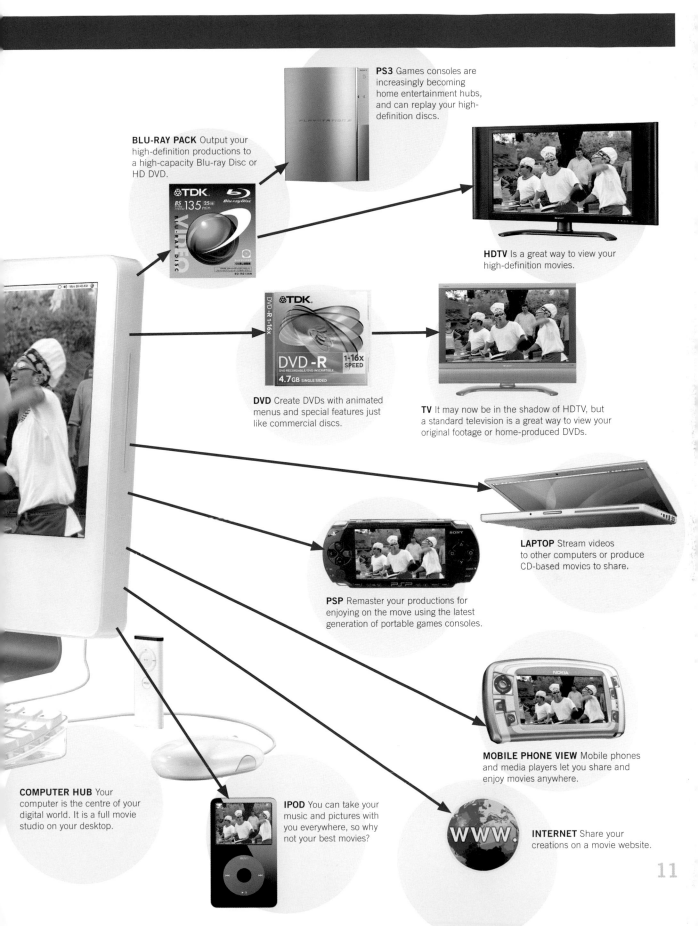

**PS3** Games consoles are increasingly becoming home entertainment hubs, and can replay your high-definition discs.

**BLU-RAY PACK** Output your high-definition productions to a high-capacity Blu-ray Disc or HD DVD.

**HDTV** Is a great way to view your high-definition movies.

**DVD** Create DVDs with animated menus and special features just like commercial discs.

**TV** It may now be in the shadow of HDTV, but a standard television is a great way to view your original footage or home-produced DVDs.

**LAPTOP** Stream videos to other computers or produce CD-based movies to share.

**PSP** Remaster your productions for enjoying on the move using the latest generation of portable games consoles.

**MOBILE PHONE VIEW** Mobile phones and media players let you share and enjoy movies anywhere.

**COMPUTER HUB** Your computer is the centre of your digital world. It is a full movie studio on your desktop.

**IPOD** You can take your music and pictures with you everywhere, so why not your best movies?

**INTERNET** Share your creations on a movie website.

11

# THE MECHANICS OF DIGITAL VIDEO

>> As video camera users, we once had a simple choice of recording formats: Video 8 or VHS-C. These were both tape formats, and offered pretty similar quality. Apart from variants of each, which offered incremental quality improvements, there was little to choose between them. In the digital world, however, our options are far wider.

### DV (MiniDV)

DV has become almost a standard in tape-based digital video formats. The 'mini' prefix is a nod to the professional user who also has the alternative of a full-sized cassette. MiniDV camcorders can produce results almost as good as broadcast quality, although absolute quality depends on the camera and processing electronics. DV is easily edited on a computer.

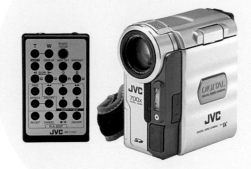

⌃ **MINIDV** Despite alternative formats providing the opportunity for really small digital video cameras, the MiniDV format has fought back with some minuscule models such as this.

### HDV

This is a high-definition TV (HDTV) format that uses MiniDV cassettes. It uses a special compression technique for the video data that enables the recoding of high-resolution images, in widescreen. It can be handled in exactly the same way as standard-resolution formats using editing applications that are HD-enabled.

⌃ **HDV** Standing the test of time, tapes suitable for use in MiniDV cameras are now also compatible with the HDV format.

### DVD

Using a small 8cm recordable (or re-recordable) DVD, this format has the convenience of allowing immediate replay in a conventional home DVD player. Likewise, DVDs can be loaded directly into a computer for editing. Some cameras and DVDs also permit a limited amount of in-camera editing, enabling poor shots to be discarded and the order of the remaining shots to be revised. Quality can be good but can also vary, as can compatibility.

⌄ **DVD** Popular because of the ease of viewing, DVD camcorders offer good – although not exceptional – video quality.

### Flash memory

Digital video cameras built around the same memory cards found in digital stills cameras can be very compact and, because the recording system has no moving parts, robust. The capacity is insufficient to offer extended recording times at the highest quality, but if you're producing video for the web, and don't need this quality, then they are ideal.

⌄ **FLASH MEMORY** With a tiny memory card as the recording medium, flash memory-based cameras can be very small. Different models have different recording formats, but MPEG4 is common.

## Older formats

In decline now, Digital 8 and MicroMV are two formats you may encounter, particularly with pre-owned cameras. Digital 8 was designed to smooth the transition from pre-digital formats and is compatible with analogue Video 8 and Hi8 recordings. MicroMV uses tiny video tapes and MPEG2 recording (see box) to allow the creation of small cameras.

> ⌄ **MICROMV** The minuscule video tapes of the MicroMV format.

## HDD and Microdrive

Microdrive and hard-disc drive cameras use mini computer hard discs for recording. Multiple recording qualities allow for recordings of up to several hours. The drawback is that footage must be downloaded to a computer or DVD to free space in the camera. This is an important consideration if you take one away on a long holiday or trip and intend to record at the highest quality.

> ⌄ **HDD** Add a lens, sensor and recording electronics to a mini computer hard disc drive and you have a compact camcorder that never needs to have its tape changed!

---

### INFO

# VIDEO COMPRESSION

Recording the huge amounts of video data required for high-quality video images is possible only because that data is compressed prior to recording. Compressing data in a way that doesn't unduly compromise quality is a delicate balancing act. There are several different compression types that you will hear of in the video world, but these are the key ones:

### • DV

As well as an acronym for digital video, DV is also a format that uses its own compression system. Although the compression system results in a lot of data being thrown away, it produces very high-quality video reproduction and forms the basis of some professional compression types.

### • MPEG1

MPEG stands for the Motion Picture Experts Group (the industry standards organization). MPEG1 is a comparatively old and primitive compression method originally used for compressing video for use on CD-ROMs. It is still in use for Internet video and, mainly in the Far East, for Video CDs (see page 126).

### • MPEG2

Supporting data rates ten times faster than MPEG1, this high-quality standard is used for DVD and some digital television broadcasting systems. It is also used in some digital video recording formats, such as MicroMV and DVD. It is used extensively in high-definition television, including the high-definition video format HDV.

### • MPEG4

This is a more recent compression standard for multimedia and web-based media. This is a scaleable format: it can be used to produce high-quality video for mobile phones, iPods or more conventional hardware up to and including high-definition television. The benefit of this compression system is that it uses slow data rates but offers high video quality.

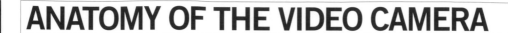

# ANATOMY OF THE VIDEO CAMERA

>> Most of us regard our video cameras as a mysterious box that converts our commands into footage. We have little concept of what happens inside. However, a basic understanding of the processes and inner workings can make us more confident moviemakers and, ultimately, help us produce better movies. And what is going on inside is not that much of a mystery anyway. Let's take a look.

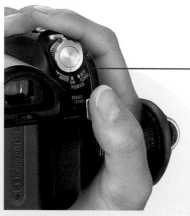

**ON/OFF/START BUTTON** Press it to start shooting, press it to stop (or, in some cases, press to start, release to stop).

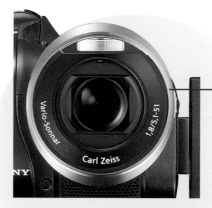

**LENS** The lens, as in all cameras, focuses the image of your chosen scene on to a light-sensitive chip sensor. The image is formed in exactly the same way as on movie film in a cine camera. Many cameras use a three-chip configuration to record blue, green and red light separately via a cunning prism system at the rear of the lens – all in the interests of improving quality.

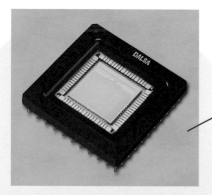

**SENSOR** The sensor in most digital video cameras is a CCD (Charge-Coupled Device), although CMOS (Complementary Metal-Oxide Semiconductor) sensors, using slightly different electronic technology, are found in some cameras. Light from the image formed by the lens falls on tiny discrete elements (pixels, or photosites) that record the brightness level and, thanks to filtration, the colour. This in turn generates a digital video signal.

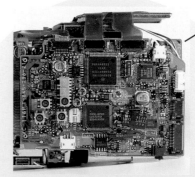

**PROCESSING** These are the processing electronics inside a camcorder. The raw digital video signal from the sensor (or sensors) first needs to be amplified and then processed to clean up any obvious noise and apply any special effects that the camera user may have configured. Timecode information is also added, indicating the time the footage was shot and providing every frame with a unique identification number. The usefulness of this feature will be discussed later (see pages 44–45).

It is often surprising, in a time of technological change, how the key components of the latest digital video camera are very similar to those that we may be familiar with from older video cameras or, indeed, even older film and cine cameras. In a way there should be little surprise in this. Many decades ago, cine camera manufacturers had devised designs that were both technically proficient and offered good ergonomics.

Even though the science – or art – of ergonomics (defined as the ability through good design of maximizing productivity by reducing operator fatigue and discomfort) has moved on in some of the detailing, a modern camera will be familiar to users of previous generations. Only in some of the detailing – mainly due to different components and different recording formats – are there significant differences.

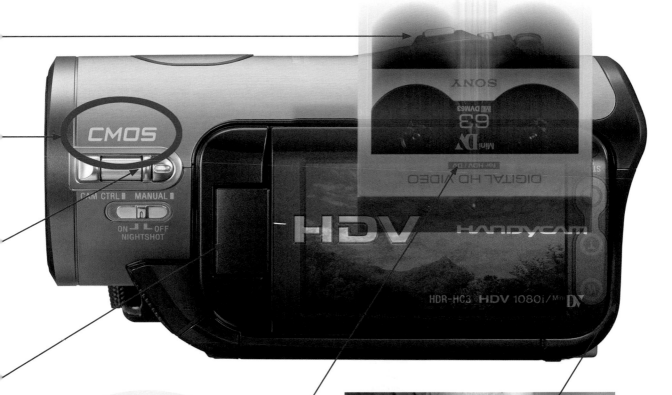

**OUTPUT** The output from the electronics can be displayed immediately on a television screen or computer (assuming the appropriate connections are present) or can be recorded on tape, DVD or memory card, depending on the camera model and type. This stored data can be replayed through the camera, downloaded to a computer or replayed on a television. Except for those cameras with fixed on-board memory, the recording media can be taken out and safely archived or copied.

**CONNECTORS** It is unusual to find a domestic video recorder that will replay camcorder tapes, so you will generally have to replay your recordings to a computer via the camera. This is not necessarily required for cameras using DVD and memory cards, as these can often be placed in the computer directly or via a memory card reader.

15

# BEGINNERS' CAMERAS

>> What camera is best for you? If you already own one, that question will be somewhat academic. But before you launch into shooting movies, it is useful to know what different camera types are capable of and what they are not. We'll start by looking at cameras that are generally marketed to beginners.

<< **SUBMINIATURES** These cameras appear under a range of names and in a variety of guises, and really small models can range considerably in quality. Some offer little more in terms of quality than that offered by compact stills cameras (known as AVI quality), whereas others offer full MPEG4 quality, albeit for shorter durations than cameras such as the Xacti. However, subminiatures are ideal for undemanding applications, web video and video note-taking.

>> **BEGINNER MODEL Lens:** Expect a modest optical zoom lens bolstered by a more substantial (but less usable) digital zoom. The usefulness of a 500x digital zoom is somewhat limited. **Sound:** Compact stereo microphones provide adequate sound quality, but tend to pick up sound from the camera mechanisms. **Recording format:** At this level, you are spoilt for choice. Models featuring MiniDV, Digital 8, DVD and solid-state media are on offer.

Beginner-level cameras don't compromise on quality, but they do make it simple to take movie footage and don't require much technical ability to operate. These cameras are ideal for people who don't want to make the next *Blair Witch Project* but do want to ensure that they record every detail of a family holiday, or their children growing up. And if they can stick the camera in their pocket between shoots, so much the better.

## Compact cameras and budget models

Beginners' cameras tend to be compact. This is both a deliberate move on the manufacturers' part – small cameras appeal to those who want to carry their camera with them everywhere – and a result of the more limited technical specification. However, there are some models (often based on older designs) that are decidedly more bulky.

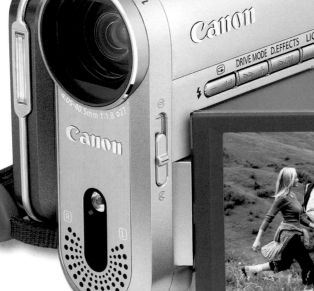

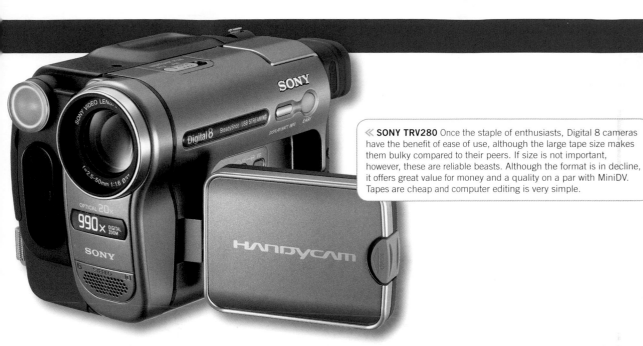

≪ **SONY TRV280** Once the staple of enthusiasts, Digital 8 cameras have the benefit of ease of use, although the large tape size makes them bulky compared to their peers. If size is not important, however, these are reliable beasts. Although the format is in decline, it offers great value for money and a quality on a par with MiniDV. Tapes are cheap and computer editing is very simple.

These tend to be 'budget' models, where compactness and miniaturization are eschewed in favour of low-cost components. Don't ignore these models; if you are working to a budget, these models rarely compromise on overall quality. You will just need a somewhat larger pocket if you intend to carry one about regularly!

Camera size is also determined by the recording medium. Clearly, video cameras that use conventional video tape, such as MiniDV and Digital 8, require a certain bulk to accommodate the tape and tape-drive mechanism. Cameras that are based around flash memory and, to a lesser extent, hard drives, don't need to make such concessions to size or complexity so tend to be more compact and, as the technology matures, cheaper.

## Cameras for true beginners

To sound a note of caution, the term 'beginner's' camera is sometimes used euphemistically to allow cameras to be built from lightweight and potentially fragile components on the pretext that they will have only light use. This is fair enough: many of these cameras will be used maybe two or three times a year. Clearly those that use removable media (such as tape and, to a lesser degree, DVD) may be more susceptible to failure with repeated use. If you intend to use your camera for shooting and editing intensively, you will probably qualify – in camera-makers' terms at least – as being an enthusiast and need to select a model accordingly (see pages 18–19).

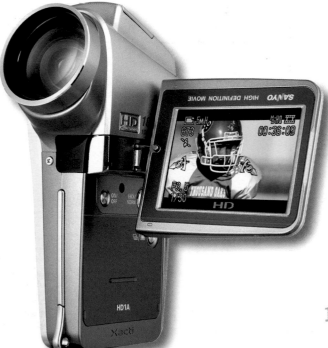

≫ **SANYO XACTI** Originally promoted by the manufacturer as hybrid digital movie/stills cameras, it is better to think of these as highly portable movie cameras with stills capability. With memory cards for storage, these models benefit from fast start-up and good image quality (MPEG4). The LCD panel is sufficient rather than generous, but necessary to keep the design compact.

**EXPERT TIP**

Serious video photographers base their choice of camera both on specifications and on feel. A camera should offer the functionality that you need and provide the functions and tools easily on demand. Try out different cameras to find one that you feel confident in operating.

# ENTHUSIAST CAMERAS

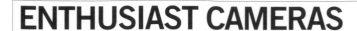

>> If you are looking for the best balance between value for money, features and quality, then enthusiasts' cameras should head your shopping list. Occupying the middle ground in terms of price and functionality, this category also offers the greatest choice.

Enthusiasts' cameras tend to offer features that are more closely focused on the needs of the more serious video photographer. Hence, we tend to see zoom lenses with wide optical ranges (though digital zooms with their super-wide ratios linger on) and the option of an LCD viewing panel and a conventional eyepiece viewfinder.

## Higher-quality features

Increasingly as we move up the price range in this rather broad swathe of models, we see quality-focused features appearing. Most significant is the high-definition HDV format. Since its launch, this format has migrated from the top-end professional video camera models to those of the top-end enthusiast. A more common feature are image-stabilization devices that ensure that, whether you are shooting at high definition or standard, the results are as sharp as you can reasonably expect within the confines of handholding. The imaging chips in this category, which are larger and with greater resolution, also help define the quality credentials.

⌄ **ENTHUSIAST CAMERA Lens:** High-quality lenses squeeze every bit of quality from the larger CCD sensors of enthusiast cameras. Computer-aided design techniques ensure that the lens is optimized and compact. **Flashlight:** The modest flashlight provided on most models is ample for any dim photos you want to take. It can even be used for video work where additional lighting is essential. **LCD panel:** At this level it provides a sharp, authentic image. For situations when the light levels are high, a shaded viewfinder ensures critical viewing and composition can continue unhindered.

⌃ **MINIATURE CAMERAS** These are cute but carry a punch. They may be small, but make no concessions to quality or performance.

## Size of enthusiast cameras

Just because we have moved into an area where quality and versatility are key doesn't mean that we have to sacrifice the virtues seen in entry-level models – size, for example. Many enthusiast cameras tend to be larger, because enthusiasts are often happy to compromise on camera size to gain the best in quality. We could draw a parallel here with the serious stills photographer who is content to carry around a bulky single-lens reflex (SLR) camera rather than a compact model.

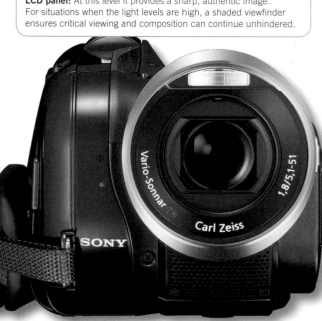

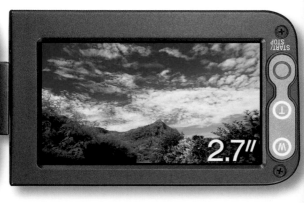

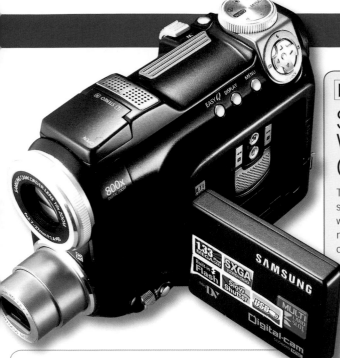

## INFO

# STILLS PHOTOGRAPHY WITH YOUR VIDEO CAMERA

Though possible with the majority of video cameras, stills photography becomes a more viable proposition with cameras in the enthusiast category. Images of 5 megapixels or more are possible, which puts these cameras on a par with many stills cameras.

Images are generally stored to a memory card; these can be downloaded either when the camera is connected to a computer or using a card reader attached to the computer and downloading directly.

Digital video cameras will never replace dedicated stills cameras, which offer increased control over factors such as exposure, but it is great to know that you can shoot some stills when you have left your stills camera at home, and also incorporate stills into your movies.

⌃ **SAMSUNG VP D6050I** Aiming to deliver quality movie and still images, this Samsung model – the VP D6050i – is part of a family of similar models. It provides both digital video and digital stills camera optics and electronics in a single body. Video is recorded on to DV and images to a memory card. In fact, this camera will accept Secure Digital and Memory Stick cards; you can even record MPEG4 video to the cards.

## Miniature cameras

There are models that offer the exceptional video quality expected in a small, pocket-sized package. Portability is significantly enhanced with little compromise in the quality stakes. The drawback (apart from the price premium) of fitting all that functionality into a very small package inevitably means smaller and therefore more fiddly controls.

⌄ **SONY HDR-HC1** Leading the second wave of high-definition HDV camcorders, Sony's HDR-HC1 brings the super-high-quality format within the reach of the enthusiast and manages compact styling too. The camera is also backwards-compatible, allowing recordings to be made in the conventional DV format.

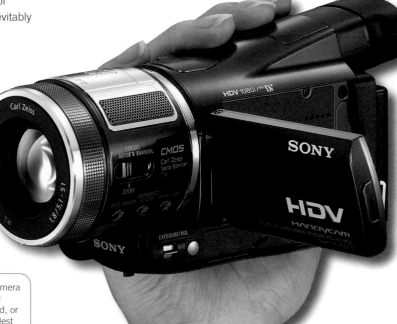

⌃ **JVC EVERIO GZ MC500** This is something of a landmark camera in technical terms: this was the first three-CCD hard disc-based camera. Up to 60 minutes of DVD-quality video can be recorded, or more if you are willing to sacrifice quality. You can perform modest editing in camera, deleting unwanted scenes and rearranging others. 5-megapixel still images can also be recorded.

# PROSUMER CAMERAS

≫ The contrived term 'prosumer' (a portmanteau of 'professional' and 'consumer') describes users who demand the highest of quality while working to a budget that is lower than that available to the professional video photographer. The cameras in this category are not cheap and are a step above those of the enthusiast. However, they are still substantially cheaper than professional models.

## Quality and control

Quality and control are the two bywords that describe prosumer cameras. Users tend to aim high in their expectations and presume the quality on offer will be the best. Prosumer cameras are equipped with high-grade components and offer a high level of manual control.

You can expect no compromise in lens design: getting the best possible image through to the sensor is a prerequisite. Building on the lens quality of the enthusiast models, the prosumer gains from more advanced design (resulting in less potential for flaring, aberrations and other image-degrading effects) and more competent controls.

Some models even offer interchangeable lenses, giving the flexibility expected by SLR camera users. Like those of the SLR camera, additional lenses can add substantially to the costs. However, for those determined to record footage of the highest quality, interchangeable lenses are invaluable.

As befits the needs of aspiring professionals, you can expect the general specifications to be the highest.

## Sensors

Three CCDs are becoming almost standard in this class of camera. A complex mirror and prism configuration is required to split the image on the basis of colour and then reintegrate the digitized image. This adds to the cost, although serious users are happy to pay this premium for the increase in quality that it affords.

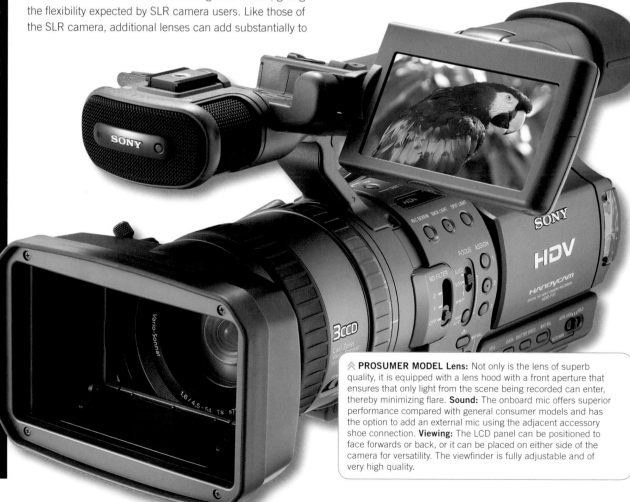

⌃ **PROSUMER MODEL Lens:** Not only is the lens of superb quality, it is equipped with a lens hood with a front aperture that ensures that only light from the scene being recorded can enter, thereby minimizing flare. **Sound:** The onboard mic offers superior performance compared with general consumer models and has the option to add an external mic using the adjacent accessory shoe connection. **Viewing:** The LCD panel can be positioned to face forwards or back, or it can be placed on either side of the camera for versatility. The viewfinder is fully adjustable and of very high quality.

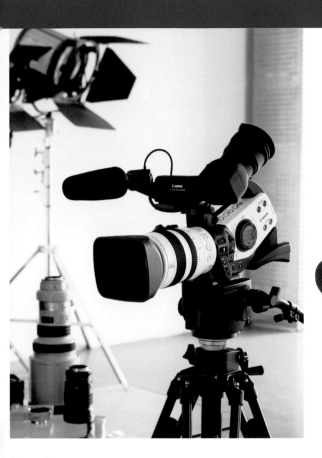

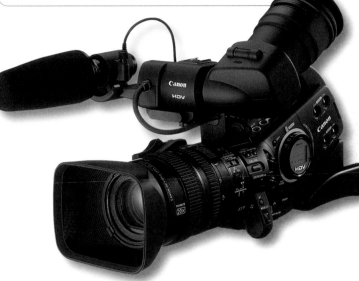

## Sound

Advances in optical quality and overall image quality have often not been matched by audio quality. Even with prosumer models, the sound recorded by the onboard microphones can detract from the overall quality. But most prosumer cameras offer an external microphone mount along with external sound-recording options. You can add a high-grade microphone on a boom (taking it well clear of the camera itself) or plug into a microphone placed around the scene.

## Recording format

HDV high-definition formats are now coming to dominate the prosumer marketplace. These offer impressive image quality and backwards compatibility with MiniDV. An alternative for those people wanting something better than MiniDV in standard resolution is the professional DVCam format. A variation on MiniDV, DVCam uses less intensive compression techniques to deliver enhanced picture quality. The demands of quality and editing of recordings at this level mean that there are no prosumer DVD or solid-state cameras.

21

# CAMERAPHONES

>> What is the most popular type of digital video camera? No, it's not one based around the popular MiniDV, but the mobile phone. But is the diminutive camera system on a mobile phone credible for moviemaking?

## 3GPP AND 3GPP2

These acronyms describe worldwide standards for the creation, delivery and subsequent playback of multimedia over 3G mobile-phone networks. Both these – which you may find as extensions to video files created on your mobile phone – are based on MPEG4. This is a versatile format for video, unique in that it can be scaled for use on a mobile phone through to high-definition TV. As well as video shot on your mobile phone, you can create or convert other movie footage using applications such as QuickTime and some movie-editing applications.

### An evolution in quality

Just a short time ago, the digital video produced by a cameraphone was fine for some fun shots at a party, but not for much else. And that was all that was needed, especially for sending to another cameraphone where network restrictions would make it impossible (or expensive) to send larger, higher-quality video.

However, all that is now changing. With the debut of models such as Nokia's N90 series, you can record real, high-quality video with your cameraphone. Rather than the low-resolution, low-frame-rate movie footage of previous models, this generation offers video capture at up to 30 frames per second (fps) – like conventional TV and video – along with stereo sound and MPEG4 recording quality.

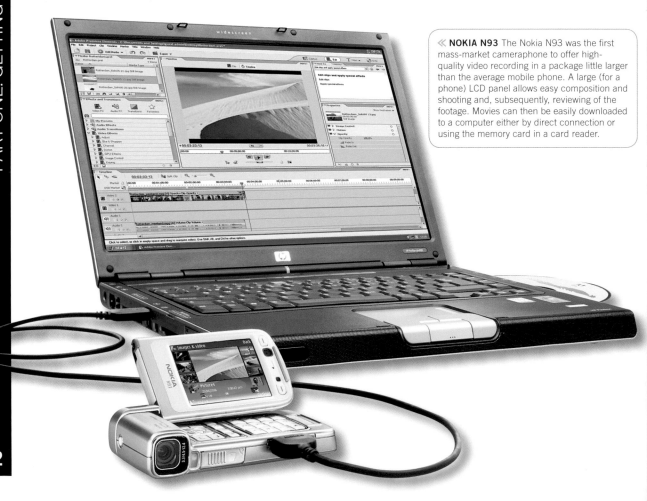

<< **NOKIA N93** The Nokia N93 was the first mass-market cameraphone to offer high-quality video recording in a package little larger than the average mobile phone. A large (for a phone) LCD panel allows easy composition and shooting and, subsequently, reviewing of the footage. Movies can then be easily downloaded to a computer either by direct connection or using the memory card in a card reader.

**EXPERT TIP**

To get the best from cameraphones, stick to bright weather conditions, or very bright interiors. Avoid shooting into the light, or shooting in dim light, where the results will be of poor quality. Keep to bold action shots too, and don't expect great things from the sound.

Some models, including the Nokia N93, which marked the coming of age of quality video in a cameraphone, also offer camcorder features such as image stabilization, a modest (but quite acceptable) 3x zoom lens, and 3.2-megapixel still images. Adding a memory card of up to 2 gigabytes (GB) allows the recording of up to 90 minutes of DVD-quality video.

Of course, with this amount of data, it is no longer viable to email the video to other users (you will need to download to a computer, as with conventional digital movie cameras), but lower-quality video can still be captured and emailed, sent by Bluetooth or uploaded to online movie galleries.

### Suitable for serious moviemaking?

The big question, then, is can a cameraphone offering high-quality recording act as your principal video camera too? The answer to this would have to be no. If you want very undemanding quality or little control in your moviemaking, these cameraphones would suffice, but for anything more you would need to have a dedicated camera. Yes, the quality is technically equivalent to DVD, but exposure systems, lenses and other features are necessarily reduced in scale or scope to fit the footprint of the phone handset, meaning you have far less creative control over your moviemaking.

Where the cameraphone does score, however, is in portability. The fact that you are likely to have it with you most of the time means you will always be ready to shoot some action should something spontaneously present itself. And, for many of us, that can be a great trade-off against the slightly inferior quality.

What of the future? Well, it was not so long ago that stills cameras married to mobile phones were rather rudimentary and designed for a particularly undemanding clientele. In a very short time, the cameras in phones have grown in sophistication and quality to the point where the best examples can hold their own against many dedicated cameras. It seems quite viable that movie cameras in mobile phones will do likewise, eclipsing video camera models at the lower and even middle part of the current marketplace.

## INFO

# MOVIES FROM YOUR STILLS CAMERA

Just as digital movie cameras can shoot still images, so most stills cameras can shoot movie footage. Stills cameras are optimized for shooting high-resolution, high-quality still images, so the movie mode will not match that possible from a movie camera. However, many models offer VGA quality (this gives a picture 640 x 480 pixels, which is just about equivalent to standard-definition TV) at frame rates of up to 30 per second (again, just like standard TV). The sound is generally mono, but you will find stereo in exceptional cases. More so than with basic movie cameras, you will discover that the sound quality is sufficient but certainly not impressive.

Video files recorded on stills cameras are generally in the Windows AVI format, which is compatible with virtually all movie-editing applications. Should you cut some AVI clips into a movie that otherwise comprises DV footage, you will notice a drop in quality, but often this is not as great as you would imagine. Remember that video footage on a stills camera can take up a lot of storage space, so carry enough memory cards with you. For best results, record video clips at the best quality that the camera offers.

So, could a stills camera take the place of your digital video camera? In certain circumstances, yes, but in general, no. If you require some movie footage to drop into a website, the video from a stills camera will be fine. But for anything more ambitious, or where quality is key, consider the stills camera only as a fallback when you are caught out without your video camera.

**VIDEO MODE** Digital stills cameras are great for photos and OK for video too. They often feature a video mode that will prove useful when you don't have your video camera to hand. This Fujifilm FinePix V10 offers VGA recording at 30 frames per second.

PART ONE: GETTING STARTED

# ACCESSORIES

>> There are many accessories that will make your moviemaking life simpler and many more that will make your movies look and sound better. But which ones should you focus your attention on?

### Microphones

A great movie shouldn't just look good; it should sound good too. Consider investing in an accessory microphone to record a better soundtrack than the best inbuilt microphones are capable of. A range of types is readily available. Some even alter their sensitivity and recording area according to how you set the camera's zoom. We'll look more closely at microphones on pages 42–43.

### Tripods

Without exception, professional video photographers mount their cameras on sturdy tripods. It may not be viable for you to carry a tripod at all times, but consider it essential for important shots. Go for a model with a pan-and-tilt head rather than the ball-and-socket head favoured by still photographers. A quick-release plate, which lets you remove the video camera from the tripod quickly, is a worthwhile investment and will soon repay its modest cost.

Monopods – a single tripod leg – can be equally successful and double up as a walking stick for long trips. Minipods, tiny tripods, clamps and even beanbags can make for more impromptu supports when needed.

## INFO

# CLEANING AND MAINTENANCE KITS

It is essential to keep your camera in top condition. Cleaning and maintenance kits are available from all major manufacturers and accessory companies. Look for kits that include a lens cleaning cloth (fine-textured microporous cloths are best), a blower and a light brush. Always follow the instructions that come with the kit, as it can be easy to make a problem worse with incorrect cleaning. Never attempt to clean the interior of the camera. If it's dirty, seek professional advice

**CLEANING KIT** Invest in a good lens cleaning kit to keep your equipment in top condition.

**⌄ TRIPOD** If you are investing in a tripod, it pays to go for a good solid model. Built from aluminium or carbon fibre, they are surprisingly light and will rid your movies of vibration and shake.

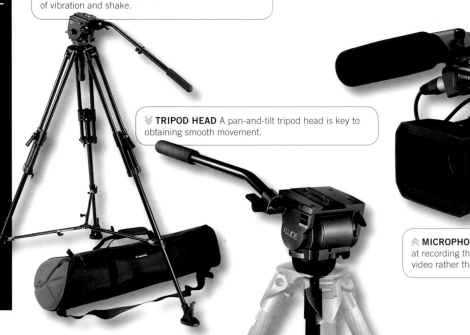

**⌄ TRIPOD HEAD** A pan-and-tilt tripod head is key to obtaining smooth movement.

**⌃ MICROPHONE** An accessory microphone is adept at recording the sound you want included on your video rather than more general, ambient sound.

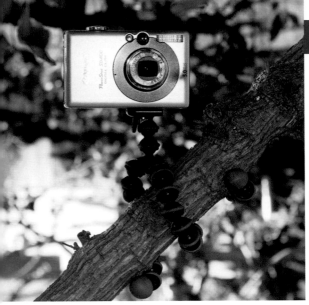

≪ **GORILLAPOD** With bendable legs, the GorillaPod combines the best of the mini tripod with an adjustable clamp. Shown here with a stills camera, it can easily support most digital movie cameras too.

**EXPERT TIP**

Some camera bags just shout out 'expensive kit inside' and can make you a prime target for thieves when you walk around the tourist routes and backstreets of the world. Remember this when shopping – there are many designs now that are discreet and anonymous-looking.

## Batteries

There is nothing more infuriating than running out of power as you are about to shoot critical footage. The battery that comes with your video camera will provide good service, but rarely are the included batteries the most powerful or longest-lasting. And the quoted figure for battery performance is always somewhat optimistic. It is good sense to equip yourself with at least one additional battery – and one with more power than the supplied one.

## Kit bags

Your video camera may be robust, but it still represents a considerable investment, and it makes good sense to protect it as you carry it around. It is useful, too, to be able to keep together all the essential filters, spare batteries and memory cards for easy access when you need them. A good kit bag will provide protection for your camera and plenty of pockets and recesses for all your accessories.

## Memory cards and tape

Don't forget your consumables – they are not really accessories as such but are just as easy to forget. Make sure you have plenty for all your needs – and then some.

⚒ **STORAGE** You can never have too many memory cards.

**INFO**

# WATERPROOF HOUSINGS

Cameras and water, dust and sand just don't mix, which is why waterproof housings such as the Aquapac are recommended. Drop your camera into this transparent, flexible bag, close the waterproof seal and you're ready to shoot. The plastic is sufficiently malleable to allow you to use the controls directly, yet clear enough not to affect the optical quality of your recordings. These bags – which are available in a range of sizes – are also a good bet if you spend a lot of time shooting at the beach or in dusty conditions. They will keep your camera clean and grit-free.

**CLEAN AND DRY** Waterproof housings will keep your camera safe from damaging elements such as sand and seawater on location.

# COMPUTERS FOR DIGITAL VIDEO

>> There was a time when any discussion on computers would emphasize the need to buy the biggest, most powerful and best-specified computer if you wanted to entertain the idea of video editing and handling those huge amounts of data. Now it is easy to do on most computer desktops and some laptops too.

**PART ONE: GETTING STARTED**

### Digital video on home computers

Why is digital video so popular today? It is mostly down to the ease with which we can edit, manipulate and enhance our footage on our home computers. Most computers you buy today will be capable of video editing virtually straight out of the box. If your current computer is getting a little old and you're looking to replace it, buy the best spec that you can afford. You will find that most computers today have ample power to run the respective software applications, but buying a computer with the highest specification you can afford will enhance performance and mean you will be well placed to take advantage of software upgrades and developing technologies (such as high definition). In addition, loading your new (or current)

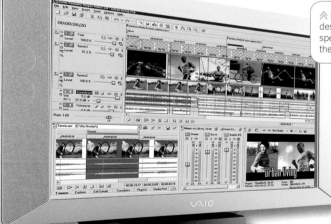

▲ **LAPTOPS** Many laptops today can pack a punch that many desktops would be proud of. If you want a laptop, check out all the specs to ensure that it will deliver in all departments, but otherwise there is no need to feel compromised.

computer with extra RAM memory will make a fast computer really fly – not just for editing your regular movies, but for compiling the results for writing to, say, DVD. You can ask your favourite online or bricks-and-mortar computer store to recommend and fit an appropriate amount and type of RAM.

### Upgrading a computer

Is it worth upgrading an existing model rather than buying a new computer? Apart from adding more RAM memory, I'd say no. Upgrades such as new CPUs (central processing

« **DESKTOP COMPUTERS** What they lack in portability they more than make up for in terms of larger screens and, by virtue of being fixed, don't need to be continually connected and disconnected when being used as the core of your video-editing studio.

## INFO
# MAC OR PC?

More professionals tend to use an Apple Macintosh (Mac for short), partly for historical reasons and partly because the technology is marginally more suited for image and movie work. PC advocates point out that any difference is marginal and that there is more software available – in choice and scope – for the PC. PCs also tend to be cheaper than Macs.

Interestingly, the more recent Macs built around the Intel chip offer a not-so-secret weapon: they can run Windows too! This makes them something of a dream ticket for the moviemaker – and general user – as you can benefit from the strengths of the Mac and the Mac operating system and also run Windows applications in a genuine Windows environment. Which is best? It's a tough choice, but I think Macs have the edge.

> **JOG/SHUTTLE DIAL** This jog/shuttle wheel from Griffin allows fine control of the playback of your movies to ensure frame-accurate editing.

units) can achieve some gains in performance, but you will probably find you will also need to upgrade the memory and the hard disc. By that time, it is probably more economical to invest in a brand-new machine.

### Laptop versus desktop
Today many laptops vie with desktops in the power stakes and you should have no qualms about using them or – if you are shopping for a new computer – auditioning them. Go for large screens, such as the 17-inch models offered by several manufacturers, to make the best use of the software. And consider an external hard disc drive to augment the onboard drive.

### Extras
A jog/shuttle dial is a great boon to the serious moviemaker. The computer is a jack-of-all-trades and the mouse, although useful, can be unwieldy for making frame-accurate edits. A jog/shuttle dial – as were once popular on VCRs – lets you move through a video frame by frame for perfect edits. You can often program subsidiary keys for other shortcuts, such as cutting or splitting video clips.

Serious video editors (and we're talking about the really serious here) will invest in special keyboards where the keys, as well as featuring their conventional characters, are also coloured and marked with all the shortcuts and functions relevant to a particular video-editing application. The price of this level of seriousness? About four times that of a conventional keyboard.

**EXPERT TIP** Enthusiast and professional video photographers often invest in a second hard disc for their computer. Dedicating this drive to video editing offers the twin benefits of speedy operation and extending the capacity – vital for those great video productions that you will soon embark upon!

## INFO
# HOW MUCH COMPUTER STORAGE SPACE DO YOU NEED?

How much space do you need to store digital video on your computer? A lot! Look at how much free space you will need for DV-format recordings:

| Duration of video | Hard-disc space required |
|---|---|
| 1 minute | 235MB |
| 30 minutes | 6.5GB |
| 1 hour | 13GB |

For HDV-format recordings, somewhat more space is required; perhaps two to three times that for DV, although this varies substantially on account of the form of data compression used by this format.

# SOFTWARE FOR DIGITAL VIDEO

>> The increasing popularity of digital video editing has given rise to a number of applications to choose from. To make the optimum choice, you need to establish first what your expectations are of the software.

With video cameras, we divided the marketplace neatly into three. We can do the same for the software world, but this time along the lines of editing capabilities.

## Basic applications

Unlike the lower tier of video cameras, which we described as 'beginner', basic applications comprise those that can be used by owners of any video camera. The criterion here is that users are not so concerned with creative moviemaking as such. Instead, the emphasis is on simplicity of editing and compilation rather than special effects and advanced mixing of video and sound.

The good news is that such basic applications are freely available. In fact, you will find excellent examples bundled with both the Windows operating systems (in the guise of Windows Movie Maker) and the Mac OS, as the more widely known iMovie HD.

Back in the early days of digital video editing, the arrival of the original iMovie was something of a revelation. Digital camcorder users could connect their camcorder, download video (which would automatically be divided into scenes), and then assemble those scenes into a movie. Simple.

Since then, iMovie has continued to develop and offer more facilities (including the capacity to handle HD video in recent iterations), but without losing its simple-to-use ethos.

## Midrange applications

Apple extends the iMovie philosophy to the midrange market with Final Cut Express. This is notionally a cut-down version of the lauded professional video editor Final Cut Pro (often know simply as FCP). In fact, it makes a great upgrade to users of iMovie who are looking for additional functionality at a modest price.

Ulead's VideoStudio is a great application for the Windows environment (and can be used with Windows installed on a Mac) that is suitable for beginners in editing and those who have graduated to more advanced moviemaking. A great benefit of the VideoStudio products is the amount of extras on offer; hundreds of effects, graphics and audio effects are included as standard.

Roxio's VideoWave is another product in the same spirit as VideoStudio. Another piece of software that comes highly recommended is Adobe Premiere Elements, a cut-down version of the professional application Premiere.

---

## INFO

# MACINTOSH APPLICATIONS

Mac users not only get iMovie free with their computers, but also companion applications iPhoto for photos, iDVD for DVD creation, iWeb for webpages and GarageBand for music production. Tight integration makes it easy to produce movies, DVDs and slideshows, add specially composed music and post the results to a website.

**IDVD** Movies created in iMovie can be exported directly to iDVD along with chapter marks and other DVD tools. Add some animated menus and you have the potential to create a professional DVD.

---

⋙ **FINAL CUT EXPRESS** Final Cut Express is a Macintosh application. You get much of the simplicity of iMovie with most of the power of the professional version, Final Cut Pro.

## Professional applications

In the world of professional video editing, money is no object. When you are editing the latest blockbuster or big-budget TV series, you need to be assured that you have all the tools required to create a finished product that is as perfect as your skills and vision will allow.

Surprisingly for applications that are used by broadcasters around the world and the Hollywood studios, these applications, although expensive, are not prohibitively so. They are, however, very powerful, somewhat complex and, in most cases, unforgiving of the inexperienced.

Adobe's Premiere (a Windows application) has done for movie editing what the same company's Photoshop has done for image editing. There's nothing of any consequence that you can't do with Premiere. In its more recent outings, Premiere has offered full compatibility with widescreen broadcasting and high definition.

As many professional broadcasters, video-production houses and quite a few devoted amateurs will attest, the Macintosh-only Final Cut Pro (FCP) is the leading video-editing application. The popularity of FCP has grown tremendously in the last few years thanks to an unrivalled

⌃ **IMOVIE** Entry-level applications (such as iMovie HD here) are remarkably competent. They are often employed by advanced users who need great results fast, as well as the rest of us, when creating our holiday movies.

combination of ease of use and features. Some other names to look out for include Avid Xpress DV and Sony Vegas Video. The latter program is particularly strong in support of audio systems and successful at producing impressive multi-channel sound movies.

⌃ **VIDEOSTUDIO** Ulead's VideoStudio is crammed with resources to help you produce a mini-epic from your footage, and features one of the least intimidating interfaces.

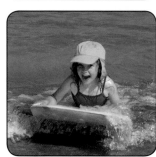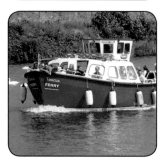

# PART TWO: DEVELOPING MOVIEMAKING SKILLS

You've got the kit, now it's time to get the skills. There is nothing mystical or magical about making a great movie – as any great director will confess. It all comes down to skill, practice and almost certainly a bit of luck. You can't control luck, but you can develop skills. That's what we'll explore in this section.

# THE IMPORTANCE OF COMPOSITION

>> In still photography, composition probably tops the list of important skills. In the video world, it is doubly important. Now you need to be mindful of the geometric composition of scenes (constructing each as if it were a still photograph) and the dynamics – how elements of the scene move relative to each other and relative to the frame.

∨ **FOREGROUND INTEREST** Including the tree branches at the top creates an attractive frame for a more effective shot.

Here we will look at the basics of geometric and dynamic compositions separately, starting with the geometric aspect.

As video photographers, we are at a slight disadvantage compared to stills photographers. They can use image-editing applications to manipulate the elements in a scene and position them precisely, if so desired. No doubt that opportunity will one day become possible in video-editing applications, but until then we need to be more circumspect. Like photographers from a pre-digital age, we need to pay close attention to what we see in the viewfinder. Fortunately, useful rules have been established as to what comprises a good photo, and we can exploit these for our movie scenes. The term 'rules' tends to imply a certain strictness, so it's best to think of these rules simply as good practice.

## Include foreground interest

People who take photographs often make the classic mistake of concentrating on a subject rather than on that subject with

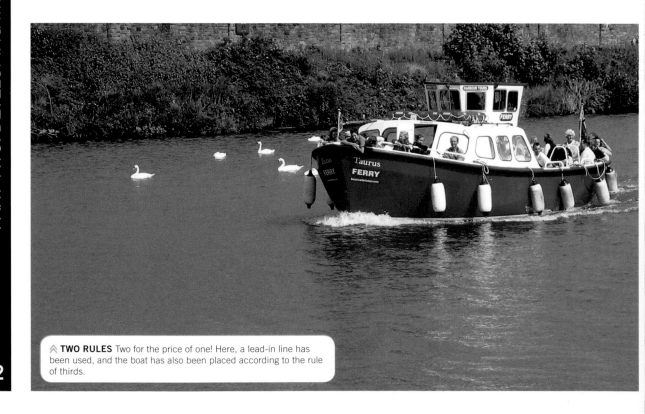

∧ **TWO RULES** Two for the price of one! Here, a lead-in line has been used, and the boat has also been placed according to the rule of thirds.

reference to how it sits in the frame. The result is often a tiny subject in an otherwise empty frame. This is not necessarily a problem with moviemaking, where we can use such images as an establishing shot (see pages 58–59) but, nonetheless, empty space is wasted space. Unless you want to create the feeling of a subject in a wide, lonely environment, try to include foreground interest, or framing interest. Overhanging trees and doorways are ideal and prevent your scene from becoming flat.

## Use lead-in lines

Allied to foreground interest, lead-in lines are a great way to lead the viewers' eyes to the subject. A row of houses or a footpath, for example, can lead the eye into the scene to the subject at the end.

&#8681; **LEAD-IN LINES** The powerful converging lines in this scene draw our eyes to the sphere in the distance.

## Use the rule of thirds

This is probably the most quoted photographic rule. It avoids cliché purely because, in composition terms, it works. Imagine that your scene is divided into three, both horizontally and vertically. To create the most powerful compositions, place subjects (in the case of people, place their eyes) at the intersection of these dividing lines. Strong horizontals, such as the horizon, should also be placed along one of the dividers, rather than dead centre.

The rationale for the rule of thirds is that it avoids the obviously staged look when something is placed at the exact centre of a frame. It also prevents the subject dominating the scene, or overshadowing other subjects in the scene. The asymmetry produced is also more natural looking to viewers, even though we have contrived to make it so.

It is important to remember with any rule, of course, that you should not stick to it slavishly or contrive every shot to conform to it. Where you need to, or where you think it will be more creative, break the rule!

## Move into the scene

This is another compositional tool that is used in still photography and is perhaps more important in video. If you have a moving subject that you are following by panning the camera, it is always better to have that subject appear to be moving towards the centre line of the frame. This is because, as viewers, we want to see where the subject is going, rather than where he or she (or it) has been.

This is probably one of the easier rules to master and implement. It is also good practice because, rather like the rule of thirds, it encourages us to think about the subject placement, rather than (as is instinctive) place it centrally.

Can you break the rule? You certainly can if it will produce a more effective shot. Having your subject (a car, or boat, perhaps) cross the frame and recede into the distance makes a great closing shot. Combine it with a fade (see page 101) to end a movie or a section.

# UNDERSTANDING SHOT TYPES

>> Over the decades, moviemakers have defined a series of shot types to simplify continuity and introduce consistency. This seemingly prescribed array of types is not meant to restrict creativity but rather to help sequence your shooting and, most importantly, to help the viewer follow your movie. It is also a great boon when planning a movie; using the shot type abbreviation makes it simple to storyboard and turn your ideas into a working script.

Of course, you won't feature all shot types on every occasion. As your shooting skills develop, you will quickly realize what you need to shoot in order to tell your story most effectively or obtain the best visuals. It is also important that you don't have consecutive shots of the same type. The result, unless you are careful, will be a jump cut: something your viewers will find at best jarring and at worst uncomfortable.

### Long shot (LS)

In this type of shot, your subject is close enough to fill about three-quarters of the height of the shot. If the subject is a person, this may be sufficient to identify them or at least make out some details.

The less commonly used very long shot (VLS) and extra long shot (ELS) place the subject at about one-third the height of the frame and a quarter (or less) respectively. In an ELS, it would be hard to distinguish the subject in a crowd and only just possible to discern if part of the landscape.

### Medium long shot (MLS)

This intermediate shot can be used in place of either the medium or long shots. In the frame, a subject is shown from the knees up.

### Medium shot (MS)

In this shot, the subject is framed from the waist up. This gives sufficient resolution for us to be clear what the person is doing and to interpret any expressions on his or her face.

### Medium close-up (MCU)

In this type of intermediate shot, a subject is framed from the chest up. Viewers can concentrate on the expressions on the subject's face, and that subject is no longer clearly seen in the environment.

### Close-up (CU)

One of the most powerful and revealing shot types, the close-up frames the subject from the shoulders up. Depending on the context of the shot, you will be able to see every nuance of their expression and interpret any emotion, should the scene be a dramatic one.

### Big close-up (BCU) and extra close-up (ECU)

Both of these shot types frame the subject's face and eyes tightly. They should be used sparingly; the power conveyed by a mere blink or twitch can be very revealing, but can also be regarded as invasive.

>> **LONG SHOTS** The very long shot and long shot successfully place subjects in their environment.

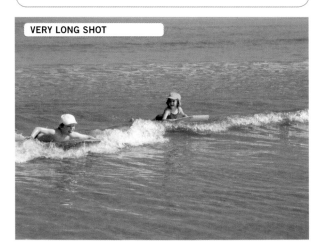

VERY LONG SHOT

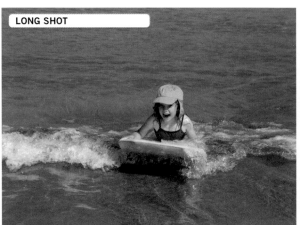

LONG SHOT

**MEDIUM LONG SHOT**

**CLOSE-UP**

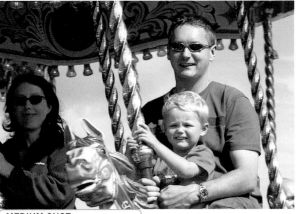

**MEDIUM SHOT**

**BIG CLOSE-UP**

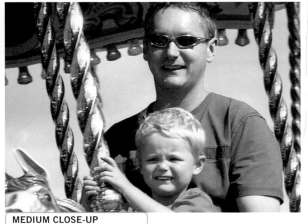

**MEDIUM CLOSE-UP**

**EXTRA CLOSE-UP**

⌃ **MEDIUM SHOTS** Medium shots are something of a transitional phase. They provide a successful and seamless way of linking the essentially location-setting long shots and the powerful (and expressive) close-ups.

⌃ **CLOSE-UP SHOTS** The three close-up shots become progressively more powerful. They work successfully at recording emotion but, less flatteringly, also have the potential to reveal every spot and blemish on the subject's face!

# UNDERSTANDING SHOT TYPES

It is good practice to use the standard shot types in a production, but a movie composed purely of these is going to look rather formulaic and predictable. There is a risk that the camera, which represents the viewer, spends too much time observing the action rather than being part of it.

Imagine for example, you were making a movie of two people, one chasing the other. Following the convention we have just described, we would see them running along a road (MLS), chasing each other down an alley (MS) and running across a park (LS, ELS). When we watched the movie, we would observe the action as bystanders. We would not be involved nor, frankly, would we feel inclined to be so.

Consider, instead, how a professional filmmaker might approach the same event. Sure, there would be a LS or MS to establish the setting, but there would also be some alternative shots. There might be a rooftop shot to show where our couple were coming from and what was ahead of them. There would almost certainly be a frontal shot, at maximum zoom, to shows the expressions of the chased person and the chaser. Suddenly we are aware of scale and, through the emotions of the runners, we become engaged. That engagement could be further enhanced if the camera were to adopt the view of the chaser. We would see the chased person struggling to gain ground and feel the tension mounting.

Your movies may not be steeped in melodrama like this example, but an eye for a good, powerful shot will make your movies far more effective. Here are a few examples that you will soon find space for in your movies. Again, standard abbreviations have been given, which you can use as shorthand on your shooting scripts.

**HIGH ANGLE** Zooming in towards the two boys in this high-angle shot helps place them in the context of their surroundings.

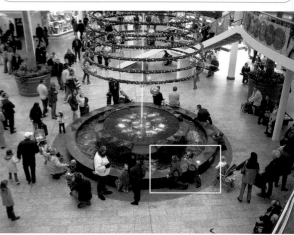

**LOW ANGLE** If you turn the usual low-angle shot on its head and put children up high rather than adults, you create quite a different result – that of warmth and curiosity.

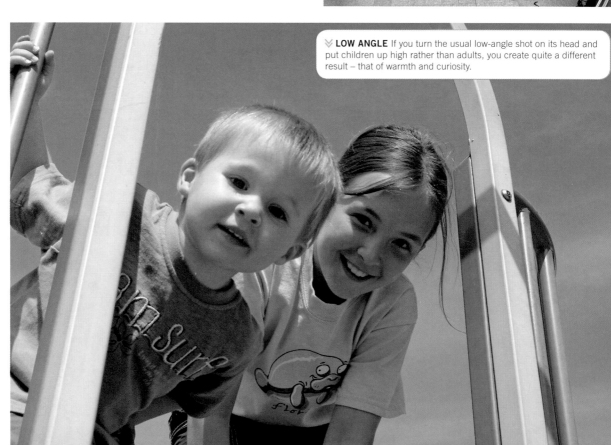

PART TWO: DEVELOPING MOVIEMAKING SKILLS

## High angle (HA)

Shooting from a high vantage point – from a second-storey window or a taller landmark – is a great way to place your subjects in context. A slow zoom into those subjects helps define their place within that landscape; a slow zoom out is an excellent way of showing scale and making your subjects look subordinate. Alternatively, shooting from a slightly raised eyeline is a useful way to express superiority on the part of the subject represented by the camera.

## Low angle (LA)

This is a powerful way to express dominance. Imagine making a video of a naughty child, suddenly caught out by a parent. You can shoot from the child's perspective, looking up at the looming parent above. Mood and emotion can be captured in one.

## Bird's eye

More extreme than high angle, bird's-eye shots are taken from almost directly overhead, with the camera pointing downwards. This is ideal for isolating a single person or subject in a crowd. Care is needed with these shots, as the overhead view is not a view we are normally familiar with.

The converse of bird's eye, a worm's eye view, is more problematic to shoot and, because of its extreme low angle, more specialized in use.

## Ground Level (GL)

Not to be confused with a worm's-eye view, the ground-level shot involves shooting horizontally from a very low angle. You might use this – in the example of our chase – to concentrate on the legs and feet of the subjects to help build pace. Or you

**EYE-LEVEL VIEW**

**GROUND-LEVEL VIEW**

⌃ **GROUND LEVEL** Here, the standard eye-level view is uninspiring, but the ground-level view is much more interesting.

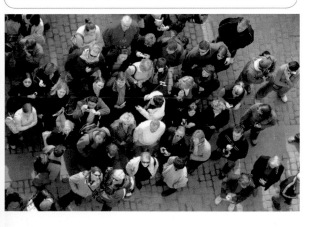

⌄ **BIRD'S EYE** The bird's eye view needs to be used sparingly and with specific purpose. For example, here closing in on the small crowd of people begs the question 'what are they looking at?'

can intercut scenes shot from this angle with those of a dog snuffling through long grass to give the dog's-eye view.

## Profile shots (PR)

This shot is taken with, as the name suggests, a person in profile, side on, rather than facing directly towards the camera. The intimation in such shots is that the subject is either preoccupied by something ahead or is in a pensive mood, oblivious to all around.

## 3/4 profile (3/4PR)

A more engaging version of the profile shot sees the subject three-quarters on to the camera, facing a point to the right or left of the cameraman's shoulders. This is akin to the over-the-shoulder technique that we will look at in more detail later on pages 60–61.

37

# USING COLOUR

>> Apart from aficionados of monochrome, photographers relish the exploitation of colour. Just think of mouth-watering shots of brilliant blue skies and azure seas in holiday shots. Clichéd? Perhaps, but compelling nonetheless. It will come as no surprise that digital moviemakers can – and should – exploit colour to a similar degree.

Colour has a profound effect on the mood and feel of a movie. Overcast skies, which tend to mute colours, can suggest a heavy, ponderous mood; bright skies, which enrich colour, can suggest a positive, upbeat feel. As moviemakers, we can capitalize on this.

## INFO

# CONTROLLING COLOUR SATURATION

Taking the lead from image-editing software, most video-editing applications allow you to alter the colour saturation of your movies during the editing stage. In some programs, this control extends to changing the colour balance selectively (for example, to make two scenes, shot under slightly different lighting conditions, match). Don't use these features in place of getting good colour in the first place – it is better to think of these features as allowing you to make a good thing better.

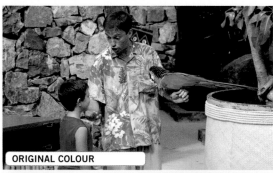

ORIGINAL COLOUR

SATURATED COLOUR

**IMPROVING COLOUR** A modest increase in colour saturation can lift a scene and give it much more impact.

### Bright and muted colours

Bright sunlight makes colours look more saturated and therefore more attractive. Unfortunately, in moviemaking terms, our eyes are adept at compensating for changes in colour and saturation due to lighting conditions. A vibrant red rose we see on a sunlit day we will perceive as equally vibrant in shadow and almost as vibrant on a cloudy, rainy day.

A camera – whether still or video – is much less forgiving and will give us an authentic result. Consequently, if that red rose is shot in shade, it will show the colour muted, and on a rainy day the rose will appear largely drained of colour. Of course, in each of these conditions the whole landscape will be similarly affected. Problems only arise where you have, in your finished movie, shots taken under different lighting conditions as adjacent scenes.

Take the rose again as an example. You might shoot some scenes of the garden including the brightly lit rose in all its

> **EYE-GRABBING COLOUR** Bright colours can enhance a subject. It is important to get the balance right between the subject and any colours in the scene to ensure that those colours don't compete for the viewers' attention.

> ⌃ **SUNLIT COLOUR** The addition of just a little sunlight makes the green in this shot much more saturated and vivid.

glory. Later in the day, you shoot a series of close-ups of the flower heads. In that time, the lighting has gone from bright sunlight to shady. You may not have noticed at the time, but when you intercut a long-shot scene of the rose bush with a close-up of the flower heads there will be an obvious and unexpected colour change.

## Competing colours

It is important to have a good eye for colour; it is equally important to be aware of the prominence of colour. Bright colour in a scene will attract attention and if that colour is not part of the subject of the scene, it will compete for attention with the subject. As your skills develop and your eye for colour progresses too, you will find ways around this. Here are a couple of suggestions:

- Use a brightly coloured object as a lead-in to your main subject. You could pan across or up to the subject so that viewers will be drawn to that subject.
- Counterbalance the subject in a scene with a bright colour. Think about implementing the rule of thirds (see page 33). Putting the subject's eyes at one intersection and a brightly coloured object diagonally opposite uses colour to enhance the composition.

> **EXPERT TIP**
>
> You can use your video-editing software to reduce colour saturation, or remove the colour altogether. This is useful if you want to create the illusion of old film footage, especially if you combine the effect with Aged Film, an effect that introduces uneven exposure, scratches and dust. Some cameras let you record in black and white too, although I wouldn't recommend this. Instead, shoot in colour and remove the colour during the editing. This means you can use the original footage in colour later if you want to.

39

# THE IMPORTANCE OF LIGHTING

>> There are many elements that go into making a great movie, and good lighting is one of the most important. Digital movie cameras today are very good at shooting in the most adverse of lighting conditions. However, that shouldn't be an excuse for not getting the best lighting that you can for your movies.

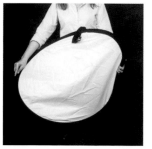

Lighting isn't just something that needs to be provided to illuminate the subjects of your movies. It is also a powerful tool to provide mood, atmosphere and affect your viewers' perception of the movie.

Getting the light right comes with experience. Knowing when to use ambient light, when to add reflected light and when to add additional artificial light is a skill, but thanks to the immediate feedback possible with digital video, it is one that is soon learned.

For most situations, you will find that the ambient lighting will be sufficient and quite acceptable. In some cases it may not be perfect, but your only option is to use it as it is.

« **FOLDING REFLECTOR** Lastolite reflectors offer large reflection areas, but pack away into a compact pouch.

⌄ **BOUNCED LIGHT** Using a reflector to bounce light back on to the faces of your subjects can dramatically improve your shot.

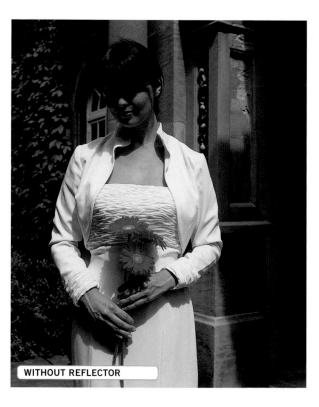

WITHOUT REFLECTOR

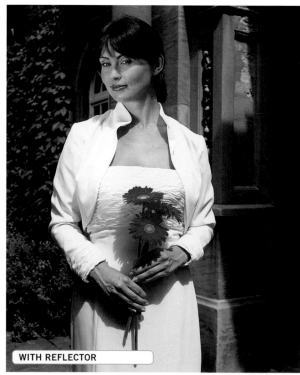

WITH REFLECTOR

# LIGHT SOURCES

Different light sources – candles, light bulbs, sunlight – cast a different colour on our movies. Our eyes are so adept at accommodating the wide range of colour casts different sources produce, we often don't realize how wide the variation is. However, your video camera cannot record such a vast dynamic range. Therefore, it is useful to have some knowledge of the colour of light sources. This is particularly important when you have mixed lighting in your scenes. Consider, for example, an interior scene lit by standard light bulbs but also lit by daylight streaming in through the windows. You need to use the camera's white balance either to get a good average or lock on to the most significant light source.

These two shots of a floodlit building clearly illustrate how profound colour casts can sometimes be. The original shot is how the building would appear if it were filmed using a camera that has been set for daylight photography. Because the lighting of the building is much redder than daylight, the building takes on a corresponding cast.

If we were to set our camera's white balance control for tungsten lighting (that is, conventional light bulbs), the result is a more pleasing neutral colour, a colour that would better represent our perception of the building. In this case, we could also have set the camera to auto white balance and let the camera make its own judgment. Auto white balance is fine where there is a single type of lighting casting a colour cast; it is less effective where there is more than one lighting type.

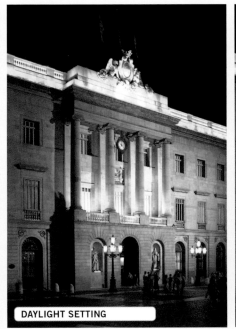
DAYLIGHT SETTING

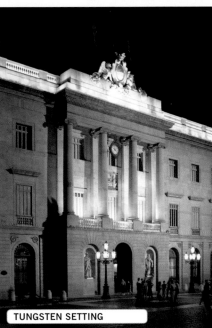
TUNGSTEN SETTING

**COLOUR CAST** Setting the correct white balance setting for the scene will result in much more natural looking lighting.

## Adding light

Still photographers have the advantage here because they have access to flash-lighting tools that can create almost any light scene – if only for the briefest of instants. Moviemakers are less fortunate in this respect, but we still have some useful opportunities. Camera-mounted auxiliary lighting is one option, but not one that lends itself to atmospheric or mood lighting. We could liken this to the harsh effect of direct, face-on illumination from a still camera's flash. It is harsh, and likely to illuminate a scene very unevenly. Head outdoors and you will find even the most powerful on-camera light is no match for balancing bright daylight or for filling in shadows in the manner of fill-in flash. (See *Get the Most From Your Digital Camera* for more information on lighting.)

## Modifying light with reflectors

A practical way to modify light is to use reflectors. These have the benefit of reflecting incident (ambient) light, so the reflected light will be in proportion to the rest of your lighting.

Folding reflectors, such as those offered by Lastolite, are excellent for filling in shadows and providing a counterbalance to a bright light source. You can even use them to overcome the high contrast range with backlit subjects. The best thing about these reflectors is their portability. Reflectors can also be used to modify the reflected light. Double-sided silver or gold reflectors allow additional warmth to be added to the reflected light where necessary; an intermediate 'warming' pale gold is great for enhancing skin tones.

41

# RECORDING SOUND

>> Digital technology has made it easier than ever to manipulate sound and audio (whether part of a video recording or not), but you still need to ensure that you record the best possible sound in the first place.

There is almost no limit to the amount of money you can spend on equipment with a view to obtaining sound as close to perfection as possible. For most moviemakers, however, a sensible and limited budget will determine how far you can go. You can adopt an incremental approach, determined by your budget and how much you are prepared to compromise on portability – the better the quality of the equipment, the more heavyweight it tends to be.

### Onboard microphones

There is often disparaging talk about the quality of onboard microphones in digital video cameras, but when needs must they will provide you with an adequate audio track. The drawbacks of using these are that you will pick up the annoying whine of the camera mechanism, unwanted ambient sound and even the breathing, muttering and movements of the camera operator.

### Camera-mounted accessory microphones

The next step towards improving audio quality is to invest in a basic accessory microphone. These devices can be mounted on the camera's accessory shoe. They connect either by an external connector to the camera's sound input or directly through contacts in the shoe.

Accessory microphones can be omni-directional, recording sound from all around (rather like the onboard microphones but offering better quality), or they can be more selective. Some models offer zoom options, to let you zoom into, say, the conversation of your subjects, isolating that conversation from the ambient noises. On the downside, these mics can add to the bulk of the camera and there will still be some problems – wind noise, for example – that need further steps to neutralize.

**EXPERT TIP**

A great place to find a wide range of microphones, often at reasonable prices, is musicians' stores. Take your video camera along with you to check compatibility. Taking your camera may also give you the chance to audition any models that the stores may carry.

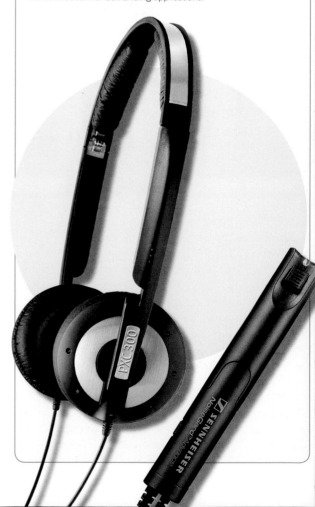

### INFO

## NOISE CANCELLATION HEADPHONES

If good sound quality is essential to your production, or you need to monitor the quality of the recording, consider investing in a pair of noise cancellation headphones that you can connect to your camera. This will give you a good representation of the sound quality being recorded and limit the ambient sounds that your ears pick up. These headphones are not cheap, but will protect you from discovering too late that your sound recording is below par.

**SENNHEISER HEADPHONES** Noise cancellation headphones, such as this model from Sennheiser, are essential for monitoring the soundtrack for demanding applications.

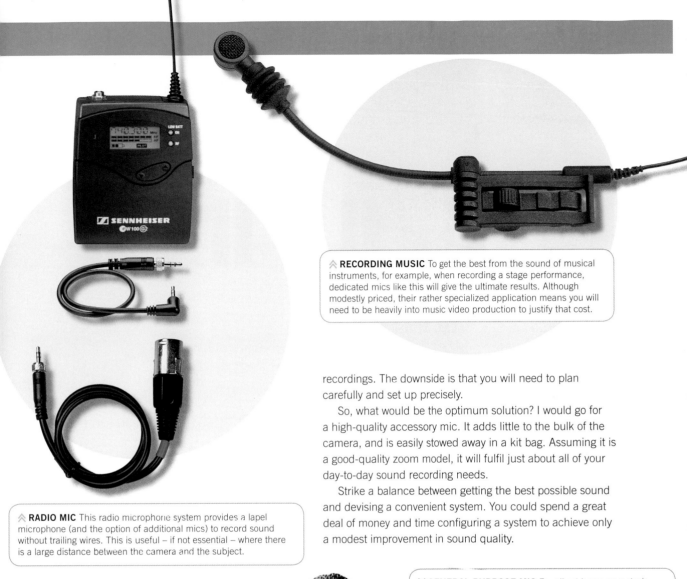

**⌃ RECORDING MUSIC** To get the best from the sound of musical instruments, for example, when recording a stage performance, dedicated mics like this will give the ultimate results. Although modestly priced, their rather specialized application means you will need to be heavily into music video production to justify that cost.

**⌃ RADIO MIC** This radio microphone system provides a lapel microphone (and the option of additional mics) to record sound without trailing wires. This is useful – if not essential – where there is a large distance between the camera and the subject.

recordings. The downside is that you will need to plan carefully and set up precisely.

So, what would be the optimum solution? I would go for a high-quality accessory mic. It adds little to the bulk of the camera, and is easily stowed away in a kit bag. Assuming it is a good-quality zoom model, it will fulfil just about all of your day-to-day sound recording needs.

Strike a balance between getting the best possible sound and devising a convenient system. You could spend a great deal of money and time configuring a system to achieve only a modest improvement in sound quality.

**⌄ GENERAL-PURPOSE MIC** Equally at home on a desk in front of a newsreader, or mounted on a boom, general-purpose microphones will provide very good sound recording. Consider using a windsock to cut down on wind noise if you are recording outside; even if the air is still, just a modest draft can cause annoying sounds.

## Boom microphones

You see these occasionally – and accidentally – on TV programmes. The boom microphone is mounted on a long extension pole that can be positioned over the heads of subjects to pick up their conversations. The boom can be attached to the camera (in which case, for stability, a tripod is pretty much essential) or can be held in position by a soundman. In the latter case, he or she needs to be mindful that the microphone stays out of shot but is held steadily. A windsock (a furry glove) and a zeppelin (a mesh grille) mounted over the microphone will ensure wind noise and damage from knocks are minimized.

## Sound stages

To obtain the ultimate in sound quality, you need to set up a mini sound stage. Using fixed microphones together with portable ones, such as lapel mics that can be attached to subjects' clothing, you will obtain high-quality, precise

# TIMECODES AND TIMELINES

≫ The timecode feature is one of the most useful for the home moviemaker. However, you rarely find it mentioned in the specifications when shopping for a new digital movie camera, and often details are buried deep within the instruction manual.

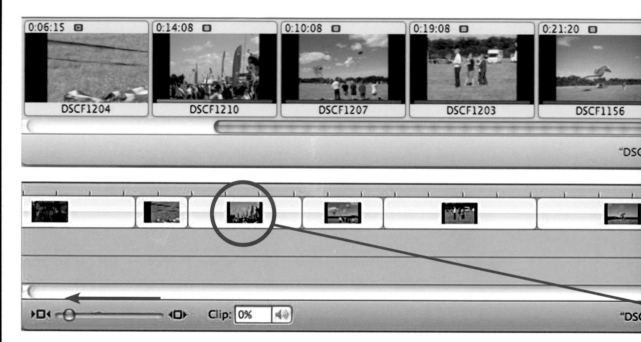

## Why timecode is important

When you make a recording on digital video tape (or other media, for that matter), other useful information is recorded too. The precise list of information will vary between cameras; sometimes you will get camera settings, and often date and time – but you will always have a timecode. This is the most important piece of information, because, when used correctly, it gives a unique identification to every single frame that you have recorded. As there are at least 25 frames recorded every second (closer to 30 on North American and other NTSC-based countries), that is a lot of information.

The timecode records the hours, minutes, seconds and frames in a format of hh:mm:ss:ff. For example, 01:23:11:17 would distinguish frame seventeen shot one hour, twenty-three minutes and eleven seconds into the tape.

Timecodes are often shown in the viewfinder or on the LCD panel as you record. This is for visual reference only: the data is actually recorded invisibly along with each frame so does not appear when the footage is played back unless you request its display. This is a great advance on some of the pre-digital timecoding systems that could, by an inadvertent selection by the camera operator, be indelibly printed on every image.

So why is a timecode so useful? There are a number of reasons, but here are the most important:

- It helps you keep a log of the position of shots on a tape or disc.
- It makes it possible to get frame-perfect edits and edit movie clips for precise durations.
- It allows multiple cameras to be synchronized, for example, when covering a live event with two or more cameras and being able to cut between the two at will.

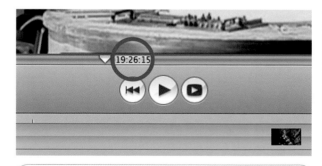

⌃ **TIMECODE DISPLAY** When you replay a video clip in your movie-editing application, you can see the timecode displayed at the play head. This allows you to make frame-accurate edits.

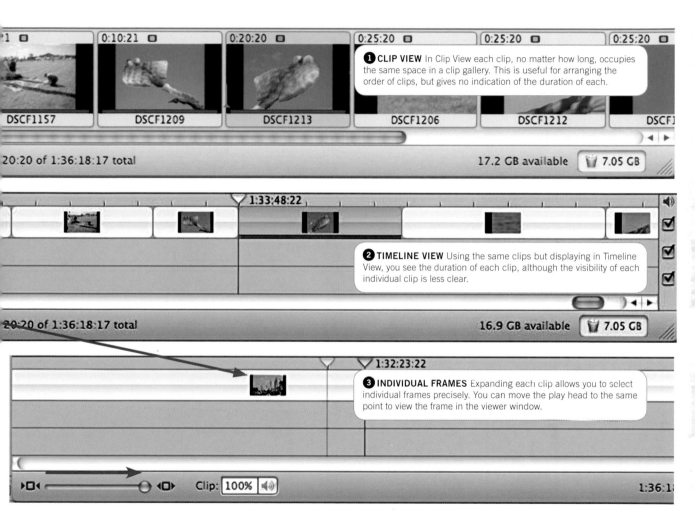

**1 CLIP VIEW** In Clip View each clip, no matter how long, occupies the same space in a clip gallery. This is useful for arranging the order of clips, but gives no indication of the duration of each.

**2 TIMELINE VIEW** Using the same clips but displaying in Timeline View, you see the duration of each clip, although the visibility of each individual clip is less clear.

**3 INDIVIDUAL FRAMES** Expanding each clip allows you to select individual frames precisely. You can move the play head to the same point to view the frame in the viewer window.

## Creating a definitive timecode

Once you have seen how useful a timecode can be, you will want to make sure that you get a good, robust timecode on every tape you use. Unfortunately, actions such as removing and replacing a tape in a camera, and winding forwards and backwards, can create breaks in the recording and cause the camera to reset its timecode system. The result can be multiple, identical timecodes on the same tape.

You can prevent this, and get a 'pure' unique timecode by pre-coding your tape. This is a process that involves recording over the entire videotape with the lens cap on prior to recording movie footage. Essentially, you are just recording a timecode: when you re-record over the otherwise blank tape, you will lay down new material against the existing timecode.

## Timecodes for editing

Timecodes come into their own when you want to edit a movie precisely:

1 In a default format, most movie-editing applications display individual clips in a movie as thumbnails, sometimes called a Poster frame View or Clip View.

2 Display the same information in a more representative way by switching to Timeline View, which displays each clip as a bar proportional in length to its duration.

3 With iMovie, you can adjust the scale of the timeline to lengthen or shorten the time periods represented (one tick here equates to a minute). With the bars expanded to maximum, you can edit precisely, to the nearest frame.

45

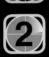
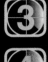

# WIDESCREEN VS STANDARD

>> We have widescreen in the cinema and on TVs, so what about widescreen home movies? Traditionally, video photography used a standard aspect ratio of 4:3. That is, the ratio of the width of the film frames and the height is in the proportions of 4 to 3. In the early days of television tube production, this was the best ratio, in terms of width, that could be achieved.

### The transition from standard to widescreen
The aspect ratio of 4:3 is not ideal, and there has been a demand for an aspect ratio that better matches our eyesight. Hence, we have seen cinematic formats such as CinemaScope and the even wider Cinerama.

Video cameras, with their cine heritage and need to fill only a standard-sized television, have long eschewed widescreen formats. However, that has changed in only

a few years. Digital television and HDTV have altered our expectations, and widescreen is now seen as the norm.

Increasingly, digital movie cameras offer widescreen shooting using the standard widescreen format of 16:9. In some cases, this may not be real widescreen (see below), but certainly all those cameras that offer the HDV format allow shooting in true widescreen. We are in a transitional phase between a standard-format past and a widescreen future,

⌃ **PERFECT MATCH** Standard-format video displayed on a standard-format TV. Perfect! The recording fills the screen and, as we are viewing the entirety of the video picture, we get the best possible resolution.

⌃ **LOSS OF HEIGHT** The other option when displaying standard-format video on a widescreen TV is to 'zoom' the TV picture so that the video image fills the width of the screen, but only by sacrificing the top and bottom of the picture.

⌃ **LOSS OF WIDTH** Standard-format video displayed on a widescreen TV. We have two options here. The first is to view the video so that the entire height is displayed – this will produce black sidebars due to the narrower width of the video picture.

⌃ **EXPANDED AND DISTORTED** Some televisions will let us expand the picture to fill the height and width exactly. This will produce a stretched picture that is not particularly watchable and certainly not authentic.

△ **LETTERBOX VIEW** Widescreen video displayed on a standard-format TV. You can choose to show the full width of the movie on the screen, but you will get the characteristic letterbox appearance with black bars at the top and bottom. This shows the entire picture, albeit with a reduced sized image.

△ **LOSS OF WIDTH** Zooming to get the full height filled with the video image will mean sacrificing elements to the right and left.

△ **PERFECT MATCH** Widescreen video displayed on a widescreen television results in a perfect match – a full-resolution image filling the screen exactly.

△ **COMPUTER SCREEN VIEW** Displaying on a computer screen. Media players such as QuickTime display any media in its native format. The player will automatically adjust to display correctly.

so what does this mean in terms of recording and viewing media? The short answer has to be compromise. Some recordings will display perfectly on some televisions, some less so, as illustrated here.

### Thinking about shooting formats

Whatever format you shoot in, be mindful of the intended recipients of your video. If you intend to distribute via the web, don't worry – any format will do.

If you want to cover all bases, shoot in standard format but keep your important subjects out of the areas at the top and bottom that would be cropped when viewed on a widescreen TV. Conversely, if shooting in widescreen, keep the main action in the central part of the screen.

Bearing in mind the move towards an all-widescreen future, it probably makes sense to shoot in widescreen and think in widescreen. Apply the rules described previously, such as the rule of thirds (see page 33) to the widescreen workspace. Widescreen gives much better visual results when handled correctly, so take advantage of it!

<div>

**INFO**

# PSEUDO-WIDESCREEN

Some cameras offer a format that is technically widescreen but lacks the resolution of true widescreen. The top and bottom of a standard video image are cropped off to produce a letterboxed image. The lower-resolution image is consequently softer and less distinct.

</div>

**EXPERT TIP**

Widescreen can cause some problems. Any tilt in the camera will be more obvious, so it is important to mount your camera on a tripod whenever you can. The wide view can also allow unwanted elements to creep into the scene. You need to be extra vigilant when checking the viewfinder or LCD panel.

# SHOOTING WITH HDV

>> Once you have seen HDV (high-definition video) as it was meant to be seen, you can be overwhelmed by the quality. It is not just the extra resolution: colour, contrast and brightness also appear greatly enhanced compared with standard-definition video, and are more than a match for the best in broadcast television.

However, sometimes HDV can get caught out, particularly with fast action. You may have noticed with some programmes on digital television stations that fast-moving and detailed images – whether a football game, action movie or just the rapid movement of the presenters – can result in the image breaking up, momentarily, into blocks.

This is down to the data rate (that is, the amount of digital data being received and processed) and the way that data is compressed. The main television stations tend to use high bandwidth – high data rates that mean the picture quality will be good even on fast action. Smaller channels buy less capacity and the result is more highly compressed data and consequent artefacts that detract from picture quality.

HDV is remarkable not only for the picture quality it offers but also because it maintains compatibility with conventional MiniDV tapes and recording times. However, it can only achieve this by a very heavy compression of the data. This level of compression causes some problems, notably in the handling of fast-changing scenes.

## How data is compressed in HDV

Let's look at the method used to compress data in the HDV format. An HDV camera will begin a recording by capturing a complete, high-definition image of the first frame of the shot. This is called the I-frame. For the next frame, it does not record the whole frame again but only any changes between it and the previous one. This is the P, or predictive, frame. Most HDV cameras will record just one I-frame followed by 14 P-frames. In normal circumstances, there is only a modest amount of change between frames. It is by using this method that the impressive compression is achieved. But what if there is a lot of change between each subsequent

STANDARD DEFINITION

HIGH DEFINITION

⌃ **SHARPER WITH HDV** This close-up of an eye was recorded in standard definition and then in high definition using the same camera. A rigid mount was used to ensure sharp focus in both cases. The detailing in the hair particularly emphasizes the high-definition advantage, but the sharper image also produces a darker iris and brighter highlight due to the image's finer pixel structure.

## INFO

# RECORDING SHARP IMAGES IN HDV

HDV gives the opportunity for ultra-sharp, ultra-detailed images. But to record ultra-sharp images, you need to ensure that your focus is spot-on, with no room for error. Even a tiny amount of defocusing – something that would never be noticed in standard definition – can be all too obvious in HDV and ruin a great shot. Some HDV cameras can aid you with a feature called Focus Assist – a super-fine focusing system. Otherwise, to be assured of good focus, make it easy for the camera to work by providing as much light as possible and taking particular care when you are shooting indistinct areas where focusing mechanisms traditionally struggle to get a good focus. For the same reason, try to avoid using filters on HDV cameras where you can emulate the filters later with your editing software. Filters cut down the light available to the CCD sensors. Some filters, such as soft focus, make obtaining sharpness more difficult and are better simulated when you come to edit your movie.

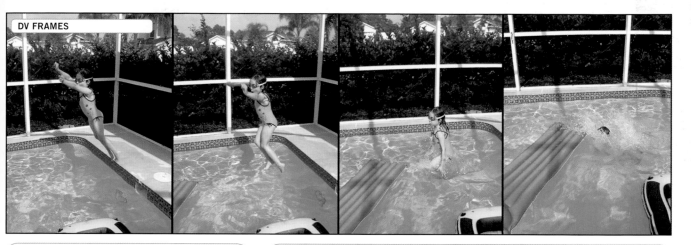

**DV FRAMES**

⌃ **DV EQUAL RESOLUTION** These sections from DV frames show that the resolution of each frame is approximately equal even though there is fast action taking place. Compare this with the HDV frames.

⌄ **HDV ARTEFACTS** The first frame (an I-frame) in this HDV sequence is much sharper than the first DV frame. The following frames (P-frames) show blocking in areas of fast movement. Much of the last frame is affected because of camera motion. This is only a small section of the frame, though, so when viewed the artefacts will not be as severe as these shots might suggest.

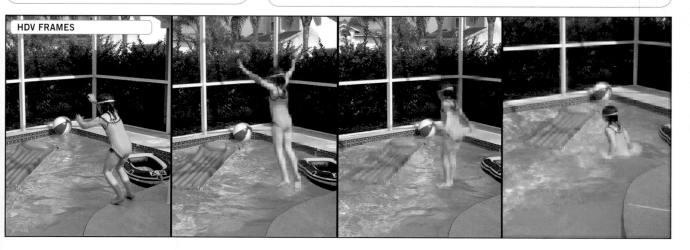

**HDV FRAMES**

frame? For the first P-frame, the camera will need to record a lot of new data – perhaps on a par with an I-frame in extreme circumstances. The next P-frame will need more data too, and so on. So more data arrives than can be successfully compressed to fit in with this compression regime. The result: the image can't be recorded in the necessary detail and, instead, small blocks of 'averaged' data are recorded.

There are two possible ways to avoid this problem when shooting with HDV. One is a practical solution, and the other is technical.

## Avoiding artefacts: a practical solution

The practical method is to shoot carefully and with deference for the HDV format. It is more important with HDV (compared with any non-HD format) that you use a tripod or other camera support so that consecutive frames are – apart from

essential action and movement – identical. You can also ensure that the light levels present in the scenes are higher than you would normally allow for. If you have been a film-based photographer in the past, you may have worked with the particularly fine-grain films that are the equivalent in the film world of HD video. The finer the grain, the slower (i.e., the less sensitive) the film and consequently the more light that was needed for exposures.

## Avoiding artefacts: a technical solution

Some camera manufacturers use a shorter run of frames, such as one I-frame and five P-frames, ensuring that there are far more fully detailed frames per second. The disadvantage of this is that the electronics can sometimes struggle to maintain consistent colour and brightness levels across the frame.

# CONTINUITY ISSUES

>> Whether drama or documentary, a movie's storyline depends on continuity. One scene should, unless for some creative or dramatic reason, lead seamlessly into the next. However, events often conspire to prevent such a transition, which is why you need to keep continuity in the forefront of your mind when shooting.

Flawless continuity is rarely achieved; websites abound that note continuity errors in every major movie – errors that most of us would overlook. Sadly, it is the otherwise helpful auto controls on cameras that often lead to continuity problems.

## Continuity in colour

Changes in white balance lead to the most common continuity errors. Set to auto, the white balance control does a fine job of neutralizing colour casts in a scene, but when the lighting changes, the corrections made become obvious. Such changes in lighting might occur when the sun comes out from behind clouds between different scenes.

In variable light conditions, it is best to continually monitor the white balance settings and change them manually (from overcast to sunshine settings, in this case). It can be a chore, and the corrections don't necessarily lead to spot-on continuity. However, the errors will be sufficiently minor as to go unnoticed or be easily corrected at the editing stage.

Remember, too, that in some situations you may want to avoid colour corrections. If, for example, your action moves from outdoors to an interior lit by tungsten light, in auto mode the camera will automatically adjust so that the warmly lit interior becomes completely neutral once inside. Locking the camera on your outdoor white balance setting will ensure consistency and allow you to edit out intermediate footage without any colour issues.

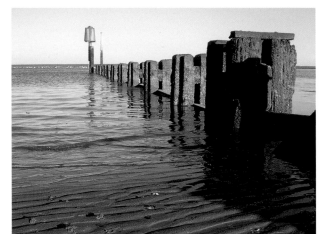

⌃ **COLOUR CONTINUITY** These shots demonstrate inconsistency in the colour continuity. A close-up of this beach scene illustrates much more saturated colour than the wider, establishing shot. Switching colour balance from auto to sunny daylight would produce more consistency. Through the viewfinder there appeared no difference between the shots, but the change is all too apparent on the recording.

## Continuity in exposure

It is essential that an even exposure be maintained between shots. Auto-exposure control means that your camera will always judge the best exposure for each shot. This is ideal in principle, but for perfect continuity you need the exposure calculated for a specific element in a scene to be identical between shots. If, between scenes, there is a change in composition such that a bright (or dark) area is introduced, the auto exposure will compensate automatically.

The solution? If you have the controls available, you can meter off a consistent element in the scene. If not (and this will apply to the video cameras most of us possess), you will need to make corrections at the editing stage.

## Continuity in contrast

Allied to changes in lighting, contrast can vary in a scene when the light levels and type change. Overcast skies or indirect lighting lead to softer, flatter contrast, whereas bright sunlight delivers high contrast.

## Environmental and prop change continuity

There are a whole host of potential environmental continuity problems, and these can be exacerbated if the time between shots varies significantly. Vehicles parked in a road, for

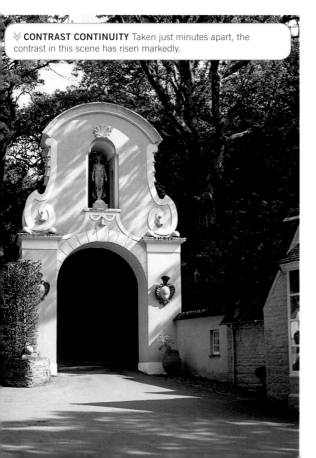

**CONTRAST CONTINUITY** Taken just minutes apart, the contrast in this scene has risen markedly.

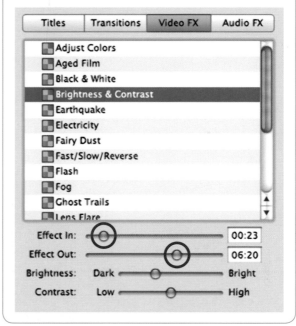

### INFO

# CONTINUITY INSURANCE

Video-editing software provides the tools to make compensations for in-camera continuity problems. These tools are usually found under Video Effects. The brightness and contrast can be adjusted as shown below. This needn't be for the whole clip – the Effect In and Effect Out sliders allow you to apply the effect selectively.

**SOFTWARE CORRECTIONS** If you don't get things right when shooting, video-editing software may help you out.

example, might be driven away between takes, leading to an obvious discontinuity; or perhaps the weather conditions change dramatically.

Prop changes are alterations to elements that you deliberately introduce to the scene. Some of these you have control over, but you need to be vigilant. One good example is inconsistent drinks glasses. You might be shooting people having a discussion around a table, or perhaps interviewing someone at a table. The series of shots that make up your intended scenes go well and, before you wrap up, you shoot some cutaways (see pages 70–71) and alternate angles. The trouble is, the subjects have been drinking as the shoot progresses, and when footage is intercut, levels of liquid in the glasses fall… and rise… and fall… Viewers will notice this apparent sorcery and overlook the magic in your script!

# PART THREE:
# SHOOTING YOUR MOVIE

Enough of the theory! It's time to start making movies. In this section, we look at what you need to do to start producing great footage. We all have the urge to pick up the camera and go off shooting, but let's begin by taking a more considered view and deciding what you want to achieve beforehand.

Putting together a story – whether your production is dramatic or documentary – is the key to success. You need to take a structured approach to both planning and shooting. Then, when you come to edit the film, you will be confident that you have everything you need to create your masterpiece.

# PLANNING AND STORYBOARDS

>> It is important to plan any movie you intend to make, no matter how informal. A movie should tell a story and have a structure. Think ahead and your time in the editor's chair will be far better spent.

A movie is principally a visual vehicle and should provide a treat for the viewers' eyes, so the visual elements should be prominent and engaging. A series of visuals that does no more than illustrate a narrative is unimaginative and likely to bore your audience. That is why it is important to plan any movie, ensuring that you don't fall victim to clichés.

## Basic planning

How detailed your planning needs to be depends on the type of movie you are making. An informal shoot of a school sports day may not need a detailed shooting script, but it still pays to think ahead. Obtain a schedule of events so you know what is happening when and where. You will need to know where to be to get the best shots. That is probably all the planning necessary in this case. Keep everything in perspective: don't go into too much detail where you don't need to.

You will need to be flexible. You might find the positions that you planned on using for the best shots aren't feasible when you arrive on location. It may be that these prime points aren't prime at all, or you may find they are crowded with other parents determined to make their own record of the day. The latter is a good reason to get on location early!

> ⌄ **STORYBOARD TEMPLATES** It is a good idea to have storyboard templates to hand when planning your movie. They are commercially available, but it is just as easy to produce one on your computer – or even with pen and paper!

## INFO

# PRACTICAL CONSIDERATIONS

So, you have your plan, shooting script, storyboard and lots of ideas. Is that it? Essentially, yes. However, you will often discover that events conspire to prevent you executing your plan, so try to take all reasonable steps to prevent problems arising.

A frequent problem, for example, is building works. You head off to your location only to find that the landmark building you planned to use as a backdrop is swathed in scaffolding. Or builders are working at the house next door, causing no end of visual and audio pollution.

Another problem results from photographic restrictions. You can't shoot with a video camera everywhere. Some places, for safety, security, deference or just awkwardness don't permit photography (see pages 56–57). Scenes you planned for the church, city hall or other public building could be frustrated if photography is not permitted there.

## Detailed planning

Some movies will need more in-depth planning. Professional moviemakers will probably spend between five and ten times the time spent shooting the movie in planning every shot. You don't need to dedicate so much time to the planning stage, but do need to apply a little more thought. The two new elements you will need to work with are a script and a storyboard. These are complementary. The script, which describes the story in terms of scenes, will need to be sufficiently detailed so that, should you want to add a voiceover, the scenes described will match that commentary. The storyboard is a pictorial representation of the scenes. This is the filmmaker's initial visualization of the movie. You may have a good story and a script in place, but what are you actually going to shoot? That's where the storyboard comes in. A storyboard looks like a comic-strip cartoon of the movie, with each shot you intend to take represented pictorially. These sketches don't need to be artistically perfect; they should merely represent the intended sequence of scenes and the camera angles you want to record.

Establishing shot – harbour wide-angle view and detail

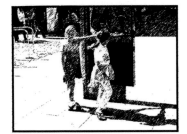

Children at map – pan down, get them to look at ice cream van

Buying ice creams MS/MSU

Eating ice creams at fountain, get children to talk about trip

Walk through the fountains

Establishing shot of boat ready for trip, get shot of trip sign if poss

Why bother? You may have every scene fixed in your head, but when it comes to shooting on location you will have other things to think about. All those structured thoughts could quickly disappear and leave you floundering. Putting it all on paper doesn't just provide you with a definitive sequence; it will also highlight opportunities and problems.

The opportunities may include scenes that can be more conveniently shot out of sequence to save time and reduce continuity problems. For example, if you are shooting a conversation and alternately shooting scenes facing the person speaking, it makes sense to shoot all the scenes involving one person speaking first, and then all those of the other person. This avoids breaking every few seconds to reposition the camera. You will also see good points to shoot cutaways.

The problems that may be highlighted include camera angles that you conceived in your head that will not work in the real world. The storyboard lets you trial different scenarios prior to committing them to your movie.

## Creating a storyboard

Producing a storyboard should never be considered an onerous task. Make it simpler by creating template sheets marked up with rectangles (of the appropriate proportions of the video frame), with space for comments below.

- Draw using a soft pencil; it will make it easy to sketch out shapes and fill in shadow areas.
- Add notes. These could be brief or more detailed depending on what the scene actually involves.
- Use arrows, frames and additional notes to plot any movements of the camera and of the characters.

Remember that storyboards are there to make your shoot easier. They are not designed to inhibit your creativity, nor to take the fun out of moviemaking. A well-thought-out storyboard will make editing the movie much simpler; even a crude storyboard will help you to avoid errors and the chance of missing scenes.

However, don't let the storyboard rule the production. You may get on location and find there is a new angle or point of interest that will improve your movie while staying true to your vision, so shoot it. The storyboard will ensure you get everything you need, but your filmmaker's eye and judgment will help you get something even better.

EXPERT TIP

Planning should include getting together all the kit you need for shooting. This is especially important when you are shooting away from your home or your base. Nothing is more disheartening on a shoot than realizing that you have run out of tape, blank discs or battery power.

## Restricted locations

Where can you shoot and where can't you? Some people find it surprising that there are relatively few restrictions; if you rule out the obvious (military or strategic installations, particularly those in foreign countries and those with security implications), these tend to be occasionally obscure. Here are a few examples of potentially contentious locations. As an aside – but an important one – you should also be mindful of your personal security too; in some areas walking around as an obvious tourist can make you popular with some locals for all the wrong reasons.

⌄ **TRANSPORT** There are not usually any restrictions for rail transport, but most locations will require discretion, and tripods (for safety and obstruction reasons) are generally forbidden. It can also be problematic to shoot in busy locations or at busy times.

⌃ **CHURCHES** Sensitivity is generally required in places of worship; some are quite welcoming, others not so. The welcoming ones may have limitations at certain times. Discretion should be exercised at all times.

⌃ **HISTORIC BUILDINGS** For public and historic buildings there are generally no restrictions on photography, although some locations may impose restrictions or even bans for security reasons. Some places allow photography and video but may place restrictions on the subsequent commercial use of the material recorded.

⌃ **COPYRIGHTED CHARACTERS** You will be encouraged to shoot a lot at theme parks and the like, especially the iconic characters. There may be restrictions on subsequent use of the imagery (still or movie) imposed by the owners of the copyright on what are ostensibly their trademark characters.

⌃ **CHILDREN** Whether they are filmed informally in a playground or at a staged performance, there is generally no legal restriction on video photography of children. However, photography of children is increasingly regarded as contentious. Common sense on the part of the photographer should prevail.

⌄ **METRO STATIONS** There are normally no restrictions for video photographers on underground, metro or subway stations, although still photographers are generally forbidden to use flash.

57

# THE ESTABLISHING SHOT

>> The establishing shot is the one scene that, through its placement at the start of a movie or sequence, defines those that follow. You need these to make clear to your viewers where the action is taking place, and may use them to set the mood and tone of the movie as well as establish the location.

## Why you need an establishing shot

The principal need for an establishing shot is where the following scenes take place in a location that is unclear to the viewer. For example, you may be shooting your screenplay in a Paris park surrounded by landmarks that anyone frequenting the area would recognize. But those ultimately viewing the movie may not know them. Adding an establishing shot that pans down from some obvious Parisian landmarks to the park setting removes any ambiguity.

Another benefit of the establishing shot is as an opener to a movie or collection of scenes. A wedding, for example, might begin with an establishing shot of the outside of the church or venue, prior to any service or arrivals.

⌃ **CUTAWAY** Anyone watching this might presume that the movie was shot in Venice. This view is reinforced by the cutaway shot of gondolas.

⌄ **ESTABLISHING SHOT** Here is a good example of the importance of a good establishing shot. A holidaymaker shot these Venetian Carnivale performers – music, colour and a great performance.

Does the establishing shot necessarily have to be the first shot in a movie or a sequence? This is normally the case, but not always. Its purpose is to set the scene for the following shots. You might be presenting a movie as a video diary, for example. You could start with a piece to camera describing the movie. Only after this, when the action moves on to one of the setpieces, do you need the establishing shot.

The establishing shot does not need to be shot first. It may be more convenient to shoot it later in a sequence of shots. Take care, however – if you shoot a day's action and then an establishing shot, changes in weather and lighting might betray your technique when you move this final scene to the start of the movie.

## Blending establishing shots

To make your establishing shot more a part of the movie (rather than just a scene that prefaces the main sequence), take a lead from professionals. They will use the soundtrack of the main scenes over the top of the establishing shot.

---

• **How long does an establishing shot need to be?**
Only long enough to get the message over. With an obvious scene, a few seconds might suffice. With a more obscure subject or a subject that needs closer inspection, it should be a little longer.

• **Should an establishing shot be a fixed one?**
No, not at all. You might want to zoom or pan across a landscape, slowing and stopping the camera when it comes to the location of your main scenes. You have probably seen this on countless TV programmes where the camera will pan across a cityscape, eventually settling on a single building. The next scene shows people talking in a room. We make the logical assumption that this room is one within that building in that city.

• **Should an establishing shot be a single shot?**
Despite the name suggesting it should be so, if you need two or three shots to unambiguously define the location or nature of the ensuing shots, by all means take them. An example might be to show that the location of the next scenes is in an obscure warehouse building on the River Thames. The first shot is of Tower Bridge; the second, taken from Tower Bridge, looks across to the warehouses. The final shot, taken from nearby, closes in on the warehouse that will feature in your movie.

Here's a good case in point. For a wedding movie, with the church exterior as the establishing shot, the background organ music that accompanies the next few scenes of guests taking their seats in the church can be playing during the establishing shot. You will successfully link the shots together through the audio alone.

⌃ **EXTREME LONG SHOT** Fortunately, the holidaymaker also shot this extreme long shot, which appears to confirm our belief that we are in Venice.

⌃ **REAL ESTABLISHING SHOT** Now for the establishing shot that, in the final movie, will precede the others. Venice is in fact the Italian pavilion in Disney's Epcot Centre in Florida. However, the iconic nature of this shot immediately confers the setting.

# SHOOTING TECHNIQUES

>> In our earlier discussion of shot types (see pages 34–37), we looked at distance as the prime discriminator. However, even a variety of shot types can become bland if you don't put them together in a way that helps you tell your story. Having got to grips with establishing shots, we will look at enhancing your shooting technique further, with over-the-shoulder and point-of-view shots.

### Over-the-shoulder shots

Movies created by novices tend to be predominantly composed of medium shots. Even when you graduate from shooting medium shots as a matter of course, you can still fall foul of shooting your subjects from a distance. The result is often a voyeuristic look – you are looking at your subjects' world rather than being part of it.

To avoid this, and help draw your audience in, a useful technique is to use the over-the-shoulder shot (often abbreviated to OSS). You shoot over the shoulder of a subject to capture the view of that subject; you also see the subject

himself or herself engaging with this view. This creates a sense of greater involvement: the audience can see the world from the subject's perspective, so they can empathize with that person and better appreciate what is going on. As a useful side effect, you are also able to increase the perceived depth in a shot, creating additional foreground and background detail to make the shots more visually dynamic and interesting.

In manuals of video photography, you will see a formal definition of OSS that advises that the classic OSS should feature the head of the person whose shoulder we are

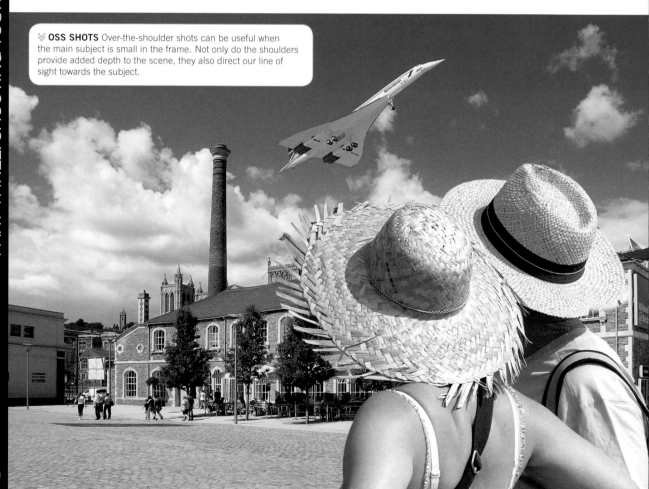

**OSS SHOTS** Over-the-shoulder shots can be useful when the main subject is small in the frame. Not only do the shoulders provide added depth to the scene, they also direct our line of sight towards the subject.

**EXPERT TIP**

An over-the-shoulder shot can be used as a cutaway (see pages 70–71) when shooting interviews. By shooting over the shoulder of the interviewee to the interviewer and having the latter nod or smile, you will obtain useful cutaways to link disparate scenes when you edit later.

peering over, filling the full height of the frame and cut off behind the ear. The subject should fill around one-third of the frame. In general usage, this definition can become rather prescribed; a looser, more practical definition would allow greater freedom in placement. This becomes more important with widescreen and high-definition video, where detailing does not have to fill a substantial part of the screen to become a significant element.

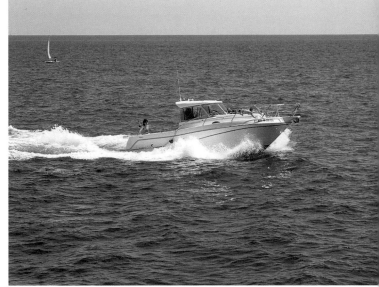

**POINT OF VIEW** After you have established what the subject is looking at, you can switch to a point-of-view shot (see page 62) to give the view from the perspective of the subject.

**OVER THE SHOULDER** The over-the-shoulder shot here shows us what the subject is looking at – in this case, the passing boat.

## INFO

# REVERSE OSS

You can also shoot an over-the-shoulder shot in reverse. Such a situation might be taken of, say, a leading runner in a race. You shoot over their shoulder to show those coming up from behind. Of course, getting a shot like this can be problematic: you will need to be ahead of the leader but not interfering; alternatively, you could shoot from a distance ahead and use the zoom to bring the leader forward. Train the camera on the followers and let the leader move out of shot as he or she runs forwards.

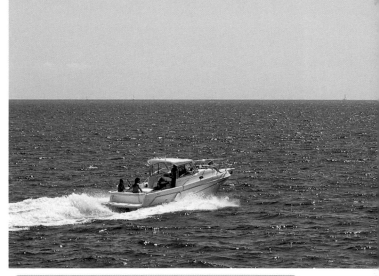

**EXTENDED SHOT** You can then continue with an extended shot, implying that the subject is watching the boat go off into the distance.

> ⌄ **POINT OF VIEW** Not quite an over-the-shoulder shot, here a continuous shot moves in from showing the subject through to giving his point of view.

### Point-of-view shots

With over-the-shoulder shots, we look at the world from the perspective of the subject. In point-of-view shots, we go a step further: the camera adopts the viewpoint of the subject and, in a sense, becomes the subject. Use this technique to add some real drama to your shooting.

Imagine you are shooting a child in a pushchair being pushed along a road. We see his or her excited face and then, by shooting from a low angle looking in the same direction as the child, we see the world from their point of view and whatever it was that caused their excitement.

Similarly, imagine a man running along the road shot as a medium shot, the camera panning to keep him central in the frame. In the next shot, we adopt his position and see the street seen through his eyes. This is one case where you can ignore the rule about using a steady support – a slight shake due to a handheld camera will add to the drama.

### Crossing the line

This tale sounds apocryphal but is painfully true. Open-top tour buses make a great platform from which to record whistle-stop tours of cities. The whole panoply of landmarks and sights is laid before you with the video opportunities often coming thick and fast. Better still, the open top means you can get unhindered views from all directions.

Many people do this and many fall foul of a subtle but important rule in video shooting – not crossing the line.

What's it all about? Think about the geometry of shooting with wild abandon all those sights that present themselves to the left and the right. Shoot to the left of the bus and we appear to be moving from left to right. Shoot the next scene to the right and we appear to be moving the opposite way.

The reaction of an audience will be bafflement followed, if they were watching too closely, by an element of virtual travel sickness. Though technically correct, the constant shooting from alternate sides makes for uncomfortable viewing and, when people are introduced, confusion.

Imagine another situation. You are shooting a man and a woman walking across a grassy field in a park. In the first shot you shoot them from their right, walking from left to right in the viewfinder. In a subsequent shot you shoot them from the left. They are now moving from right to left in the viewfinder. The appearance to the audience is that they have suddenly, without explanation or reason, changed direction, and are walking back the way they came.

Both these examples illustrate the importance of not crossing the line – an imaginary line, of course – which in the first case runs along the midpoint of the bus and in the second along the line of motion of the couple. In fact, both these examples have the same geometry: in effect, the subject and camera positions in the first example are reversed in the second.

How can you avoid crossing-the-line problems? The obvious way is to avoid crossing the line at all. Though feasible, this can lead to boring shots. And, in the case of our tour bus, you'll restrict yourself to only half your potential

## INFO
# SWAPPING POSITIONS

Another manifestation of the crossing-the-line problem rears its confused head when we shoot people walking towards, and then away from, the camera. As people approach we are aware who is standing to the left and who to the right. As, in the next scene, they have passed the camera and are now walking away, common sense would suggest that the person to the left of the frame would now be on the right and vice versa. In practice, however this can look odd, and you may get a result more acceptable to the audience by reversing their positions. That person on the left walking towards the camera is still on the left walking away.

shots! A more successful way of achieving this is to break the rule of keeping the camera still, relative to the subject, and track around. In the case of the bus, we could track around, taking in the view to the rear (or front) of the bus and continue around to the opposite side of the vehicle.

We could also use an intermediate shot. For our walking couple we could interject a frontal or rear view of them walking to link the two scenes.

## INFO
# THE SHOT TO AVOID

When you are in a situation – such as on a tour bus – where there are shooting opportunities at every turn, there is a tendency to set the camera rolling and wave it from sight to sight. This is called hosepiping or floundering. Add in a little vertical shake by virtue of the fact you're probably forced to handhold your camera and you'll shoot the most uncomfortable and unsuitable video your audience will probably ever see. Sad to say that if you take a candid look at a group of camcorder equipped sightseers, a worryingly large number will be doing just this; you can really pity the family and friends who'll have to feign enjoyment when watching the results!

Even when opportunities are coming in quick succession, concentrate on holding key ones dead centre in your shots – and add some cutaways (see pages 70–71) to break the monotony of what could become a mere video slideshow.

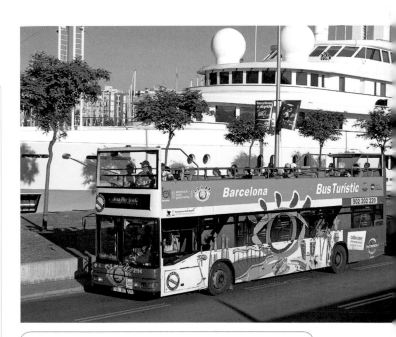

⌃ **LINKING SHOTS** Shots like this, of a tourist bus, are good for linking scenes together, particularly in a travelogue. Do ensure, however, that adjacent shots don't feature the same vehicle moving in different directions.

# STILLS WITH A VIDEO CAMERA

>> Not so long ago, movie cameras – including some of the early digital models – were capable of taking only mediocre still images. Now many cameras can produce quality images with resolutions of 3 megapixels or more, which puts them on a par with many digital stills cameras.

The purist photographer might say that 3 megapixels is pretty pedestrian by modern standards and that the quality doesn't match that of a dedicated stills camera of the same resolution. However, there is much to be said for having stills-shooting capability in your movie camera.

## Advantages of shooting stills

Your movie will often benefit from the inclusion of some still images. You may be shooting a video of a garden, or a collection of artworks, for example. As well as the movie shots that show the respective locations and the objects within them, you can present some still images of plants and individual artworks that will show them to better effect. This technique is widely used in documentary filming.

In addition, there are always photo opportunities when out on a video shoot, for which your movie camera can be pressed into service. With a good zoom, basic photo controls and excellent viewing options via the viewfinder or LCD screen, you have the opportunity to capture some pretty good shots.

## Downside of shooting stills

It's not all good news, however. A movie camera is optimized to record lots of images very quickly, compress them, and then lay them down on tape or disc as fast as possible. This inevitably involves some degree of compromise, which is generally in the areas of colour authenticity and fidelity. You would be hard pressed to question the colour quality of movie images, but a still image, one that viewers have time to consider at length and look at in more detail, can be more challenging.

Video cameras also don't need to offer the same range of colours in an image as a stills camera needs to, simply because TV systems can't reproduce such a wide range.

> ⌄ **QUALITY COMPARISON** These two shots, the left taken with a digital stills camera, the right with a digital movie camera, show some differences. There is an obvious colour difference, slight contrast variance and softness in the video image. However, if the video image were viewed in isolation (and perhaps if it were tweaked in Photoshop), it would be very acceptable.

**STILLS CAMERA**

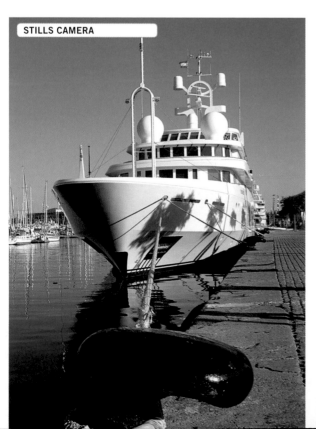

**DIGITAL MOVIE CAMERA**

⩓ **CLOSE-UPS** This floral close-up could be inserted into a video production to give viewers a chance to see the detail of the bloom. If you tried to record the same as a movie shot, you would need a tripod and the flower head would need to be firmly anchored against wind and movement.

## INFO

# THE PROS AND CONS OF MOVIE-CAMERA STILLS

**The pros**
- Convenience: you need carry only one camera.
- The option of shooting landscape shots (conventional) or upright, portrait-format shots in still mode.
- You can take still images that can be incorporated into your movie.
- You can get lots of a scene in focus.

**The cons**
- Video cameras offer fewer photographic controls.
- Resolution is not sufficient for large, high-quality prints.
- Most in-built video lenses aren't of the same quality as photographic lenses.
- You need a supply of memory cards for large numbers of still shots as well as media for video recording.
- Video cameras' depth of field is broader than still cameras. This is not so good for isolating a single subject by throwing the rest of the scene out of focus.
- Colours are not so vibrant from movie camera sensors, so you will probably need some post-production manipulation to bring out the best.

⩔ **PORTRAIT FORMAT** You don't have to stick with landscape-format shooting when shooting still images with your video camera. This shot would have lost impact in landscape mode. Incorporated into a video, you could pan upwards from the cake to the girl's delighted face. If you shoot in landscape and subsequently want to use a portrait shot in your movie, crop in on a section to fit the format of your video screen.

65

# MACRO AND CLOSE-UP WORK

≫Close-ups and Big close-ups (see pages 34–35) let you get close to your subjects and catch every nuance of their expressions. But for some types of video photography, you want to get closer still. The solution? A macro shot.

Select the macro setting on your camera and you can get in really close to subjects, capturing them from distances and at magnifications that will fill the screen with the smallest details. The design of the lenses of digital video cameras allows you to get close to objects in a way conventional cameras can't without the use of any accessory equipment.

## Defining macro

Macro in its strict sense describes a level of magnification that reproduces objects at life size or larger – 1:1 life size through to 10:1 life size. This simple definition is generally based on 35mm film cameras, where it is easy to make the direct relationship between the physical size of an object and its image on the film.

Digital cameras of all sorts use different-sized sensors and reproduce images at different scales, so this correspondence is not such a useful description. However, we can describe macro as that level of magnification that gets us very close indeed. This is perhaps not a scientific or explicit explanation, but a very descriptive one.

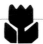

**ICON** The Macro icon found on many video cameras.

≫ **EXTRAORDINARY DETAIL** It may be an everyday scene, but a movie of this bee collecting nectar and pollen shows a degree of detail that we tend to be oblivious of.

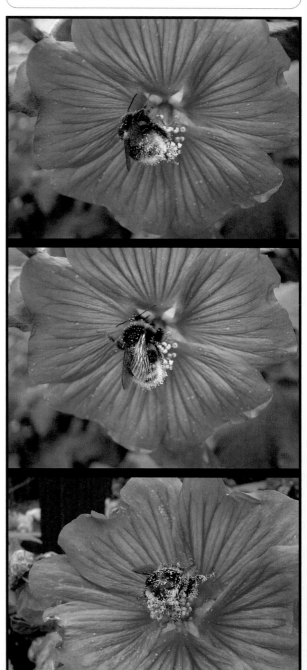

⩓ **UNUSUAL ANGLES** With your camera set to macro, you can get some unusual perspectives on the world, even if the degree of magnification is not strictly macro.

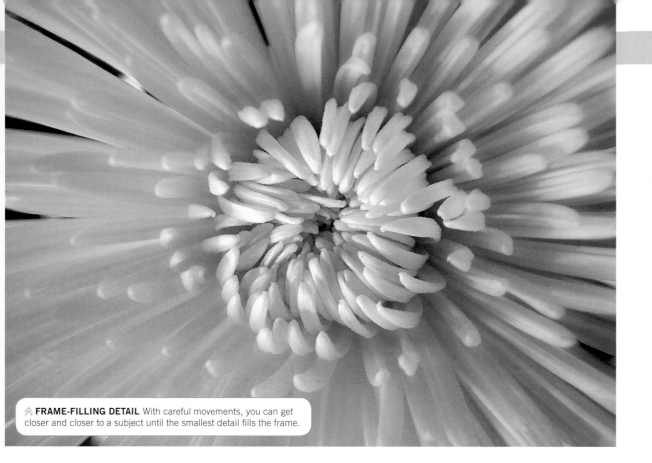

**⚠ FRAME-FILLING DETAIL** With careful movements, you can get closer and closer to a subject until the smallest detail fills the frame.

What happens when you get close to a subject? The obvious thing is that the scale of very small objects becomes larger. But this presents us with a key problem. You can end up getting so close to your subject that the front element of your camera's lens is almost touching the object. Although this is not a problem in itself, you will need to get the lighting right or your camera can end up casting a shadow.

Also, at close distances and small scales, the depth of field – the amount of the image in sharp focus – can be very small indeed. Although your camera will take care of the focusing (as it does at normal distance ranges), it is easy for the camera to focus on the wrong part of the scene and render the actual subject blurred. (See *Get the Most From Your Digital Camera* for more on macro photography.)

## Successful macro video photography

On most video cameras, you can enter the world of macro by pressing a macro button, often indicated by an icon of a tulip. This reconfigures your lens so that it is all set for close-focusing duties.

Here are a few tips to get the best from your macro setting:

- Shoot in the brightest light possible. If you are shooting indoors, bring in table lamps or any other lighting that can boost ambient levels. This will cause the lens aperture to close down and keep more of the shot in focus.

- If your camera allows a manual setting of aperture, set it to f/11. This will keep most of the scene in good focus.

- Unless your subject is moving wildly, switch to manual focus. Use the LCD panel to monitor the shooting.

- As well as getting close with your macro setting, you can also get unusual perspectives. Often the macro setting on a lens provides a wide-angle view, so with appropriate positioning you can take in a wide sweep of the surroundings.

- Don't shoot still images. If you want shots of static objects (say, collections of coins, stamps or small models), you are better off shooting with a digital stills camera and importing the still shots. A tripod-mounted stills camera is more convenient for shooting close up and can often get even closer than your video camera.

- Avoid shooting on windy days. If you are shooting flowers outdoors, the slightest wind will move your flower heads sufficiently for you to lose focus. Shoot on a still day or, if possible, clamp your subject to restrict movement.

- Try showing familiar objects at a large scale. Bees collecting nectar from a flower, for example, at screen-filling size, has tremendous impact.

# ACTION VIDEOGRAPHY

≫ Action videography often involves competency in a number of moviemaking skills, and some moviemakers approach this with a little hesitancy. My advice? Throw caution to the wind and get shooting! Chances are you'll get some great shots, some so-so shots, and quite a number of frankly disappointing ones. But, with just a little practice and some perseverance, you'll find that shooting action can be very rewarding – for you and your audience.

Moviemaking is about moving images, but many people start their moviemaking by shooting a series of tableaux – scenes that you might record with a still camera. But when it comes to action photography (which generally means action sports photography) the video camera really comes into its own.

Action sports comprise a vast range of activities. Starting with those you or your family might get involved in, they encompass track and field sports and go on to activities that only the most adrenaline-charged of us might consider. From children skateboarding in the park through to power boating and skydiving, the prospective action sports moviemaker is spoilt for choice – and has many opportunities to develop and refine his or her skills.

## Tracking movement

Perhaps the most useful and important skill required for action photography is tracking: keeping the subject centrally in the frame. Knowledge of the activity or sport is essential in predicting movements so that you are not left fumbling in order to maintain the subject. Of course, some forms of motion – towards or away from the camera – are easier to

track, as there is little lateral or vertical movement. Others, however, such as a slaloming skier, can be more problematic.

Successful tracking depends on smooth action. A handheld camera will look jerky as you attempt to keep up with the subject; movements from a tripod-mounted camera will be smoother, but you will need to be more practised in tripod use to compensate for the limitations imposed by the tripod's movements.

The zoom ratio will strongly influence results. Zoom in close to fill the frame with your subject and you will also magnify any shakes or wobbles. At extreme zoom ratios, you also run the risk of your tracking movements becoming so abrupt that your subject can appear to move backwards at times as you compensate for over-zealous or incorrect predictions of movement.

> ⯆ **DOLPHIN JUMP** At shows like this the performance will be repeated several times, allowing you to prejudge movement and camera angles. You may not get it right first time, but as your skill levels grow you will end up with some impressive shots. A hint for this type of shot – position the camera so that its position is fixed: let the subject do all the moving.

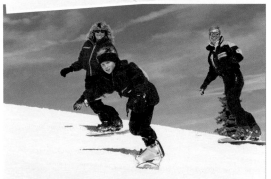

≪ **FAST ACTION** For really fast-moving action, no one will mind if the camera moves around a bit – it adds to the sense of drama. Again, as your skill improves you will get to know the positions and angles that deliver the best shots.

Switch to a wider-angle zoom ratio and you will be more successful in your framing, but at the cost of reducing the subject size. In some activities you can offset this by also recording artefacts – the wake of a powerboat, the track of a skier – as part of the scene.

The more action sports you film, the more practised you will become and better able to predict (or at least second-guess) the subject's movements.

### Emphasizing speed

Working the zoom lens is one way of emphasizing the speed and movement in your action shots. Another way is exploiting your camera angle. High angles – from the grandstand, for example – rarely impart speed and do not make the viewer feel part of the action. Get down low and you will not only make speeds look more impressive but also draw your viewers into the scene.

### INFO
# ACTION ZOOMS

A potent effect in action moviemaking is an ultra-fast zoom, swooping in on the centre of the action. Try this yourself and you will probably end up disappointed – if you move the zoom fast, you will lose focus and end up with a blurred subject filling the screen. Shoot in reverse instead. Focus on the subject, zoom in and then zoom out fast; you are less likely to lose focus. When you edit, reverse the direction of this shot. Of course, this ploy will only work where the motion doesn't betray the change in direction of playback!

**EXPERT TIP**

When trying to keep your subject central in the frame, you should also remember one of the compositional rules: that you should have moving subjects placed off-dead-centre so that they appear to be moving in towards the centre of the frame. See pages 32–33 for more on this.

# CUTAWAYS

>> Cutaways are brief shots taken with the aim of allowing more flexibility when we come to editing. They allow the editor to manipulate a movie recording (in time, approach or even sense) without the edits being visible to the viewers.

## The uses of cutaways

Cutaways have many uses. They can be used to link scenes where seconds or even minutes have been trimmed out, without the viewer suspecting. They can be used for visual variety, even if you are not compacting the overall length of the footage. A long piece to camera or a long interview can seem even longer to an audience if it is filmed from one camera angle, continuously. Short cutaways (which can be insert-edited later, so the soundtrack continues uninterrupted) break this monotony without interrupting the flow of the interviewee to change camera angles.

The more video material that you shoot and edit, the more you will come to appreciate the importance of shooting

⌃ **SHOT 3** Hard right! Here's an insert shot that explains why, in the next shot, the boat has turned to the right compared to shot 2.

⌃ **SHOT 1** Boarding: our two stars get on board.

⌃ **SHOT 4** Onwards: our stars continue pedalling away up the lake.

⌃ **SHOT 2** Pedalling away: off they go on to the lake

## INFO

# THE ETHICS OF EDITING

'That was taken out of context' is a cry you will often hear with regard to a televised interview. Often the reason that a comment was taken out of context is because parts of the interview were cut out in the editing stage for reasons of timing, approach, or even with a deliberate intent to mislead. If you are working on a movie that involves an interview, it is important that you don't show your interviewee in the wrong light by inappropriate editing. Where you need to trim an interview, make sure you don't alter the sense of the conversation by selective omissions.

⋀ **SHOT 5** Swans: the cutaway shot. Not crucial to the story, it shows what the boaters might be looking at and cuts out some potentially boring footage of the pair making their way up the lake.

⋀ **SHOT 6** Into the sunset? After the cutaway, we can cut to this view of the boat in the distance – without that intermediate footage.

cutaways; indeed, after a while shooting them should become second nature. You will quickly come to recognize situations where you might need a cutaway and shoot some appropriate footage.

## Typical cutaways

Here are a few typical cutaway suggestions. You will probably recognize their use on television and in films:

- The interview: cutaway of interviewee's hands.
- The interview: cutaway of the interviewer nodding in agreement.
- The wedding: guests watching the service intently.
- Sports events: crowd shots (useful to have different ones, with different emotions).
- Children's parties: close-up of faces to trim long games or meal sessions.

## Cutaways versus inserts

The principal role of a cutaway is to distract us by trimming or altering the pace of a movie. The content of a cutaway is largely irrelevant to the storyline, although it should be sympathetically filmed to blend in with the movie. An insert is applied in much the same way, but is more important to the movie's storyline. There can be some blurring between the two. Here is an example of how to use an insert:

- First shot: a person waiting on a rail station platform.
- Insert: person's wrist, revealing wristwatch and the time displayed on it.
- Second shot: person's attention attracted by oncoming train. Here, a cutaway could be used merely to compress time and suggest a long wait for a train. But, when used as an insert (along with other scenes), the time on the watch is significant to the storyline.

# BACKGROUNDS

≫As a stills photographer, you may have experienced what happens if you pay too much attention to the foreground and not enough to the background. You may shoot a portrait in which a tree, flag pole or telegraph pole appears to sprout from your subject's head. In the movie world, it is possible to make similar problems with your backgrounds, and risk turning your serious documentary or earnest drama into an inadvertent comedy.

Pay insufficient regard to the background and you can also fall victim to other errors: compositional errors, flaws that we might call continuity-based and those that have an environmental basis.

### Avoiding compositional errors

We are at a disadvantage compared to our digital stills photography peers in that we do not yet have an equivalent to Photoshop's Clone (or Rubber Stamp) tool to let us conceal or remove any compositional errors. Instead, we must be especially careful when composing a shot to preview the scene through the viewfinder or on the camera's LCD screen.

The camera will have a different field of view from our own eyes, and objects we consider to be out of sight might creep into shot. Similarly, alignments and perspectives through the lens may be different and inappropriate compared to our eyes' view of the same scene. The solution: learn to look around the frame in the viewfinder to observe the foreground and background.

### Background continuity

Backgrounds are rarely unchanging. The weather, the traffic and the light can change a view significantly over a comparatively short time. When you don't shoot scenes in sequence you can end up with continuity problems, as changes too subtle to notice at the time of filming appear glaringly obvious in the finished movie.

Even brief breaks between shooting shots can cause problems – ones that even professional filmmakers fall victim to. Traffic is a common cause of background continuity errors. Varying traffic flows on a background road become very obvious when a movie is edited; for example, scenes may be shot with heavy traffic moving visibly along a nearby road. Traffic lights turn to red and it all comes to a stop. The lights turn green and the traffic rolls on, leaving an empty road in its wake. Intercut scenes shot during this sequence and you end up with

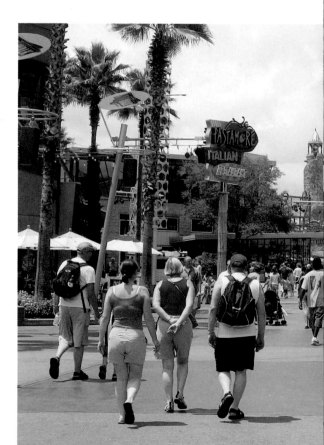

≫ **WATCH OUT...** Halfway through this piece to camera, the fountains started up.

continuity errors that your viewers find very puzzling and put down to incompetence on the part of the cameraman and editor (that is, you!).

The solution is to pay attention to what is going on in the background. You can't control activity like this, so you have to adjust your shooting schedule to accommodate it. Or, if that proves too difficult, and that road scene (or whatever scene you are including) is not essential, change your angle.

## Environmental backgrounds

Environmental background errors arise as a result of events outside your control occurring in the background. Think of all those televised street interviews or live news broadcasts where the presence of a camera stimulates passers-by – those unconnected with the action – into annoying behaviour – waving, pulling faces and shouting.

You may find when you are trying to film inconspicuously that you end up with passers-by staring at the camera, betraying its presence to all who watch the movie. If you watch a television drama and one of the actors looks directly at the camera, it can be quite unnerving for us as viewers. Those innocuous but puzzled stares from passing

⌃ **TRAFFIC** Shooting with traffic in the background is always problematic, as you can never assure continuity.

⌃ **PASSER-BY INTRUSION** This shot of Prague's Charles Bridge was spoilt when a passer-by chose to linger exactly at the centre of the shot. Without staging the whole scene, you just can't avoid this.

⌄ **USING PASSERS-BY** A good way to avoid eye contact with passers-by is to position yourself so they are walking into the scene. This is good, too, because they lead the eye into the scene.

pedestrians in your movies will have the same effect. So, how do you avoid such situations? Waiting until you have a clear spell in which there are no people passing casually through the scene is one method, but perhaps you want a shot of a busy street. In that case, standing back in a doorway or the entrance to an alley makes you less visible and less likely to attract attention. Or you could lower the camera from your eye and hold it at chest level. People tend to respond more to a camera that is held to the eye than they do to one held away from the face.

**EXPERT TIP**

Don't forget to keep your eye to the viewfinder to check for any distractions that appear during a shot. These will immediately draw attention away from your subjects. It can be hard when you're new to video shooting, but be assured that this is one of those skills that comes with experience.

# PANNING AND ZOOMING

>> Don't pan when shooting. Don't zoom when shooting. That mantra is often repeated in books on technique. However, there are plenty of occasions when panning and zooming while shooting is not only legitimate, but also very effective.

## Panning

When faced with a sweeping panorama, you could choose to set the camera lens to the widest setting and capture it all in one go. Sadly, you are likely to reduce much of the detail of the panorama to very small features along the horizon. This is where a slow pan can be ideal. You can zoom in prior to panning so the frame is filled and then track slowly left to right. The key word here is 'slowly'. It is also worth resting for a couple of seconds on the start of the pan so viewers can get their bearings. Rest a little longer on the end point. If you can make this end point a landmark, so much the better – the panning becomes a journey to a final destination. It is not essential to pan from left to right, but as most of us tend to scan left to right in our day-to-day lives, it is the more restful choice.

The mechanics of panning almost demand that you mount the camera on a pan-and-tilt head. Then, by turning the camera around the vertical axis (using the spirit level in-built on most heads) you get a smooth pan.

## Zooming

Like panning, zooming during a shot can make the viewer uncomfortable because every part of the scene is changing simultaneously. Again, the rule is to zoom slowly so viewers'

eyes can take in the changes and understand what is happening. Why would you want to zoom during a shot? Most likely for emphasis. Zooming into one person in a crowd establishes that person as the key subject. Zooming out, conversely, helps place the subject in his or her environment.

## Crash zooms

You have probably seen these on TV and at the movies. The camera zooms very fast, picking out a subject from a general view or zooming out equally fast to show the subject amid a

It's quite OK to pan in a vertical mode. For a wedding, for example, you might want to pan from the top of a church spire to a pensive groom standing in the doorway. A pan-and-tilt head (this time with the tilt mechanism invoked) makes this simple. For best results, stand back so that the camera lens is set to a modest telephoto setting – wide-angle settings can introduce unpleasant distortions in the pan, especially with architectural subjects.

**EXPERT TIP**

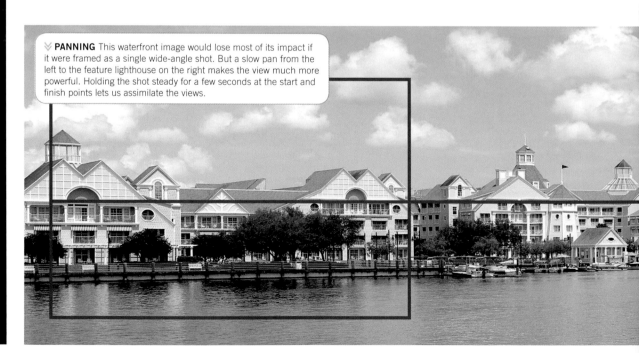

⧨ **PANNING** This waterfront image would lose most of its impact if it were framed as a single wide-angle shot. But a slow pan from the left to the feature lighthouse on the right makes the view much more powerful. Holding the shot steady for a few seconds at the start and finish points lets us assimilate the views.

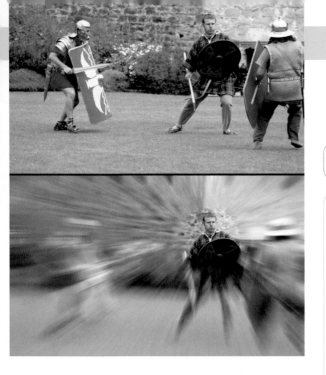

≪ **CRASH ZOOM** The crash zoom draws attention almost immediately to a specific element of the scene.

(usually) threatening environment. There is no reason why you can't use these yourself. To be effective, they need to be used where they will impart drama. It is a powerful effect and so needs to be matched with the mood of the movie. A crash zoom won't add anything to your footage of a floral garden!

Some video cameras only have power zooms (that is, the zoom is controlled by buttons on the camera rather than a handle that physically changes the zoom ratio), and these are not speedy enough to enact a crash zoom. If this is the case with your camera, don't worry – you can speed up the scene in your video-editing software when you edit the movie.

## INFO

# PANNING AND ZOOMING TIPS

- Always pan or zoom slowly, unless you need to do so quickly for dramatic effect.

- Use a pan-and-tilt tripod, or a tripod head for perfect pans.

- Don't overuse the effect. Pan or zoom only where there is a compelling reason to do so and static shots would not do justice to the subject.

- Use manual zooming if possible; power zooms give you less control over the speed of zooming.

- Shoot a few seconds of 'still' scene at the beginning and end of a pan or zoom to let your audience absorb the scene.

- You can, exceptionally, combine a pan and zoom in the same shot. Pan across slowly while zooming in to the subject of the pan. Practice is essential to make this effective and smooth.

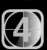

# RECORDING SOUND ON LOCATION

≫We can spend a long time adjusting composition and lighting and barely think about the sound we record. We just assume that a great soundtrack will be recorded automatically when we press the record button. For much of the time that assumption is correct, but trusting to luck is rarely a good idea, and the world of sound recording is no exception.

## Sound quality

Think of sound recording in the same way as exposure on your digital camera. For most circumstances, the 'auto everything' option delivers great photos. This option is optimized for the type of photos that most of us take most of the time. The trouble is, as enthusiastic photographers find, pushing the limits of photo-taking pushes the automatic controls beyond their capabilities. You then either need to compromise on image quality or go manual and take matters into your own hands.

As we have already noted (see page 42), the microphone on a video camera, although dismissed by serious video photographers, can turn in a commendable performance much of the time – sufficient for most day-to-day movie applications. But as your moviemaking ambitions expand, you will find it falls short of the quality that you need to match your improving video skills. On pages 42–43 we discussed some of the options for improving the sound recorded, but

your choice will undoubtedly be determined by the real-world situation of your movie locations. If you are the official video photographer at a wedding then good auxiliary microphones may be essential; if you are at the same event as a guest then a good camera-mounted accessory mic would be the best option. Similarly, on holiday you may not want to use a large microphone (depending on how patient or long-suffering your fellow travellers are).

## Monitoring sound

You can try to get the best possible sound by investing in state-of-the-art microphones, but how can you be sure that they deliver the goods? And, if you are relying on the in-built microphone, how can you be sure that it is producing its best? Many good recordings have been marred by wind noise or other intrusions that aren't evident at the time of recording.

Earlier, we advised about the importance of using a pair of headphones (see page 42). But should you pack a pair in your gadget bag for every trip? It probably makes good sense to include a lightweight pair. However, rather like microphones, you need to base your usage on the assignment. Granted, you will look something of a nerd

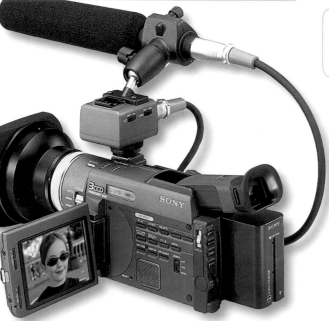

⌄ **ON-CAMERA MIC** For the best in audio quality while maintaining essential portability, an accessory on-camera microphone is a good compromise. Where the extra bulk (which is still significant) can't be tolerated, the mic can be disconnected and stowed away.

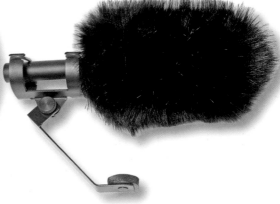

⌄ **WINDSOCK** Wind noise is a perennial problem affecting on-camera microphones and in-built microphones. You can easily overcome this by adding a windsock to prevent the wind whistling across the microphone. This is cheap, effective and easily slipped into your gadget bag.

> ⌃≫ **RECORDING MUSIC** A good on-camera microphone will deliver great sound for a fixed sound source, such as the orchestra shown right. However, something more elaborate may be needed to effectively capture a dynamic live performance such as that above.

equipped with a pair of closed-cup Sennheisers on the beach (and risk wrecking them through the ingress of sand), but for a wedding assignment where recording the words are crucial, headphone use becomes almost obligatory.

In general use, though, you can make do with a cheap pair – sufficient to give you the confidence that your recording will be OK. You can perhaps limit headphone use to the first scene of a sequence.

## Sound travels around corners

Without getting too deeply into the physics, sound is able to travel around corners and reflects from most surfaces. In addition, external environmental sounds can make their way indoors. When your camera is framing a subject, you expect to hear sounds from subjects in the scene, but, because of the way in which sound travels, you could find your shots compromised by noise intruding from outside the frame.

**EXPERT TIP**

When you are on a location shoot, record some ambient noise: the audience waiting and chatting or the background hubbub of a city. You can use the sound (only) later to better link together scenes and enhance a 'live' soundtrack. Professional moviemakers call this a 'wild track'.

You will probably be unaware of this as you shoot and, when you review the recordings, you may still be oblivious. However, you can be sure your audience will be very much aware of this, and, if the sounds are unexpected, very curious. That curiosity will deflect their attention from the story of your movie.

For example, imagine that you are shooting a movie at a railway station. Your action is concentrated on the heritage engine that is taking centre stage in your viewfinder. Off to one side, another locomotive springs to life and pulls away from the station, accompanied by a blast on its air horn. As your concentration is focused on the events ahead of you,

you will probably pay scant regard to this, but in the movie footage that results your audience will be confused. They are watching the action that you mean them to see, but the soundtrack seems to be giving them (if you pardon the railway pun) different signals.

### Adding a live commentary

If your current movie project could be broadly categorized as a documentary – and that could include everything from a formal documentary through to a travel flick commemorating your latest vacation – you might be tempted to add a commentary while you are filming. The advice in most

## INFO

# SEPARATE SOUND RECORDING

Often in film production, sound and vision are recorded separately; the two media are combined later after each has been through its respective post-processing. This is something you could do too for some exacting sound jobs. Consider a video of a concert or an orchestral performance. Sound here is critical, but the logistics of the concert hall do not lend themselves to providing the best in sound recording.

Assuming you have the permission of the organizers and the venue, you might be able to record sound directly from the microphone systems used in the venue. Instead of connecting this to your camera (which may be neither physically nor technically possible), you can set an audio recorder to tape the whole performance.

You should use a digital recorder designed for high-quality sound, such as a high-grade hard disc recorder, DAT tape or MiniDisc recorder. DAT and MiniDisc recorders can often be

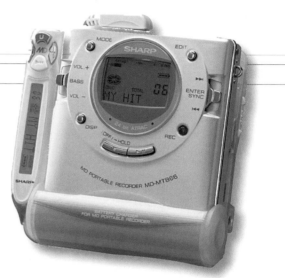

picked up relatively cheaply and even affordable semi-pro models will provide all the connectivity you need.

After recording both the video and audio you will have to match the two at the editing stage; this is not hard, although it can be time-consuming. Unlike studios and professional production units who use clapperboards to help synchronize sound and vision, you will have to match sound and vision manually, tweaking one or other to ensure that they stay in perfect sync. We will see later when we come to editing our soundtrack how easy it is to import a new soundtrack and mate it with a video (see pages 104–105). You also have the advantage that the video camera will have recorded its version of the soundtrack that you can use to compare with the high-quality version to get a precise match.

**MINIDISC RECORDERS** Pocket MiniDisc recorders offer quality greater than their size would suggest. Professional models are more flexible (if less portable), and as models like this debuted in 2000, they are available cheaply on the secondhand market.

ises would be not to, however. You have enough to think
about when filming, so adding another concern is folly. Not
only will the sound be of mediocre quality, compared to
properly recorded sound, but you will also limit your editing
opportunities. And if you fluff your lines you will either have
to reshoot or make do with the errors.

Instead, concentrate on shooting and, with reference to a
script (which should include the words of your commentary),
shoot the scenes to which you can add words in post-
production. In any case, you are likely to change your
commentary after a shoot if some of the comments that
you planned are no longer appropriate. For example, your
planned words 'Take a look at the fine Art Deco detailing
on that wonderful building' would face the chop if those
details were concealed by scaffolding as the building gets
a makeover in the tourist season!

There will, of course, be exceptions to this rule of not
recording any narrative at the time of recording. Some events
you record – particularly spontaneous ones – may well
demand some words as you go along.

⩗ **NOISE POLLUTION** These children playing on a riverbank made
a charming movie segment. However, the soundtrack just didn't live
up to the visuals. Had we looked to one side, just out of shot, we
would have seen noisy tourist boats passing by and, beyond those,
a busy building site. Though neither of these elements featured in
the video visually, their contribution to the movie soundtrack was
all too prominent.

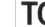

# TOP 10 TIPS FOR SHOOTING VIDEO

≫Let's distil the essential points we have discussed in this chapter: here are 10 top tips for getting great video.

## 1  Get the preparation right

- Every movie benefits from some planning. Even if it doesn't need a formal script, a loose structured approach will help you remember all the shots you need to get.
- For important assignments, check out the locations in advance; look at the lighting, or the direction the light falls. Check out the best places to shoot from.
- Make sure your camera batteries are charged and that you have packed everything you need, complete with spares where possible.

## 2  Know your camera

- Become sufficiently familiar with your camera that you can operate the basic controls without looking at them.
- Know where all the key controls are so they can be accessed and adjusted quickly.
- Establish a routine for periods of inactivity – cover the lens, turn off the camera and fold the LCD screen, for example – to conserve battery power and keep the camera safe.

## 3  Shoot clearly, shoot steadily

- Use a tripod wherever possible, and an alternative support for other occasions.
- Use the camera's image stabilization system.
- Unless essential, don't move the camera; let the subject or subjects provide all the action you need.

- Use your zoom as a framing tool. Zoom first, then shoot. Avoid zooming while shooting unless doing so for drama.

## 4  Think composition

- Check your viewfinder to ensure that the subject, background, foreground, colours and lighting work together to produce great shots.
- Keep the subject free of distractions and wherever possible shoot against a plain background.
- Ensure that the camera is level except when done for dramatic effect. Consider using the spirit level on your tripod (or one available as an accessory) to stay spot on.
- You will get better results when there is an illusion of depth; use camera positions and lighting to emphasize faces or show the front and side of buildings.
- Empty space above a subject is wasted; move the camera down or zoom in closer.
- Use the rule of thirds.

## 5  Tell a complete story

- Think about the story you want to convey to your audience and shoot accordingly.
- Include shots that obviously define the beginning and end of the story.
- Try to make your story address the 'W' questions: Who? What? Why? When? Where?

≫ **CUTAWAYS** Shoot cutaways whenever you can.

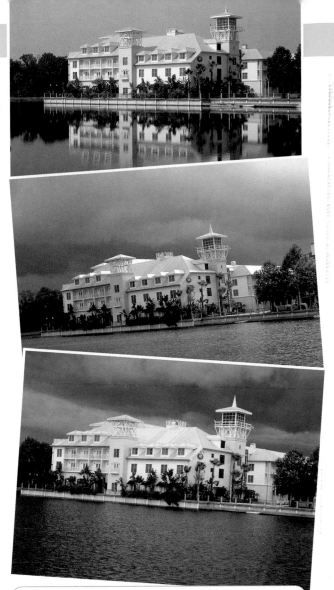

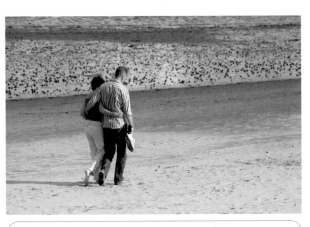

> ⚆ **COMPOSITIONAL GUIDELINES** The rule of thirds is one of the most useful compositional tools you can use.

## 6  Make the best of the lighting

- Assess your scene with regard to lighting before arranging and shooting.
- Use reflectors to fill in shadows and to even out lighting when the principal light source is behind the subjects.
- Take care when shooting in bright sunlight around midday to avoid heavy shadows on your subject's faces.
- Make sure your white balance setting is correct.
- For interior shots, ensure you have provided as much ambient lighting as possible.
- Use your LCD panel or viewfinder to rehearse potential shots to detect lighting problems.
- Shoot all the shots for a particular sequence as close as possible together to avoid continuity lighting problems.

> ⚆ **CHANGES IN LIGHT** What a difference a few hours make to the lighting: shot around 10am, 12pm and 3pm, the character of these shots is quite different even though the location is the same.

## 7  Get the best sound

- Use a separate microphone where possible.
- Monitor sound quality using headphones, especially where speech is involved.
- When conversation is important, keep your subjects within close range of your microphone, or better still use a lapel microphone.
- Be alert to distracting sounds outside the frame of your shots.

## 8  Shoot to edit

- Think about editing your movie. Shooting cutaways and wild tracks will make editing much simpler.
- Wherever possible, include a few seconds on the start and end of shots to give more flexibility in editing.

## 9  Use the different shot types with a purpose

- Balance your use of wide and establishing shots with close-ups. Establishing shots are crucial to identify and place your scenes, but close-ups help engage viewers.
- Vary camera angles to add interest to your movie, but use only with a purpose.

## 10  Wind down properly

- After a day's shooting, remove tape, DVD or any removable media and protect them.
- Charge batteries, including topping up any that haven't been used.
- Check footage to make sure it looks and sounds OK.
- Check your day's shooting against your script. Highlight any parts that will need to be shot in the next session.

# PART FOUR:
# MOVIE EDITING

As the credits roll on your favourite TV drama, documentary or movie, you will see how many people it takes to create that programme. We have rather fewer people on hand for our movies – often, we have just ourselves! So now it's time to develop another skill and take your first steps as a movie editor.

It is at the editing stage that all the movie material you have recorded is cut, reordered, trimmed and manipulated. Raw footage is transformed into a finished movie.

However, there is more to becoming an accomplished editor than knowing how to organize footage. You also need to understand the mechanics of editing movies on your computer desktop, so we'll begin this section by looking at how to set up your digital movie-editing studio.

# SETTING UP YOUR STUDIO

≫ Your movie productions can be created on the same computer you use for your digital photo albums, word processing and family accounts. Prior to creating your first movie, however, you should check your computer and software to make sure they will perform at their best for your moviemaking needs.

### Free up hard disc memory

Over time, computers tend to become clogged up with redundant files. Just think of all the trial software packages you have downloaded from the Internet and the cover discs from magazines; or the hundreds of blurred, underexposed photos pulled off your camera's memory card but rejected. Then there all the old documents, MP3 music tracks and more that you will never need again.

Your movie footage is going to consume vast swathes of your computer's hard disc, so it makes sense to free up as much space as possible. Delete or uninstall anything that you don't intend to use. Burn old documents and images to CD first, just in case you find you need any of these later.

There are many utilities designed to optimize your computer. Many of these remove orphaned files (files dedicated to an application that has been deleted) and help make even more space available. Defragmenting your hard disc (on Windows machines) will help too: this ensures that when large discs are written to your hard disc, they are done so in the most expedient manner, preventing bottlenecks.

Macintosh users don't need to defragment their discs as such, but a thorough clean out of files (especially cached files that can build up invisibly) is a good idea. Use a shareware product such as OnyX or OmniDiskSweeper to seek out and destroy all those unwanted resources.

### Ongoing computer maintenance

Getting your machine into shape isn't something to do just once; you need to keep it in good shape by regular maintenance. This shouldn't be an onerous task – some utilities perform their sweeps when your computer is doing nothing – but does pay dividends in terms of performance.

Good housekeeping becomes particularly important when your moviemaking gets underway. When you have completed a movie edit and burned it to DVD, you will have some huge files that you need to dump before starting on your next project. Even if you have not finished your movie, you will probably find there are hundreds of megabytes of video lurking in your trash. Delete these and you will boost your hard disc headroom, and possibly your system performance.

### Second hard disc

This is where it can be very useful to have a second hard disc that you reserve for all your video-editing activities. You can easily see what files are on this disc and, when appropriate, delete them. It's a great deal easier than finding the same files on your main hard disc. You can also give this disc a clean sweep periodically – clearing all files away – without compromising any of the valuable files on the main disc.

⌃ **COMPUTER HOUSEKEEPING** Regular use of a good maintenance or housekeeping application (such as OnyX, shown here) helps keep your machine in tip-top condition.

⌃ **HARD DISC MAINTENANCE** Ashampoo's Magic Defrag keeps your Windows hard disc in shape by automatically defragmenting files continuously.

**EXPERT TIP**

Keep an eye on all the cables and connectors you need. It is all too easy to mislay essential cables and you will find yourself compromised when you can't connect your camera to your computer. If the connections are not being used for other devices, leave the cables attached permanently.

# IMPROVING YOUR EDITING SET-UP

Spending just a little extra money can make the experience of editing much more enjoyable and get those creative juices flowing a little faster. Here are a few options to consider.

∧ **SCREEN SIZE** Larger monitors help with long editing sessions.

### Extra hard discs

Some people consider these to be essential rather than desirable. It all comes down to budgets. Having an extra hard disc, either installed in the computer if it has the room or externally, gives you the freedom to download and manipulate larger amounts of video footage. It also avoids some of the speed compromises of using a single disc for everything, including running your computer, accessing applications and manipulating video.

### Larger monitors

You don't need a large monitor to edit video, but it helps. If you graduate to a mid- or top-range video-editing application, all of which tend to have more cluttered interfaces, a large screen will make it much easier to work with.

### Speakers

The sound that you create for your movies is of great quality, so why not enjoy it? Computer speakers can be good, but you can do better with an auxiliary set. They don't cost too much and they can give you that true cinematic experience.

≫ **EXTERNAL SPEAKERS** Auxiliary speakers such as these from JBL can make a huge difference to the sound quality and enjoyment of your movie. Also available in white and silver!

∧ **EXTERNAL HARD DISC** This is ideal for storing your video footage, particularly if you have no room to add a hard disc inside your computer or prefer to use a laptop.

# THE EDITING INTERFACE

≫The interfaces of the most popular video-editing applications, such as iMovie, Windows Movie Maker and Ulead's VideoStudio, often have features that are very similar or even identical. This makes your job simpler. On a practical note, it means that any examples shown here using a specific software application will work similarly in another.

Compare here the interfaces of iMovie HD (below), Windows Movie Maker (top right) and VideoStudio (below right). The exact appearance varies according to the features selected and the version of the product used, but only in the detail. In fact, if you become confident in the use of any of these applications, switching to another is simple. Equally, switching to a more advanced product, once you have got to grips with one of these, will be fairly straightforward. Here are some of the features common to all editing interfaces.

**1 Monitor pane** Displays the currently selected clip, plays your finished movie and monitors the imported footage when downloading from a camera.

**2 Timeline** Shown in clip or slideshow mode with each clip given equal prominence. The name and duration of each clip are shown on each thumbnail.

**3 Clip shelf** Holds all your clips prior to dragging to the timeline. Clips can be placed here, or directly on the timeline.

**4 Feature selectors** Select the tabs or buttons to apply transitions, effects, titles or use additional media (sound files or images, for example).

**5 Transitions** Where a transition has been applied between two clips it is indicated as shown.

**6 Playback controls** You can drag the play head along the scrubber bar (immediately beneath the monitor pane) to scan through the selected clip or whole movie.

**7 Toggle timeline and clip thumbnail views** Click here if you want to change to the time-proportionate timeline view or return to the diagrammatic clip view.

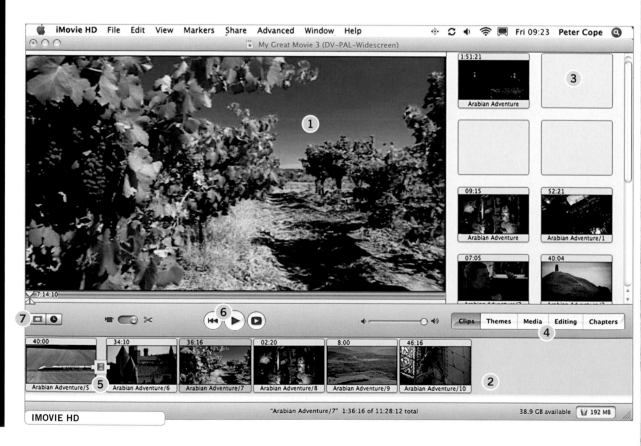

IMOVIE HD

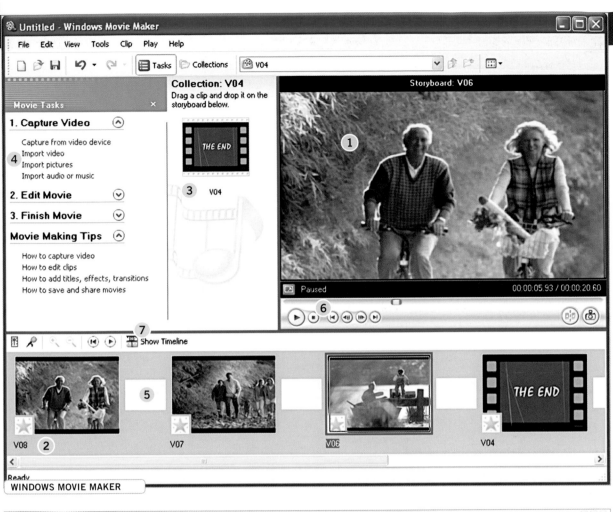

WINDOWS MOVIE MAKER

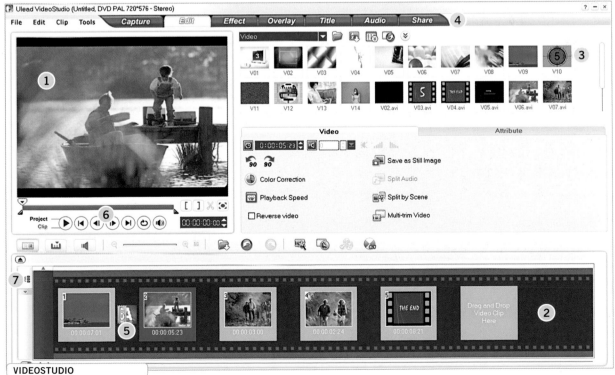

VIDEOSTUDIO

As we discovered with the main interfaces (see pages 86–87), there is a lot of commonality between features and layouts. Let's take iMovie as our example and explore its buttons and switches. The buttons take the form of tabs along the top of the window, ranged over the timeline to the right of the screen. iMovie offers five buttons: Clips, Themes, Media, Editing and Chapters. Click on each and the controls associated with that button appear in the pane below. Let's explore each of these options in more detail.

| Clips | Themes | Media | Editing | Chapters |

**⌃ IMOVIE BUTTONS** The iMovie interface.

## Clips
Select these to reveal the video clips in the clip gallery. Here are all your unused clips ready to be pulled to the timeline for editing and inclusion in your movie.

## Themes
Here is a great way to get the polished big-budget look to your movie with minimum effort. Themes are a collection of linked titles, chapter screens and credits into which you can paste video clips, overlay audio and even add images.

## Media
The Media tab offers two buttons: Audio and Photos. Select the Audio button to access audio features. You can add sound effects (there is usually a modest collection of general-purpose sound effects provided with all applications); use music stored on your computer as an accompaniment to

# THEMES

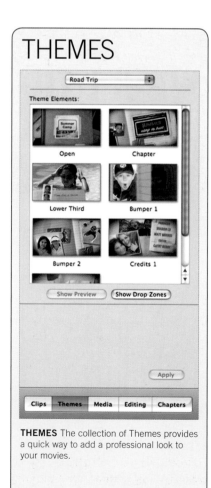

**THEMES** The collection of Themes provides a quick way to add a professional look to your movies.

# EDITING

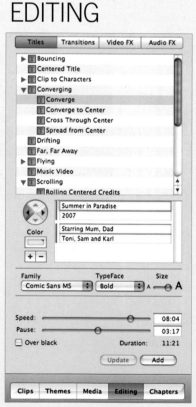

**EDITING: TITLES** The Titles pane allows us not only to select a title style but also to enter the words themselves, choose a font and set the size and colour. You can also configure speed settings where the titles are dynamic.

**EDITING: AUDIO FX** Unlike the special sound effects offered under the Media: Audio buttons (which add special effects to the soundtrack), the audio effects here modify the existing sounds to change pitch, alter the reverberation (to simulate settings such as stage and concert halls) and suppress noise.

# MEDIA

**MEDIA: PHOTOS** Click the Photos button to reveal, in this case, any albums of photos that might be stored on the computer.

**MEDIA: AUDIO** The Audio button provides access to any library of music that might be stored on the computer and special effects available to use.

**MEDIA: AUDIO** Thanks to its tight integration with iTunes, in iMovie you can access any of your collection of music, sounds or even voice notes stored in the iTunes library.

your production; or, by clicking on the microphone button, add your own narration or voiceover.

Select Photos and you have access to still images – in the case of iMovie and iLife, via iPhoto. You can pull images into the timeline in exactly the same manner as video clips. Subsequently, you can treat them as video clips when it comes to adding titles, effects or transitions.

## Editing

In iMovie, as in some other applications, the editing button reveals a range of additional options: Titles, Transitions, Video FX and Audio FX.

You can use Titles to compose and apply titles. There is a wide range of options on offer, and each of these can be customized further with regard to fonts, font colour and content. (See also pages 114–117.)

Select and customize transitions for linking together connected scenes. The basic raft provided with most applications ranges from the subtle through to the lurid. (See also pages 100–103.)

Video FX is where you can apply a romantic soft-focus effect, change the colour saturation and much more. Each effect has its own controls so you can configure the effect to match your needs. (See also pages 112–113.)

Audio FX is where you can apply effects such as changing pitch and altering reverb. (See also pages 104–109.)

## Chapters

In iMovie, you can construct chapters for a DVD copy of your movie thanks to the program's integration with DVD-authoring application iDVD. We'll look in more detail at DVD authoring later (see pages 122–125).

# TRANSFERRING MOVIES

≫It might be stating the obvious, but before editing your movies on your computer you first need to transfer those movies to your computer. How you do this will depend on your camera type.

Cameras that use memory cards, Microdrives or recordable DVDs make the process simple. You simply take the media from the camera, place it in a reader (a card reader or DVD drive respectively), and import the footage to your chosen software application directly, using import commands.

For others, such as those using DV tape, and for cameras that don't offer removable media, the process is slightly more involved. You will need to connect your camera to your computer and start your video-editing software. Turn the camera on and, hopefully, you will see the software recognize that the camera is attached and ask if you want to download. We say 'hopefully', because sometimes the camera is not detected. This is not a fault on the part of the camera or the software, and the situation can often be remedied by turning the camera off and on. Alternatively, try restarting the software. This is not a formally acknowledged fix but one that often works.

## Connecting the camera

How you connect the camera to the computer will depend on the connections that are offered by your model of camera.

It is important that you use the digital connections and not those that are designed to output the footage from the camera to a television. The digital connection is usually FireWire. Sometimes called iLink (on Sony cameras), or generically as IEEE-1394, this is a high-speed connection capable of handling the high data rates that result from replaying digital video.

An increasing number of cameras available today offer connectivity using the slightly faster USB2 format. You will need to ensure that you connect the USB2 cable from your camera to a USB2 socket on the computer. Some computers may have both a USB2 connector and a USB (USB1). The latter type is incapable of supporting the required data rate and connecting to this will prevent detection of the camera by the software. This sometimes confuses users because the two types of USB sockets look the same and often are not uniquely marked.

Camera Connected

Import

⊼ **CAMERA DETECTED** The blue screen in iMovie acknowledges that the camera has been detected. Hit the Import button and your movie will stream to your computer's hard disc. The appearance of this stage may vary according to application, but the process is essentially similar for all.

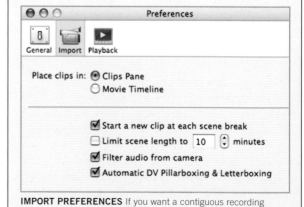

**INFO**

# AUTO SCENE DETECTION

In traditional moviemaking, each scene would be cut from the reel of processed film and those that were not discarded would be physically assembled – spliced – in the correct order. Your software will automatically cut each of your individual scenes and store them separately. This process is called auto scene detection. It is surprisingly reliable and achieves frame-accurate results.

**IMPORT PREFERENCES** If you want a contiguous recording loaded, you can turn the auto scene detection off in Preferences.

# CONNECTIONS MASTERCLASS

Turn your computer around and you will see an array of connections. They can be baffling if you have never had cause to explore them before. FireWire comes in two speeds: the standard 400MBs (megabytes per second) and the double-speed 800MBs. Like USB1 and 2, it can be hard telling them apart, but either is appropriate for downloading DV.

**USB** These cables have a large connector that links to the computer and a smaller, micro connector that connects to the camera.

**FIREWIRE** These cables also have a large connector for connecting to a computer and a smaller connector for the camera. Note that some computers, notably some Windows PCs and most Windows laptops, have a smaller connector at both ends. This is often called a 4pin to 4pin.

| | External Speakers |
| --- | --- |
| | Headphones |
| | External Monitor |
| | USB2 |
| | USB2 |
| | USB2 |
| | FireWire |
| | FireWire |
| | Modem |
| | Ethernet Networking |
| | Mains Power |

**CONNECTION TYPES** This image shows the key connections. Each is slightly different from the others, but do remember that USB1 and USB2 connectors appear identical.

## Importing movie footage

Once your camera has been recognized, control of the camera passes to the video-editing software. Hit the Import button and downloading will begin. You will see your movie replaying in the main software window; each of the scenes will appear in the clip gallery. Just sit back and wait for the movie to download. Once complete, you can stop the import, disconnect the camera and, should you deem it time for a coffee break, turn off your computer. All your movie clips will now be sitting on the virtual shelf awaiting editing.

**EXPERT TIP**

Make sure you have enough free space before downloading. Do a rough assessment, counting on 1GB per five minutes of video for a DV tape. Too little space and your download will stop suddenly. The amount of space there is remaining is usually indicated on the software interface.

# DIGITIZING VIDEO TAPES

≫ Anyone who has graduated to digital video from older, non-digital formats will no doubt have a collection of old tapes full of cherished memories that they want to preserve in the digital age. However, because these are analogue recordings, you can't import them directly into your video-editing software in the same way as digital recordings. You need to convert the analogue signal to digital first.

Converting analogue to digital is a simple task, but it does need an additional piece of hardware: an analogue to digital (or A to D) converter. This can either be built into a computer or, more commonly, purchased as an add-on. It will convert any analogue video signal (from an analogue camcorder or a video tape recorder or, indeed, other analogue sources such as live analogue TV or laserdisc) to digital. Then it can be stored on your computer's hard disc or edited immediately using a video-editing application. So far as your digital video-editing software is concerned, the incoming digitized signal is treated in exactly the same way as that from a digital movie camera. In most cases, this includes saving individual scenes as separate video clips.

## Using an A to D converter

The illustrations below right show a typical A to D converter: Director's Cut Take 2 from Miglia. Around the back are all the connections essential to effect any conversion. These comprise input connections that allow you to connect a VCR (or camcorder or other analogue device) using either RCA connectors for standard-resolution video or an S connector for high-band recordings (such as S-VHS, S-VHS-C or Hi8). The converted signal is output, in this case, through a FireWire connection to the computer. Some A to D converters will offer USB2 output, as USB2 is more common on Windows PCs.

To record the digitized footage, start the video capture/video-editing software and start playing tape in the source.

⌃ **A TO D CONVERTER** The front of this Miglia A to D converter is commendably simple, with switches to select import (capture) or output and NTSC or PAL video formats. Around the back, things are much more interesting, with all the connectors necessary to attach any analogue device.

**INFO**

# THE DIGITAL 8 ADVANTAGE

Users of Digital 8 video cameras have a significant advantage if they also have a collection of Video 8 and Hi8 video recordings: many cameras will not only replay these older tapes, but also convert them to a digital signal that can be imported to your favourite video-editing application. In fact, that's probably why you bought one of these cameras in the first place…

Sit back and wait for the recording to play out. You can now handle the converted footage in exactly the same way as original digital footage. You do need to be mindful that analogue video formats (even high band) are somewhat inferior in quality to digital video and the results will not be as sharp as you might be used to. This is normally no great problem. Only if you were to frequently intercut scenes shot in analogue video and digital video would you be particularly aware of the difference.

Note that an A to D converter also has the ability to convert digital signals back into analogue outputs. You can use this option to copy your finished movies back to an analogue medium. This is ideal if you want to create some VHS video recordings of your edited movies (whether the original footage was digital or analogue).

**EXPERT TIP**

You can use an A to D converter to record footage from DVDs when it proves difficult to import footage directly to your video-editing application. Connect the analogue output of a DVD player to the inputs of the A to D converter and import as we have described. There are two drawbacks to this. First, because you are using analogue communication between the DVD and A to D converter, quality may fall slightly in the process. Second, commercial DVDs will have copy protection to inhibit copying.

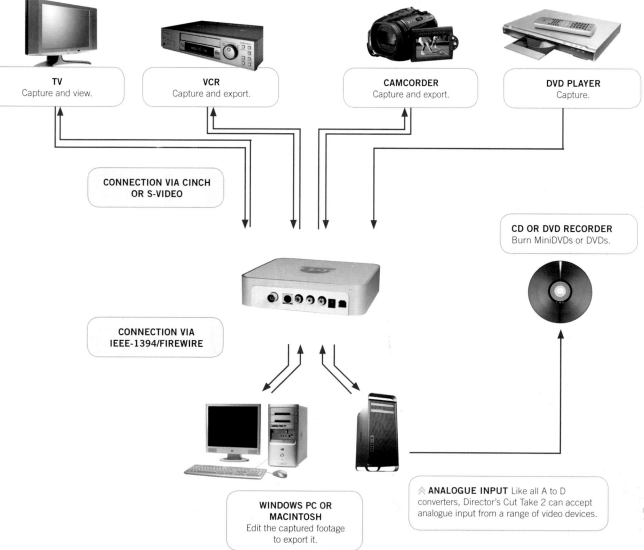

**TV**
Capture and view.

**VCR**
Capture and export.

**CAMCORDER**
Capture and export.

**DVD PLAYER**
Capture.

**CONNECTION VIA CINCH OR S-VIDEO**

**CD OR DVD RECORDER**
Burn MiniDVDs or DVDs.

**CONNECTION VIA IEEE-1394/FIREWIRE**

**WINDOWS PC OR MACINTOSH**
Edit the captured footage to export it.

⌃ **ANALOGUE INPUT** Like all A to D converters, Director's Cut Take 2 can accept analogue input from a range of video devices.

93

# DIGITIZING SUPER 8MM FILM

≫Predating even analogue video, many of us will have old home movies comprising reels of Super 8mm film. This format was in its heyday in the 1960s and 1970s, so there are likely to be valuable memories on each reel. Also, by virtue of its age, this film will be fragile and, compared with video recordings, of inferior quality.

PART FOUR: MOVIE EDITING

You can give this material a new lease of life by transferring it to digital video. However, movie film is one step further removed from the digital domain than analogue video, and the conversion process needs a slightly different approach.

### Reviewing the footage

Your first step should be to review the footage that has been in store for so many years. The best way to do this is to use an editor – one of the small hand-driven devices used to view and edit your movies. If you don't have one stashed away in the attic, you can find them on eBay or in many photo stores specializing in secondhand equipment. This is a worthwhile job for several reasons. After so many years in storage, there is a chance that dampness could have caused some of the film to stick together. An editor, being controlled by hand, can

> ≫ **REVIVING 8MM** The projector may have long since died, but your old 8mm movies can live again and look better than ever, thanks to digital processing.

let you ease the film loose again, whereas a projector, with its abrupt and unyielding drive, could badly damage the film.

The second reason is to check for splices. If whoever shot the film originally was a keen filmmaker, he or she may well have produced an edited movie. Unlike our digital editing systems, this would have involved chopping up the film into individual scenes and then reassembling them in the correct sequence. This was a small-scale version of the process that editors of feature films use.

Splicing (joining) the individual scenes was a precise job that involved finely stripping down a frame at the end of each scene and then using a solvent to bond the two pieces of film together. Over the years, these splices can deteriorate and become brittle, and may need to be reassembled before the film can be digitized. If you have a splicing kit you can do this fairly easily. If not, you can still pick up some sticky-tape-based splicing kits that use tape in place of solvent.

While you have the tools available, is it worth editing the movie further at this stage? No. Editing film is very fiddly, and if you damage the film you could lose precious material for good. Only fix any broken splices or other damage and then leave well alone.

### Transferring Super 8mm

Back in the days when cine photography and video coexisted, various machines were produced that allowed movies to be recorded on tape directly. Most of these involved projecting the movie on to a small screen and using an angled system to record that screen. They worked to a point and satisfied the undemanding audience of the day, but would never pass critical muster today.

Your best bet now is to package up your cherished memories and send them to a facilities house that can use professional equipment to effect the transfer. That equipment is normally a telecine machine: it is the same equipment that is used to prepare a film-based feature film for TV broadcast. A quick Internet search or enquiry via your favourite photo store (many of which provide the service themselves) should reveal several

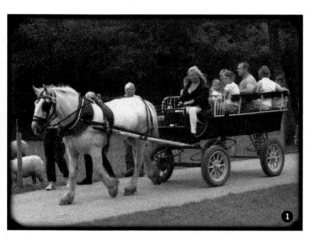

companies who provide this service. You will find that the passage of time often takes its toll on the colour in the images, typically with blue skies drifting towards magenta and vivid reds tending towards orange. Conversion equipment will, to a degree, correct colour casts, but you can safely leave the fine corrections until later. Many of the labs that perform transfers provide additional options. For example, they can add titles, a soundtrack (often rather clichéd sentimental music), all for a nominal extra charge. You can pass on these – you can do all this (and more) yourself when editing your digitized movie. It's best, too, to opt for a DV tape copy of your movie footage, rather than a DVD. This will make editing much easier.

Let's see the process in action:

## 8mm film to digital video

❶ Here is an original frame from a movie shot in around 1975 and probably not viewed since 1980.

❷ The digitized version, on DV tape, on close inspection seems a little softer than the original. However, colour and contrast are greatly improved. The special software filters that worked hard to remove the graininess in the original copy have introduced the softness. The frame has also been cropped slightly to lose the black border and (most of) the darkened corners – Super 8 frames had rounded corners.

❸ Finally, applying a sharpening filter does tend to produce artefacts around edges, but increases the perceived sharpness. The result is a movie that looks as fresh as the day it was shot.

## Editing your digitized movie

You can now edit your movie in exactly the same way as newly recorded footage. Once imported into your movie-editing application, you can start making it even better. Tools in the software will let you improve on the sharpness, reduce noise (help remove the graininess of the original 8mm images) and correct colour casts. If you have had a movie with sound transferred, you will also be able to clean up the soundtrack, boosting the volume and removing background hisses, crackles and noise.

# EDITING ESSENTIALS

>> So, you have downloaded all your video footage from your camcorder and, perhaps, converted some old analogue videotape for use too. Where do you go from here? How do you transform this raw material into a polished movie?

Creating your movie requires a number of steps:
- Scene selection: note the shots that you need for the movie and reject those that are obviously unsuitable.
- Scene ordering: assemble the scenes on the timeline in approximately the correct order; those scenes shot out of sequence can be moved to their intended position.
- The rough cut: review and monitor the strung-together scenes so that the embryonic movie can be further refined at the next stage.
- The full edit: implement the edits determined at the rough-cut stage. This may involve trimming clips, removing material within a clip, insert edits and more. Effects and transitions can also be added at this stage. Marrying any sound effects, audio tracks, or commentary with the existing original audio also takes place at this stage.

Let's look at these stages in more detail:

## Scene selection

This is largely an intuitive operation. You will know as you review the clips stacked up in the clip gallery which are important and which are irrelevant. Depending on how you shot your scenes, there will be a few or many scenes that can be discarded immediately. This may be because they are obviously worthless (where, for example, the camera was accidentally left running; are duplicates (where better or alternative shots will be more appropriate for the movie); or are simply superfluous.

**ASSESSING SHOTS** With your memories of shooting still fresh, it should be easy to assess which shots can be discarded. If your memory is a little less sharp, you can click on a scene to review it.

Remember that you can view a clip by clicking on it, whether it is in the clip gallery or on the timeline.

Deleting these clips – by dragging them to the trash – does not necessarily mean they are lost forever; should you discard something that you later remember was significant, it can be retrieved from the trash or, if you have emptied the trash, reinstated from the original recording. It is a good idea, for your first edits at least, not to delete clips at all. Leave them in the clip gallery just in case you need them.

## Scene ordering

Once you have decided on the scenes that you consider important to the movie, you can start assembling them on

**ADDING CLIPS**

**REMOVING CLIPS**

**CREATING A TIMELINE** Scenes (as clips on the clip gallery) can be dragged in any order to the timeline and rearranged at will. If you need to remove a clip but don't want to delete it, you can simply drag it from the timeline back to the clip gallery (to any convenient location there).

`0:00:00`

# EDITING PRECISION

If you have split a clip and then played each segment separately, you might find that the split was not at precisely the frame you wanted. Movements of the play head using the mouse do not always give frame-accurate precision. Often the odd few frames overrun is of little consequence, but when you need an accurate cut, expand the scale of the timeline. Now your mouse – and a steady hand – can give you the fine cut you want.

⌃ **CROPPING** To crop a clip, you need to define the area to be cropped using the crop tools (the triangle sliders beneath the scrubber bar). Drag these to define the start and end of the area you wish to delete. The section to be deleted is indicated in yellow. Then delete the area (in the case of most applications, Edit > Cut). Note that you can also copy and paste the selected frames using the corresponding commands in the Edit menu.

- discard more superfluous material
- adjust the pace of the movie
- maintain continuity
- conform to a soundtrack if required (that is, be adjusted to fit a commentary or paced to accommodate a music track).

the timeline in the correct order. Using the thumbnail view of the timeline is a useful way to arrange the clips into order because you can oversee a greater number of clips at any one time. Switch to the time-based display to see how long clips are, relative to each other. It is useful at this point to use your shooting script or plan to check that you have all the shots detailed there, and if your sequencing is correct.

## The rough cut

In the days of film-based movies, the rough cut would be the first time that individual shots were assembled into a movie. It could then be reviewed in a single piece. The editor would be looking to:

We can work through the same procedure ourselves but, rather than having to splice together all the separate scenes, we can play the scenes in the timeline as a continuous movie straight away.

Your rough-cut review will probably be a fairly repetitive process. The first viewing will highlight some clips that need removing that escaped notice during your original scene selection. You will also note parts of other scenes that need to be culled or trimmed. This process is one that becomes more refined as your editing experience develops. Your first attempts will undoubtedly concentrate more on the technical aspects, but as your skill and eye for concepts such as pace and continuity sharpen, your editing skill in regard of these will also increase.

## The full edit

To become a more proficient editor you will need to develop a little expertise and experience, and this is something that comes with time. But to get started you will need to know the mechanics of editing, and in particular some key editing techniques. These will be the staple of most of the editing that you will be undertaking on your movies. And the good news is that each of them is simple to learn and just as simple to implement. They are:

- splitting clips
- trimming and cropping clips
- inserting one clip into an existing timeline.

Let's look at these skills in more detail:

⌃ **SPLITTING** To split a clip, position the play head at the point you wish to split the clip and select Split Clip at Play Head from the Edit menu (the exact command name may vary between applications). The play head here is indicated on the scrubber bar and the thumbnail. A pair of new clips is produced, with the second given the suffix /1. If you play the clips, you will notice that the result is similar to playing the original clip, as no material has been removed. However, you could now insert a new clip (a cutaway, perhaps) between the two, or crop either or both clips.

⌃ **TRIMMING** Some applications, including iMovie, let you trim a scene without splitting first. Simply move the sliders to the start and end points of the material that you want to trim away.

## Splitting clips

Arguably the simplest edit is splitting a clip: dividing a single clip or scene into two. This is a straightforward process, so it is a great place to start and to get a handle on editing precision – cutting or trimming accurately. Splitting a clip involves first selecting the clip you wish to split, moving the play head to the point at which you wish to split the clip and, using the command Split (Split Clip at Play Head in iMovie), dividing the clip in two. You will see that the original clip on the timeline will be replaced by two clips, representing the two segments.

Unlike trimming a clip, splitting does not involve discarding any part of that clip. You would use this method if, for example, you want to trim a clip but use one of the resulting segments elsewhere.

## Trimming and cropping clips

Depending on your shooting skills, few clips are perfect for immediate use on the timeline. They may be the wrong length, have superfluous elements or include the call for 'action' at the beginning. Culling the clips to remove this material is an important part of editing.

So, what's the difference between a trim and a crop? A crop, like the term in photography, involves trimming at the edges – in this case, frames from the beginning and end. Trimming is technically the removal of frames in the middle of a clip, sometimes requiring that a clip be split first at the point at which frames need to be removed.

## Inserting one clip into the timeline

When you have dragged your clips to the timeline and reviewed the result, you might find that the resulting movie does not flow as you expected, or that the continuity isn't right. The solution lies in adding another clip (from your clip gallery or even your library of shots) at an appropriate point.

To insert a clip – an insert edit – you simply drag the relevant new clip to the timeline and drop the clip between two existing clips. Or, if it is more appropriate, split an existing clip as described above, and drop the new clip in between.

# UNDOING EDITS

Sometimes you won't like your edits, or realize you have made a mistake. Fortunately, video-editing applications give you options for undoing edits. In iMovie, for example, there are several options:

**1** Choose Edit > Undo to undo (remove) your last edit. You can continue to use this command to step back through your edits, cancelling one at a time.

| Edit | View | Markers | Share | Advar |
|------|------|---------|-------|-------|
| **Undo Cut** | | | | ⌘Z |
| Can't Redo | | | | ⇧⌘Z |
| Cut | | | | ⌘X |

**2** Choose Advanced > Revert Clip to Original to undo all of the changes and edits applied to that specific clip.

| Advanced | Window | Help |
|----------|--------|------|
| Extract Audio | | ⌘J |
| Paste Over at Playhead | | ⇧⌘V |
| Lock Audio Clip at Playhead | | ⌘L |
| **Revert Clip to Original** | | |

**3** Choose File > Revert to Saved to undo all of the edits and changes applied to your movie project since the last time you saved it.

| File | Edit | View | Markers | S |
|------|------|------|---------|---|
| New... | | | | ⌘N |
| Open... | | | | ⌘O |
| Open Recent | | | | ▶ |
| Make a Magic iMovie... | | | | |
| Close Window | | | | ⌘W |
| Save Project | | | | ⌘S |
| Save Project As... | | | | |
| **Revert to Saved...** | | | | |

## Inserting one clip into another

Dropping a clip in as an insert edit may improve the flow of a movie, but can cause problems with the soundtrack. The new clip will arrive complete with its own audio which, interposed between other clips, may sound incongruous. Generally, long clips or scenes are not recommended, but sometimes it is not appropriate to trim. A good example here would be a video of a concert. You can't trim down a band performing a number without glaring continuity problems, but three, four or more minutes of the same view will bore your audience, no matter how strong the subject.

This is the perfect opportunity to use an overwrite edit. With this, you lay down a new visual over the top of a section of the original but leave the original soundtrack – and continuity – untouched. Cutaways of, in this case, the audience enjoying the performance or location shots are ideal for overwrites and help to keep up viewer interest.

## Accuracy in editing

Though each of these edits is, as we've noted, simple to implement, the skill comes in making sure that the edit is made accurately. All editing applications will allow you to move the playhead frame by frame so that you can accurately determine the point of the edit down to a specific frame.

Bearing in mind that each frame is only 1/25 second (or less if you are working at 30 frames per second) is it that important to be frame-accurate? In many cases, no. Where it becomes significant is when we need to trim or cut a shot to remove unwanted material. Leave just a single frame of this material behind and it's surprising how visible it can become!

# THE SCRUBBER BAR

Getting around your movie and movie clips is a key need in editing. You can do this via the scrubber bar – the bar that runs under the movie pane. Drag the slider and you can move to any point in the movie or the selected clip.

**1** Scrubber bar
**2** Play head
**3** Time at play head
**4** Video clips
**5** Playback controls

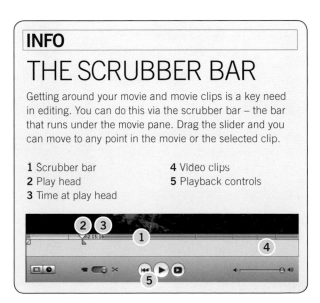

# ADDING TRANSITIONS

≫When you review your raw footage, you will see that one scene ends abruptly and the following scene begins in the next frame. Professional productions, however, use transitions to move between scenes for a far smoother effect.

Raw footage comprises discrete shots. Even though consecutive shots (or those that will be consecutive in the final movie) follow on from each other in storytelling terms, there will be a hard cut between them. In a finished production, there will still be hard cuts between many shots, but others will fade in or fade out, or one scene will dissolve into another. These transitions can be thought of as the punctuation for your movies. If shots were sentences, dissolves could be considered colons and semi-colons, fade-ins and fade-outs as paragraph introductions and endings, and ordinary cuts the ends of sentences.

Transitions can also be used creatively. For example, a fade-out on a scene – where the scene fades to black, followed by a fade-in with a new scene appearing out of black – can be used to suggest the passage of time between the scenes. It can also be used to convey a change of location.

## Transitional effects

Video-editing applications offer a wide range of transitional effects that can be applied between scenes. Use these with care, however: many novices have an irresistible urge to use every transition in the palette just because they are there. The result may be eye-catching, but also rather unsettling to your viewers. It is best to stick with a limited selection and learn to use those creatively. Ask yourself these questions before applying a transition:

≫ **FADE-IN** Starting with a black screen, the image gradually appears (over a few frames or seconds).

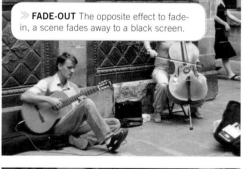

≫ **FADE-OUT** The opposite effect to fade-in, a scene fades away to a black screen.

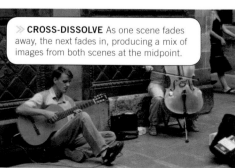

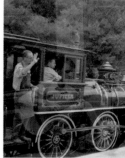

≫ **CROSS-DISSOLVE** As one scene fades away, the next fades in, producing a mix of images from both scenes at the midpoint.

- Do I need a transition at this point?
- Is there a rationale for putting a transition between these two scenes?

If the answer is yes to both, then:

- Is my intended transition the most appropriate?

To help address these questions, here are some of the key transitions and some examples of how they may be used:

## Cut

A cut is an abrupt change – the result when consecutive shots are recorded.

- This is not an applied transition, just the default. One scene ends and in the next frame another begins.
- This is, again by default, the most frequently used transition.

## Fade-in

The scene fades in from a black screen.

- This is a great way to start a movie proper, following the

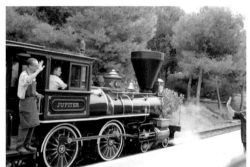

titles, or to start a new section of the movie.
- It can be used as part of a fade-out/fade-in (see below).
- You can use a fade-in following a previous scene that has no transition with care. A series of views of a holiday destination, for example, works well when each scene fades in but ends in a cut with no transition.

## Fade-out

The scene fades to black.

- This can be used to close the movie or complete a section of a movie.
- It can also be used to suggest an ending – of a holiday, for example, or a section of the storyline. This would normally be followed by a scene with no introductory transition.

## Fade-out/fade-in

The first scene fades away to black, and the next scene emerges from black.

- You can use this as a way to link disconnected items.
- It is the equivalent of chapters in a movie.
- This is a 'big' transition, and therefore should be used only where there are major changes to the continuity between adjacent scenes.

PART FOUR: MOVIE EDITING

### Cross-dissolve

One scene fades from view as the next appears; the screen brightness remains constant throughout.

- This is one of the most widely used transitions.
- It is ideal for use when there is a change of camera locations or linking shots in the same location (think of two people staring at each other and the picture fading between them to show corresponding expressions).
- The speed of this transition can infer the significance of the jump between scenes.

### Wash

This is like the fade-in/fade-out, but moves through to a white screen rather than black.

- You can use this to link connected subjects (rather than disconnected in the case of fade-in/fade-out).
- It is less formal than a fade-in/fade-out.

### Wipe

In this transition, one scene is replaced by another by a line sliding across the screen, obscuring one scene and revealing the next. That sliding line can move horizontally, vertically, diagonally or be of another shape, such as a circle of increasing diameter.

- This is a very obvious transition that can be used in the same manner as a cross-dissolve, but the more overt effect draws viewers' attention.
- It can be used for a major change to the movie's timeline.

### Transition times

Although applying a transition is essentially a drag-and-drop activity, you do have control over the transition duration. You can make the transition longer or shorter using a slider control provided. Long transitions suggest a longer gap between events in subsequent scenes, while short transitions, especially washes and cross-dissolves, are great for keeping up the pace in a movie.

### Rendering a transition

When you apply a transition to a clip, or between clips, you can preview the result in a preview window; at that stage the transition has not actually been applied. This is because applying a transition involves rendering – applying the appropriate effect of the transition to each affected frame of your movie. This can take some time, particularly if it is a complex transition. The progress of the application (the rendering) is usually displayed under the appropriate frames. You can generally continue with other editing work while this is in progress.

### In-camera transitions

Not all transitions need be applied at the editing stage. With some forethought, you can create in-camera transitions that can be perceived by your audience as less obtrusive but equally effective in conveying emotion or some other value. Some examples of these transitions are the sky shot and the blur transition.

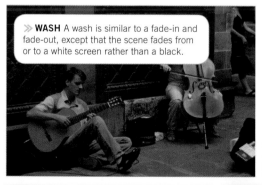
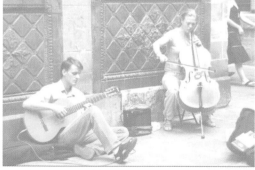

>> **WASH** A wash is similar to a fade-in and fade-out, except that the scene fades from or to a white screen rather than a black.

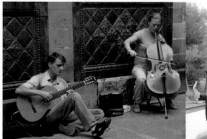

>> **WIPE** A vertical line sweeps across the screen, obscuring the original scene and revealing the new one.

In the sky shot, at the end of the first scene, the camera pans upwards to the blue sky. For the next scene, the camera first pans down from the blue sky (which may be in an entirely different location). For a blur transition, at the end of the first scene, the camera lens is defocused (usually by turning it to close-focusing or macro range) so that all detail in the shot becomes unrecognizable. The next shot begins with a defocused lens that gradually focuses on the subject.

⌃ **SKY SHOT TRANSITION** By panning up on the first scene and downwards on the second, these two disparate shots are linked without the need to select and apply a transitional effect. Don't worry about the distinct difference in the sky colour – this won't compromise the effect.

# SOUND EDITING

>> Assuming you have recorded good-quality sound as part of your movie, now is the time to make it even better through audio editing. By its nature, video is your principal driver for editing, and any mistake in the video will be very obvious. However, you shouldn't neglect the audio, as audio errors are just as significant.

There are two key issues to address when editing the sound recorded with the video. The first is that of differing sound levels. You may have recorded sound across a wide range of ambient conditions and this has led to an equally wide range of audio levels. If you are irritated by the way commercials on TV always sound louder than the programming they interrupt, you will know how annoying it is for an audience to be subject to varying audio levels.

The second issue is cuts. You have cut your original video to pieces and reassembled it. Visually, you are quite happy to see one scene abruptly following another. However, when that abrupt change is accompanied by an equally abrupt change to the sound, it is going to jar with the audience.

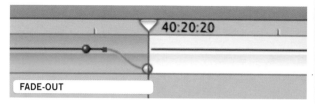

**FADE-OUT**

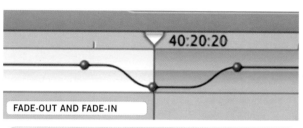

**FADE-OUT AND FADE-IN**

⋀ **AUDIO FADE** You can perform a perfect audio fade by clicking on the start of the fade-out point and dragging the line down. Repeat the process in reverse and you have a fade-in. The rate of fade-out and fade-in can be different: they should be matched with the video content for best effect. In this case, a moderate fade-out is followed by a slower fade-in.

### Editing sound levels

Editing and manipulating sound levels is basically a similar process to that employed for video, although you will be editing the sound to fit the established video. With most video-editing applications, editing is done on the timeline.

When you examine the timeline, you can see the representation of the clip along with any transitional effects that you might have applied. Now, if you select Show Clip Volume Levels or Edit Volume (commands vary between software), you will see the volume level for that clip overlaid.

### Audio fades

The simplest edit that can assuage any sound inconsistencies between scenes is the audio fade. Like the video fade, this is a frequently used effect and one you will hear on TV and at the movies. It is used frequently because it is effective and simple to carry out.

You can implement the audio fade effect by clicking on the volume line where you want to start the fade-out (which you might want to synchronize with the video) and dragging it downwards to the bottom of the clip window. The angle of this slope will determine how quickly the sound level is

⋀ **EDIT VOLUME** Selecting the Edit Volume command (**1**) will introduce a volume level line (**2**). You can edit the sound by introducing changes to this line (**3**); dragging it downwards will reduce the volume; dragging it upwards increases it.

reduced. Of course, as well as fading out you can also fade in the sound, or combine a fade-out with a fade-in.

## Audio cross-fades

Taking a cue from another video effect, the audio cross-fade works along the same principle. When the audio from one scene draws to a close and fades out, that from the following scene fades in. This works very well because it works in tandem with the video. This effect is often used in radio: audio plays and dramas use cross-fades extensively.

Producing an audio cross-fade is a slightly more involved process than implementing a simple fade, because you need to detach the soundtracks from the video in order to be able to manipulate them.

## Splitting audio and video

On page 77, we talked about the value of recording a 'wild track' and using your video camera for this. For it to be used as an audio track, you need to split it from its video. This is also the technique you need to use when preparing two scenes for an audio cross-fade. It can be done by selecting the Extract Audio command. Once done (and disentangling audio and video takes a few minutes), you will have a video track and audio track displayed on your timeline, both in perfect synchronization.

In the case of your sound cross-fades, you will want to keep the two audio tracks synchronized, but for a wild track you will have no further use for the video (which can therefore be discarded) and you can freely move this track to wherever you wish.

## Adding sound effects and music

Once you have mastered extracting audio and moving a wild track around, you are well placed to add further sound effects and even music to your timeline and match them into your video action. Even if you have given wild tracking

On page 77, we talked about the value

### INFO

# USING WILD TRACKS TO COVER NOISY SCENE CHANGES

Once you have applied a wild track, there is a useful dodge that you can apply to cover particularly stubborn joins between scenes. Apply a moderate fade-out and fade-in at the boundary of two scenes and, with the wild track playing out alongside, nudge the level of this up a little so that as the sound fades out from the video tracks themselves the drop in sound level is countered by the rise in the wild track level. You will get an almost perfect audio blend between the two scenes. Use this technique to overcome any short transient noises such as a car horn or a dog bark – by dropping the video soundtrack momentarily and boosting the wild track to compensate.

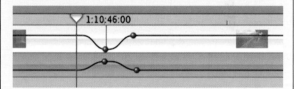

**EVEN LEVELS** Can you hear the join? Fading out the actual recorded sound and boosting the wild track is a great way to cover scene breaks while keeping the sound levels constant.

a miss, you should find it easy and fun to add soundtracks to enhance your production.

When you select a sound effect – perhaps a round of applause, or a sudden thunderclap – you can drag it along the timeline and place it exactly where you wish. To make sure that you have placed it exactly where you want, play the video: it will play back along with any accompanying soundtracks. If the position of your sound effect is wrong you can simply move it.

Some effects, including laughter and applause, and even traffic noises, can be faded in and out in the same manner as other audio tracks. This can be useful if you need to trim that round of applause so it doesn't extend too far into the scene to which you are applying it.

Music can be imported in the same manner as a sound effect and similarly dropped on the timeline. In applications such as iMovie and VideoStudio, the process is made especially easy as music tracks are accessible from within the application. If your chosen application doesn't have this feature, you can use the Import command to import music in a form acceptable to the software.

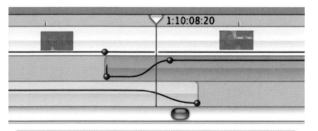

⌃ **AUDIO CROSS-FADE** For these two scenes, the audio tracks have been separated and are shown as the second band (soundtrack of the first scene) and lower band (soundtrack for the second scene). The former has been faded out and the latter faded in so that the average sound level remains reasonably constant.

## Music syncing

When you add music to your production you might want it to provide a backing to your main audio tracks or, perhaps, your commentary and narrations.

Alternatively, you may want the music to be an integral part of the movie, for example, with key scenes accompanied by music synchronized to the action. Music syncing, or back timing, was a process used by sound engineers in the days of film. Working with the film editor, they would determine the point at which the important action needed to be married to the corresponding passage in the music and then, often using simple counters and stopwatches, determined how far back the music had to be placed for the requisite syncing between action and music to take place.

You can achieve identical results today but with much less hassle. Using the techniques already discussed, you can review the music while monitoring its waveform. You can then identify the particular waveform segment that you need to correspond with the action and move the whole audio clip to match up.

In this way you will have moved the beginning of the clip to the requisite place and, should this start position be premature in an audio sense, you can fade out the sound using the sound level controls until needed.

## Do-it-yourself music

You can circumvent any problems with copyright, timing and synchronization by creating your own score for your movie.

---

### INFO

# GARAGEBAND

GarageBand was designed not for use by professional musicians but rather by the rest of us, particularly when we need to put together some musical accompaniments fast. In GarageBand you can select an instrument and a rhythmic loop. This is dragged on to a timeline (much in the same manner as movie clips are dragged to a timeline) for replay. You can repeat the loop ad infinitum or have multiple loops played consecutively. GarageBand, like all similar applications, allows you to have multiple tracks (each with similar or different loops) playing concurrently.

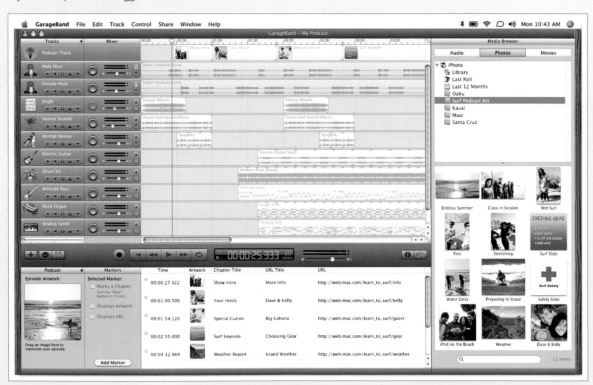

## INFO
# VIEWING YOUR AUDIO

If you want to see what your audio track looks like, rather than just seeing it represented as a simple line, you can toggle between the linear and waveform. Why would you want to see your audio? This is useful when you want to synchronize your soundtrack precisely with a specific point in the video. You can monitor the audio waveform and identify, say, a specific crescendo and then adjust the position of the soundtrack to match a corresponding video frame. You can still perform any edits on this soundtrack when in this view.

**WAVEFORM VIEW** In waveform view (accessed by selecting Show Audio Waveforms), it becomes easy to identify momentary silences (red arrow) and continuous music (green arrow). This is crucial for synchronizing a soundtrack with a video.

This may sound daunting, but even if you have no musical skills at all there are some great tools to help you produce a unique soundtrack.

Producing your own soundtrack puts you in good company. Almost every professional studio is equipped with a copy of Logic Pro or Cubase, the industry-leading applications for sound production and management. Equipped with either of these, you will be able to do nearly anything with your soundtrack, including creating one from scratch.

Unfortunately, these products are expensive and require much study and skill to exploit. For the rest of us, there are products that are easier to use, affordable and capable of delivering the goods fast.

Take a look at Acid XMC from Sony and Apple's GarageBand. Both of these follow the same principle of building music from a series of pre-installed audio loops. As you build your project, the application will automatically fit each loop to your music by altering the key and tempo of each selection.

Both applications are drag-and-drop systems: find the music loop that you like, apply it and then harmonize it with other loops and accompaniments. Once you have gathered together your loops in the semblance of a great tune, you can edit this rather like an original soundtrack, bringing in fades, cross-fades and adding acoustic effects. You can even match your music to the locations in your movie, perhaps giving the

## INFO
# SOUND EFFECTS

Most applications let you apply effects to the soundtrack. Audio effects are applied in much the same way as video effects; you first select a clip and then an effect. A preview button lets you audition the effect and make adjustments if necessary before finally committing it to your soundtrack.

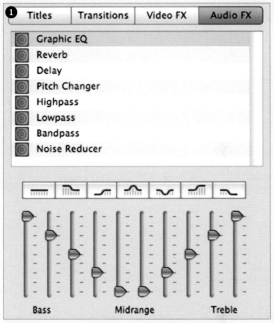

**①GRAPHIC EQUALIZER** Like any hardware or software graphic equalizer, the audio effect equivalent lets you adjust the prominence of different frequency components to, for example, boost the bass to give a more ponderous, threatening feel.

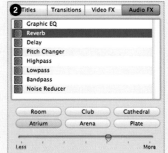

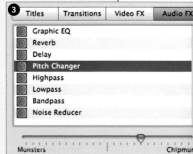

**②REVERB** If the soundtrack you recorded in a cathedral, stadium or arena sounds a little flat, Reverb can boost the echo-like effects that are characteristic of each venue. Simply select the most appropriate venue type and then the amount of reverb.

**③PITCH CHANGER** If the Darth Vader character in your remake of *Star Wars* is a little high-pitched, Pitch Changer can sort it out. It will also make that newly broken voice sound soprano again!

reverberation characteristics of a stadium for a movie of a sports event.

Both GarageBand and Acid XMC offer upgrade paths (to Logic Express and Logic Pro in the case of GarageBand, and Acid Music Studio and Acid Pro for Acid XMC) for anyone bitten by the bug and wanting more music power.

### Adding narration

Adding a narrative to your movie can be done live as you record your original video, but this is not generally recommended. When you need to focus on getting the visuals right, recording a narrative could lead to one compromise too far. It is better to be mindful of your narration when recording the video (that is, ensuring your video shots are of sufficient duration to accommodate your chosen script) but apply the voiceover later.

Adding the sound in the studio offers you other significant benefits, too. You can re-record at will, so if you fluff your lines you can just begin again. You can also alter the narration or the edit to make the audio and visual components match precisely.

To record your voiceover later, all you need is your video-editing software and a good microphone. The recording features are generally very simple, comprising a level meter to monitor your voice level. You should rehearse your lines first, not only to make sure that you get the words and

⌄ **VOICEOVERS** Recording a voiceover is simple. Hit the Record button and make sure the sound level stays around halfway up the scale, which you can monitor as shown below.

video in sync, but also to ensure that your voice level is loud enough to be properly recorded but not so loud that it becomes distorted.

Your recording environment should be as quiet as possible. Just as your camera microphone can pick up camera noise during a shoot, so your narrative can be marred by picking up your computer's fan and other noises.

A dedicated sound-recording room is not viable for most of us, but you can get impressive results by simply moving as far as you can from your computer and using a Bluetooth mouse and keyboard. Any computer noise will then be reduced to a minimum. Working at home gives you another advantage: carpets, curtains and soft furnishings are ideal for creating a great sound recording environment, stifling echoes and reverberation.

⌄ **PROFESSIONAL SOUND** For professional-grade soundtracks with the ultimate in versatility, Ultrabeat is hard to beat.

### INFO

## ADDING MUSIC LEGALLY

As you are crafting your movie you will probably already have some music in mind to add to the soundtrack. Unfortunately, if it is commercially produced music – and that includes virtually everything you hear on the radio, TV and on CD – you won't be able to use it without falling foul of copyright laws. These prevent the use of music for anything other than personal use. To use them in a production – even if it is just your home movie – you will need to pay royalties, which would probably be prohibitively expensive.

Fortunately, there are many publishers of royalty-free music that, once purchased for a modest fee, can be used freely in your movies. It may not feature top names and tunes, but royalty-free music can still be pretty good. It will be worth doing a search on the web too, as there are a large number of music tracks designed for all occasions that can be downloaded and then easily incorporated into your production.

**« LOGIC EXPRESS** If you reach the limit of your simple music software, you can upgrade to intermediate or top-level applications and add even more to your compositions.

## INFO

# SONY ACID PRO

Sony's Acid Pro is a professional-grade sound-editing application that is also used by a number of enthusiasts. Although the interface can look complex and daunting, broken down into smaller components it becomes easy to follow and just as easy to use. The best feature of such applications is that they include tools that make it possible for someone with no musical aptitude to create impressive soundtracks using simple building blocks.

# INCORPORATING STILL IMAGES

≫ It might seem a little strange to incorporate still images in a video production. However, this concept is not as incongruous as it might seem; it can add some powerful elements to your movie.

Consider this example. You are making a biographical movie of a child. Over the years, you have shot so much footage you are spoilt for choice. However, if you go back to the child's early years, you may have only photos. Similarly, for a holiday movie, there may be some important episodes when you only had a stills camera with you. Neglecting these stages purely because there is no video available will lead to an incomplete movie, so what do you do? You put the photos in, too. And, with a little digital sleight of hand, you can make a parade of photos just as interesting as conventional movie footage.

⩓ **THE STILL IMAGE** Drag and drop an image to a movie timeline and it will appear as just that – a still image.

## INFO

## PORTRAIT PHOTOS

Displaying a portrait (vertical) format photo in a video slideshow doesn't make good use of the screen; there will be wide black bars to either side – more so if you are shooting in widescreen. By using the zoom control, you can fill the screen with a selected part of the image. You could also use the scan feature to scan up the zoomed photo to take full advantage of the Ken Burns effect (see right) and keep the screen filled with imagery.

**LOSS OF IMPACT** To show a portrait image in its entirety in a movie is very wasteful of space and doesn't give much impact to the shot.

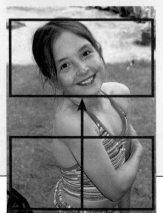

**PAN AND ZOOM** With a touch of zoom and an upward pan, the same shot fills the screen and becomes much more compelling.

⩓ **KEN BURNS EFFECT** The Ken Burns Effect dialog box provides controls for zooming and panning across and image and also for the speed at which any motion occurs.

⩓ **STARTING THE PAN** The dialog box lets you move the image around to define a start point from where, say, a pan will begin.

## The Ken Burns effect

The so-called Ken Burns effect is a simple technique of image pan and zoom to make your still images more dynamic on screen. You can zoom in or out from a specific point on a photo, or pan across the shot in any direction. You can also combine both effects. Master this simple technique and you need never worry about including still images in your movies – in fact, you will probably look for opportunities to add some!

**1** Images can easily be imported into video-editing software, either by dragging and dropping or using the Import command. Once in, they are displayed, rather prosaically, full-frame, as this shot from iMovie shows.

**2** This is OK, but for a subject as dynamic as this, you will achieve far greater impact by introducing a little movement. You do this via the Ken Burns dialog box.

**3** Begin by determining the way you want the image to look at the start of the scene (note that we're no longer referring to the photo as an image but rather as a scene). Select Start in the dialog and use the slider to determine the amount of zoom. In this case, we'll begin by zooming in close on the swimmer's face. You can click anywhere on the image and move the image around. Next, flip the switch to End and adjust the photo's position and the zoom to that which you want at the end of the scene. In this case, we'll zoom all the way out and move the image to the left.

**4** You can now preview the effect by clicking on the Preview button. You can adjust the duration of the scene via the timing slider (the tortoise and hare icons in iMovie). By default this is five seconds; you can change this, especially if you are trying to match the scene to a commentary. Once you have applied the effect you can treat this as any other scene. Drag it to your timeline, apply transitions, use special effects, or even overlay it with a title.

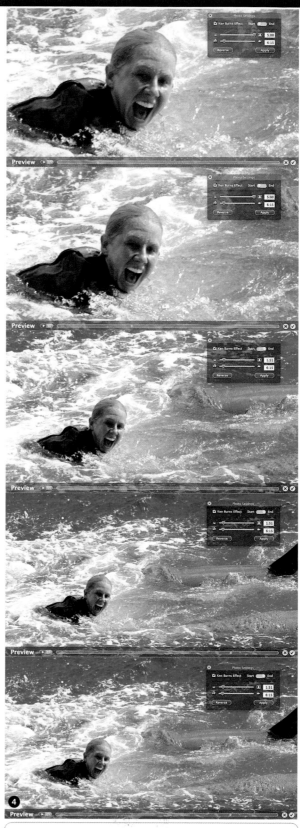

THE EFFECT IN ACTION The complete scene.

---

### INFO

# WHO'S KEN BURNS?

The term for this effect in iMovie – Ken Burns – is named after the documentary moviemaker Kenneth Lauren Burns (born 1953). If he did not create the technique, he used it to best effect in his productions for the US PBS network including *The American Civil War* (1990), *Baseball* (1994) and *Jazz* (2000).

# SPECIAL EFFECTS

>> Special effects in movies can be real crowd-pleasers, and video-editing applications boast their fair share of special-effects options. They are more modest than the spectacular CGI (computer-generated images) in the average Hollywood blockbuster, but in the right hands they can add considerable impact to your movies.

As with transitions (see pages 100–103), it can be easy to overuse special effects. The results will have impact, but for all the wrong reasons!

So how do you assess which are useful and which are not? Which can you use freely and which do you need to be more circumspect with? Fortunately, special effects tend to arrange themselves into distinct types.

### Improvement effects

A glance at any listing of special effects will reveal that some effects are not special effects per se, but rather corrective

⩔ **AGED FILM** This is ideal for making footage you shot yesterday look as if it were created decades ago. Great for flashback shots!

⩔ **ADJUST COLOURS** Use this to enhance colour saturation and the warmth of the colour in an image. You can also adjust the brightness to prevent muddied colours in shadows.

ORIGINAL COLOUR

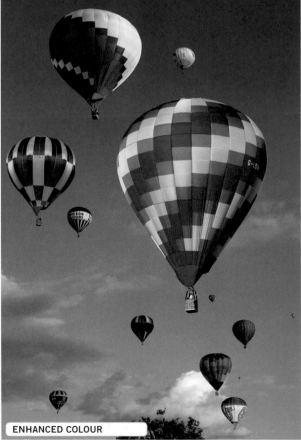

ENHANCED COLOUR

ORIGINAL FOOTAGE

SOFT-FOCUS EFFECT

⤊ **SOFT FOCUS** Compared to the original shot, this suggests romance and is excellent for dreamy, watery scenes.

⤊ **EARTHQUAKE!** Add vibrations, left and right, up and down to create anything from a slight tremor through to a Richter Scale 9.

effects. In this category we can place effects such as Adjust Colours, Sharpen and Brightness/Contrast. You would typically use these to subtly improve your movie footage.

If you want to enhance the mood of certain scenes, these are the filters you will need to turn to. Here you will find effects such as the romantic Soft Focus, Aged Film (giving that well-worn cine film look), and Motion Blur. The last one is great for adding speed-effect blurs when these have been difficult to shoot in camera.

### True special effects

Fancy a blast of lightning? Want to simulate an earthquake? Add mystery with some fog? Rest assured, there are effects that will give you all this and more. Because these effects can be somewhat extreme, it is important to use the controls provided with each to create just enough of the effect. Apply too much of the effect and you can lose the illusion: your viewers will instantly recognize this to be an effect and in no way natural. More subtle effects in this category apply weather-change effects such as rain and snow.

## EXPERT TIP

If you want an extra-special effect or something not included in your application's basic set, check the web for third-party effects that can plug into your application. Like Photoshop filters, there are lots around – some good, some not. You are sure to find something that will meet your needs.

# TITLES AND CREDITS

≫Topping and tailing any commercial video production or movie are the titles and credits. Sometimes these are essential, sometimes informative but often something that, on a DVD or tape, we fast-forward through. Let's explore the ways we can create useful and informative titles for our productions.

## Do you really need titles?

There tends to be an assumption that titles and credits are the final, essential elements that we need to add to complete any movie. That is not necessarily the case. Some movies will be so self-evident that to include a title will at best be patronizing and at worst seem an unfavourable parody.

In some movies, the context and nature will be self-evident; good location shots and establishing shots will convey to your viewers the nature of the movie and the expected subject matter. A shot of a beach in the sunshine or a Florida theme park, overlain with 'Our Summer Vacation' or 'Our Holiday in the Sun' will be stating the obvious and detract from the quality of your ensuing movie footage.

Similarly, if there is an opening shot of an archetypal landmark such as the Eiffel Tower, it's obvious that this is a movie about Paris. In these cases – unless there is a specific reason to add a title – your movie will be more effective without them. However, if the movie prefaced with the Eiffel Tower shot is actually a documentary about engineering building techniques, the nature of the movie is less obvious and a title becomes essential.

## Impromptu and location titles

Often the easiest and most effective titles are staring you in the face: they comprise the signage at the location where your movie is shot. It could be the name of the theme park, a village sign, or even a destination board at the airport.

≪ **SIGNAGE** Colourful signage provides ideal title material.

≪ **LOCATION TITLES** An obvious location shot like this immediately informs your audience of where the movie is set.

## Collateral and ephemera

A shot of some pertinent collateral or ephemera can provide a very effective graphic title. The front cover of a guidebook with the name of the city or site clearly displayed is a great way to announce a travelogue or to illustrate the beginning of a new chapter in a longer movie.

You could use tickets, holiday brochures or a postcard picked up from a local souvenir vendor. In the latter case, you could be particularly clever and, after a few seconds on the picture, turn the card over and let your viewers read a brief message on the reverse.

## Sound for titles

Titles needn't just be visual; sometimes sound can be just as important. Take, for example, an opening shot of two children proudly holding … holding what? OK, the shot doesn't let you see that they are holding boarding cards for a balloon flight, but their announcement to that effect tells you what this movie is about.

## Approaches to title productions

You can use your video-editing software to create bespoke titles to superimpose over your movie footage. You will find all the tools you need to create almost any form of title that you want. But here we need to sound a note of caution. Video-editing software gives you the opportunity to use a myriad of fonts along with any colour you choose for your titles.

However, the fact that you can appear to be original with your titles by a combination of extreme graphics and psychedelic colour doesn't mean you need to be – this can create titles that are quite off-putting. So how should you approach title production?

## Title types

Main titles are those that normally appear at the start of the film and occupy a prominent central position. Of course, there is no rule that says they have to appear over the first scene, nor that they must be dead centre. If you have a good reason for doing otherwise then by all means follow your instincts. You might, for example, want a few establishing shots prior to the title or, in terms of position, a title in the lower portion of the screen might be more appropriate.

≫ **DYNAMIC SIGNS** A pan upwards on this rollercoaster signage to the track above would make a great opening title.

≫ **NON-CENTRAL TITLE** A good example of where an offset title works, sitting in otherwise empty space.

**INFO**

## TITLES: GETTING THEM RIGHT

Could you read that straight off? Is that font empathetic with the subject matter? No to both. We need to try again. Wacky fonts have a place, but not in titles!

This is a much cleaner font, and also suggests an appropriately military theme, but legibility is still not the best.

Arial is the most legible of fonts. It is not exciting perhaps, but your audience will expect excitement from the subject matter, not the title. Keep the colour simple too. Black is usually legible on screen, but strong colours such as blue and orange clash and make for uncomfortable viewing.

### Fonts and legibility

Many fonts look exciting or appropriate when printed on to paper but not so when viewed on a television screen; the scanning process, different screen resolution and the fine detail in the font can all conspire to render your wording illegible. It is important to check your chosen font for size and legibility. The larger the size of the font and the less cluttered the background, the more choice you have. Conversely, if you intend the font to be smaller and have a busy or cluttered background, a good sans-serif font such as Arial or Helvetica (standard on virtually all computers) is the better choice.

### Font colour

Adding coloured fonts is great fun, but take care that the colours don't clash with the scene behind. Some colour combinations that look good on paper just don't work on screen because of the high contrast: they will be difficult for your audience to look at, let alone read. Orange and green is a particularly brash combination that doesn't work well.

### Wording

Keep words to a minimum. You want your movie to tell the story, not your titles.

### Creating titles in editing software

Creating titles in your software application is simple. For example, in VideoStudio you can select the Title tab and, with the scene you require the title to be placed over in the viewer window, select one of the templates. Of course, you don't have to use a template as is; the dialog box below the templates lets you customize all elements as you wish. You can change the font, colours and other parameters. In the viewer window you can change the size and position at will. In iMovie the

⌃ **DYNAMIC TITLING** This is clearly a staged shot, but one that conveys the excitement of the moment and acts as an evocative title.

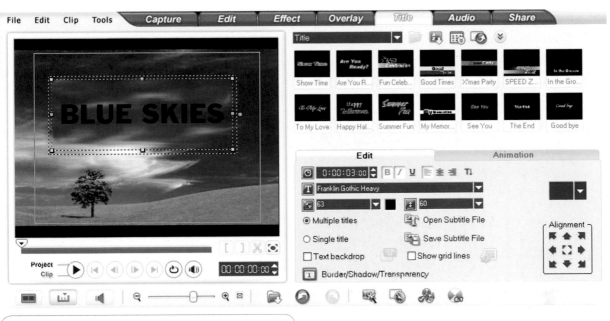

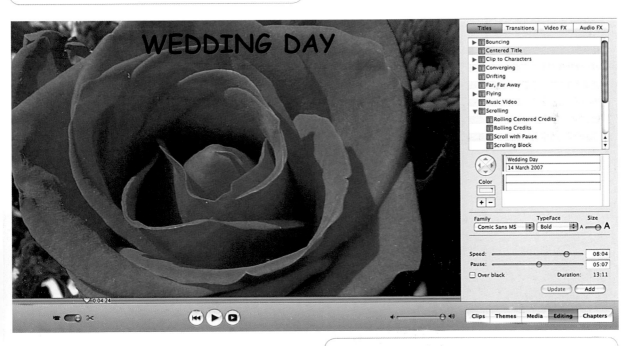

process is similar; you select one of the title types from the Titles menu after pressing Editing. As with VideoStudio, you can then choose the font, colour and size. You can also choose the speed at which a title moves (useful for rolling end credits) and whether you want the title to be placed over a black background rather than a scene from the movie.

# COMPLETING YOUR PROJECT

>>You have cut your footage, added transitions, edited the sound and added a few embellishments. What do you do next? Watch your movie!

That might seem to be a somewhat fatuous suggestion, especially as you have probably been watching nothing else throughout the creation of your project. Unfortunately, that can be the problem. You have been so close to the project for so long and been working so intently on details that you can lose track of the bigger picture. Now you need to take a dispassionate view of your work.

### Take one
Sit back and watch the movie from start to finish. First time through, just make a quick note of any obvious errors. It is surprising that, no matter how sharp your eye and keen your attention to detail, there are often glitches in the sound

> ⌄ **WATCH YOUR MOVIE** Play back your movie, as a DVD on TV if possible, and be critical. Watch for any mistakes to the visuals or the sound, particularly if you have mastered multi-channel sound.

or video that will compromise your production. Resist the temptation to fix each problem as you arrive at it – it is important to see the production as a whole, rough edges and all. Some people prefer to create a rough DVD (without chapters and extras) so they can watch it on a TV, from where corrections can't be made on the spot. Remember, though, at this stage you are only looking for technical faults.

Once you have scanned the whole production, you know the scope of the remedial action necessary. Now you can go back and make the corrections.

### Take two
Now settle back and watch the movie again. This time, you need to observe the content of the movie more closely. Refer back to your original storyboard or script, if you have one. Does the movie tell the story in the way that you planned? If

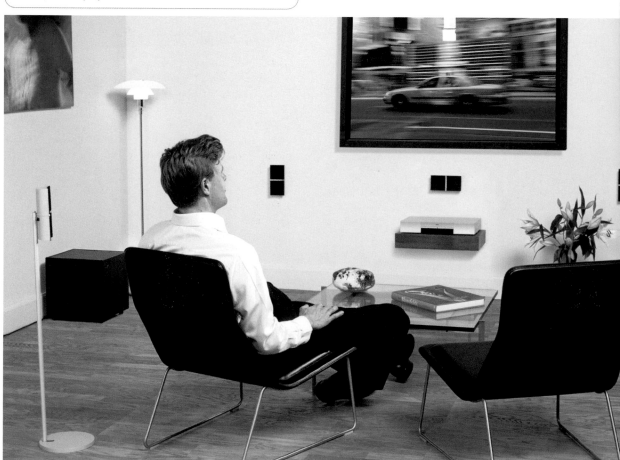

# SAFETY FIRST

You have put a great deal of time and effort into getting to this stage, so make sure you protect that investment. The most efficient way to save your production is to send it back to your digital video camera.

You will need to set up your studio in exactly the same way that you did when downloading the original video footage. We're making a couple of presumptions here. The first is

**BACKING UP** Exporting your movie to a new tape in your camera is the most efficient way of backing up. You can add a black screen to the start and end of the movie to give it a professional touch, and also to allow the camera time to get up to speed when starting.

that you are using a DV, HDV or Digital8 camera. Only with these formats is it really viable to store back-ups on account of capacity and cost – tape media are sufficiently low-cost to allow a library of back-ups to be kept.

The second is that your digital video camera accepts an input from your computer. Some don't; they allow you only to import footage from the camera.

When you export your movie you do so as a finished movie – something you can watch from start to finish or even distribute tape copies to anyone who might enjoy it. However, as a back-up of your movie, you can later reload the recording from tape to your video-editing application should you want to revise your editing.

If you don't have a tape-based camera, then you can still create a safe back-up. This might be via DVD (or multiple DVDs in the case of large projects) or a back-up to another hard disc. When copying to DVD, make sure you export your project and not the movie to the DVD. The project contains all the information you need to re-edit later, whereas the movie is just the movie.

Whatever method you use, make sure that you keep your original media wherever possible. That way, if all else fails, you can go back to your original footage and create a brand new production.

you were working to a script all the way through, it probably will and you probably won't need to make any modifications, but don't be afraid to be critical.

Be especially critical about continuity. Does everything flow as you expected? Do you have any peculiarities – people appearing and disappearing without warning for example, or some bizarre crossing-the-line effects? If you do, then go back (both in your edit and this book) and fix them. Take a look too at the pace of the movie. Is the pace consistent throughout? You can have situations where the movie has been tightly cut in some parts (to produce a fast-paced result) but less so elsewhere. Unless there is a good reason for this, make sure you re-edit all the scenes for a consistent pace.

It can be useful to have a friend or relative watch the movie with you. Although they may not have the movie skills or knowledge that comes in useful for addressing the technical points, they can provide useful feedback on the storyline. They won't have been so close to the editing process as you so can provide impartial comments. It can be so easy – after working closely on your project for so long

– to be somewhat blasé about the storytelling component of your movie. All the technical skills we have learned along the way are only a means to an end, a way of best telling our stories. So many times – particularly when you are new to video editing – you can end up making presumptions that your potential audience just won't be in a position to make themselves. That is why having a friend take a critical view is so important.

As you and your friend review the movie, draw up a list of potential problem areas and new edits that will need to be made and then set about making them. Remember you're on the home strait now, so any final edits you make are the ones that will really make your movie work.

## And finally...

With all the final edits made you can, in the words of the professional filmmaker, sign off your movie for publishing. Whether your ambition is to show your movie on a big screen, send it across the Internet to any interested parties or one of the many options in between, the next chapter will explore each of the opportunities.

# PART FIVE: PUBLISHING YOUR MOVIE

So, your movie is complete. Apart from planning the next one, what is there to do now? You need to move from the editor's chair into the producer's chair: it's time to publish your movie.

Time was when publishing your movie would involve nothing more than copying the final master of your movie to a video tape. Video remains a publishing option, but you are more likely to want to publish your movie to any one of a whole host of media. From DVDs to iPods, the Internet to mobile phones, there are plenty of ways your movies can be enjoyed. And you are not restricted to showing off your results to a chosen few family members and friends; you can broadcast to anyone curious enough to want to take a look.

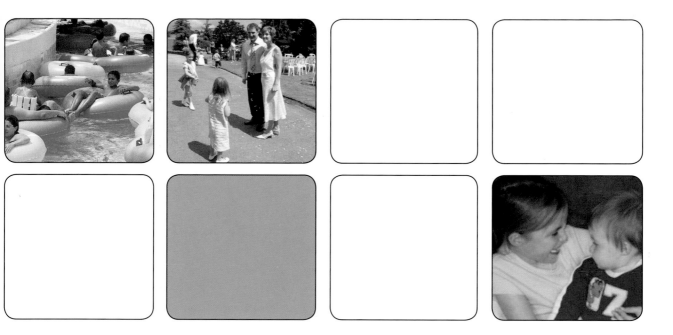

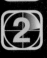

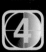

# CREATING DVDS

≫DVD has become almost the default method of distributing high-quality video material. Discs are cheap, easy to produce and copy, and store large amounts of footage. Other formats, such as Blu-ray Disc and HD DVD, are appearing and are focused on high-definition programming, but the ubiquitous nature of the DVD and, more importantly, DVD players, will ensure it retains its premier position for some time to come.

Creating your own DVD with all the features and functionality you might find in a commercially produced disc is surprisingly simple. The only requirement is that you have a DVD disc burner (either in your computer or attached to it) and some DVD-creation software. DVD production boils down to just six stages, most of which require from the user just a few mouse clicks and some drag-and-drops:

- Adding chapters.
- Choosing a theme.
- Creating menus.

- Adding additional resources (an optional step).
- Checking the project.
- Encoding the resources and burning a DVD.

Let's look at each of these stages in more detail:

### Adding chapters

Quality considerations aside, a key benefit of DVD over video tape is the ease with which we can access different parts of the disc. This is mainly thanks to the chaptering process. We can build in points – chapter breaks – to where the movie can jump on a command from us. We can make these at regular points (say, every five minutes) or at selected scenes.

You can add chapters by scrolling through the movie and adding a chapter mark at the relevant points. If you have used iMovie for your movie editing, then you can add the chapter marks and name them within the program. You can then export to iDVD directly.

| # | Frame | Chapter Title |
|---|-------|---------------|
| ◇ 1 | 4:58:09 | **Arriving by Sea!** <br> Link URL |
| ◇ 2 | 10:57:22 | **First Evening** <br> Link URL |
| ◇ 3 | 16:45:24 | **The Cathedral** <br> Link URL |
| ◇ 4 | 41:37:16 | **The Templar Castle** <br> Link URL |
| ◇ 5 | 48:07:20 | **The Caves** <br> Link URL |
| ◇ 6 | 55:20:00 | **Rome – the Journey Home!** <br> Link URL |

( **Add Marker** )   ( Remove Marker )

≫≫ **ADDING CHAPTERS** These can be added almost anywhere on the timeline and given a distinct title. When the DVD-creation software takes over, the chapters appear as interactive titles along with video clips corresponding to the chapter-mark position. Here, the same chapters are shown in two different themes.

# DROP ZONES

When you have selected a theme, you will find that many contain drop zones. These grey windows let you drop movie clips or images into them to customize your menus. In the case of movie clips, these will play automatically.

Some menus will feature a number of drop zones. If you don't want to laboriously drag a clip or image to each, you can often select auto fill to have each drop zone filled automatically.

**CUSTOMIZATION** You can further customize a theme by adding your own movie clips or images into drop zones.

## Choosing a theme

Themes comprise menus and submenus and provide your DVD project with a cohesive look. Most applications include a number of theme templates that you can use directly or customize to provide a look appropriate to your production.

## Creating menus

Once you have added chapter marks to your movie, you will want to provide a means for your viewers to get from one to another and to be able to preview those chapters. Once you have chosen a theme, you can use the menus and submenus of that theme to provide the navigation.

Some themes offer simple text navigations, allowing users to select a chapter from a list; others let you add a visual to each selection in spaces known as drop zones (see box).

## Adding additional resources

You may want to include additional material on your DVD – for example, some still images or some audio files. As well as incorporating still images, you may want to add copies of the original image files. Think of these as akin to the 'extras' provided on some commercial DVDs. You can add these now and provide menu links to them. In some applications, still images can be run as slideshows and you can add music to accompany them when replaying.

**THEMES** A theme provides a consistent look and feel to a production and might include, as here, menus for the 'front page' of the DVD, submenus and an extras menu. Themes are also used in some video-editing applications (see pages 88–89).

## Checking the project

Now the compilation of your project is complete you may want to preview it, to see if the navigations you have provided actually work and the project has all the elements you expected. Press the Preview button to enter the preview mode. You can now treat your project as if it were a real DVD and navigate around it as you would the finished disc. When you exit the preview you can make any changes necessary.

## Encoding the resources and burning a DVD

When you are happy with the project, hit the Burn button to start the production of your DVD. This will begin the process of encoding your entire movie, and any other resources you

are including, into a form that can be burned to the DVD. This can take a considerable amount of time – often a number of hours. At the end of this process the DVD itself will be produced.

### Shortcuts: Magic iDVD

An application such as iDVD is fairly straightforward to use, but it still requires a little practice and experience to deliver its best results. Wouldn't it be great if you could just drag and drop the necessary elements into a DVD project, for those productions of lesser importance, or to preview footage prior to making your final production? Well, that's exactly what Magic iDVD offers.

To create a DVD using Magic iDVD, here are all the steps you need to perform:

- Open iDVD and click on the 'Create a Magic iDVD' button.
- Name the project.
- Select the theme you want to use from one of those displayed in the gallery.

- Click on the Media button to display movies, images and audio files and drag them to the respective places in the Magic iDVD window. You can drop audio files on to still images to add a soundtrack to a slideshow.
- Click the preview button and demo your DVD. If it's OK, burn a DVD; if not, make adjustments and repeat.

### Camcorder to DVD

Many applications can transfer video directly from a digital video camera to DVD in a single step (this is called OneStep in iDVD). DVDs created in this way will start to play immediately when put into a computer or DVD player and there will be no menus or navigational tools (although you can fast forward and rewind through the footage).

Use this only if you want a simple record of an event to distribute prior to editing or as a means of quickly and conveniently backing up movie footage.

> ⩔ **MAGIC IDVD** With an interface even simpler than iDVD, Magic iDVD can help you produce a production in minutes (sadly, there is no shortcut for the encoding process).

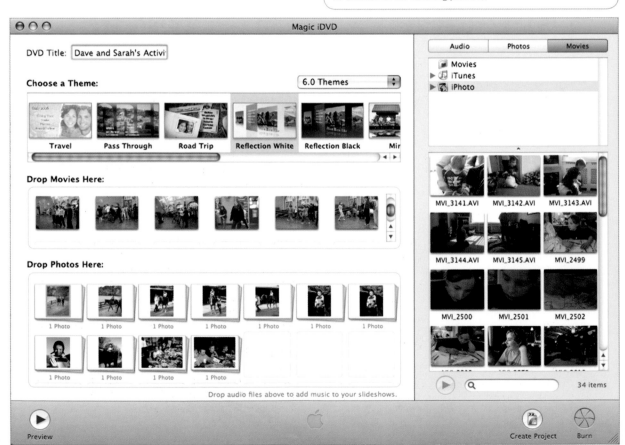

⚔ **DVD STUDIO PRO** Professional DVD production tools are similar in style and effect to their junior siblings, but often allow a greater degree of interactivity. The map on the left-hand pane of this screen from DVD Studio Pro gives an indication of the links between different menus and resources, much more detailed than the linear trees that the consumer applications offer.

## INFO

# DVD CREATION FAQ

### • How long does it take?
It can take a few hours to encode an hour of movie footage and burn it to a DVD. The time depends upon the length of the movie, the type of menus specified (still or animated) and the compression quality (Best Quality or Best Performance).

### • Why does it take so long?
The program has to take a very large video file and convert it into a much smaller one to fit the DVD, with minimal loss of quality. It also needs to encode the menus and any extra material. Finally, of course, it has to burn the resulting files to DVD. You could have a 12GB source video to fit on a 4.5GB disc, along with 500MB of animated menus and extras.

### • What is the difference between the two quality settings 'Best Quality' and 'Best Performance'?
Best Quality is for the best possible image quality. The encoding program optimizes the recording for the space available and delivers the best results. In this format the disc normally takes slightly longer to burn but is worth the wait. Best Performance uses a different optimizing technique that can deliver results faster and often accommodate longer

recordings. You will lose some quality: how much depends on the length and detail in the recordings.

### • How much should I put on?
Some programs will allow up to six hours of video to be recorded on a single-layer DVD, but this will produce video that is heavily compressed and poor quality. Normally, try for no more than two hours on a single DVD. You will obtain good-quality results with only minimal compression artefacts.

### • What about menus and submenus?
Menus and submenus take up space on the DVD. Menus that are text-based take up less space than multiple-pane animated menus. If you are tight on space you may not have room to use the more space-hungry menus and will have to settle for simpler designs. Again, checking the DVD capacity meter will show you how much space you have to play with.

### • How do I make multiple copies of a DVD?
Some software can automate this, copying the relevant files to disc and prompting you to add a blank disc at the appropriate point. In applications such as iDVD you will be prompted once the first disc is produced to insert a second to make another copy.

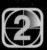

# ALTERNATIVE DISC FORMATS

>> DVDs are not the only disc-based video format; there are also Video CDs and Super Video CDs. These are less popular because their quality is not as good as DVD and, more significantly for the Hollywood studios, they can't offer recording lengths sufficient for many movies. However, as you are more likely to produce short features, both formats are worth considering.

### Video CDs

Video CDs (VCDs) use standard compact discs and can be burned in standard CD burners. They achieve the ability to hold significant amounts of video by resorting to the MPEG1 compression format. A precursor to the MPEG2 used in DVDs, MPEG1 as used in VCDs tends to have lower resolution that puts the picture quality on a par with VHS video recordings. Around one hour of video with stereo sound can fit on a single CD. You can't add chapter marks, so these are best suited either to shorter movies or anything that you would normally watch from start to finish in one go.

VCDs can be played on most DVD players, virtually all computers with a CD-ROM or DVD-ROM drive, and also on

---

**INFO**

## MINIDVDS – A HYBRID

Sometimes called a cDVD, the MiniDVD is a DVD that has been recorded on to a CD rather than a standard blank DVD. The video quality is identical to that of a standard DVD, the compromise being that with the limited capacity of CDs you can record only around 17 minutes of video at best. Another limitation is that, because MiniDVD is not a tightly defined standard, not many DVD players will play these discs. However, almost all computers with a CD-ROM or DVD-ROM drive will play them successfully.

---

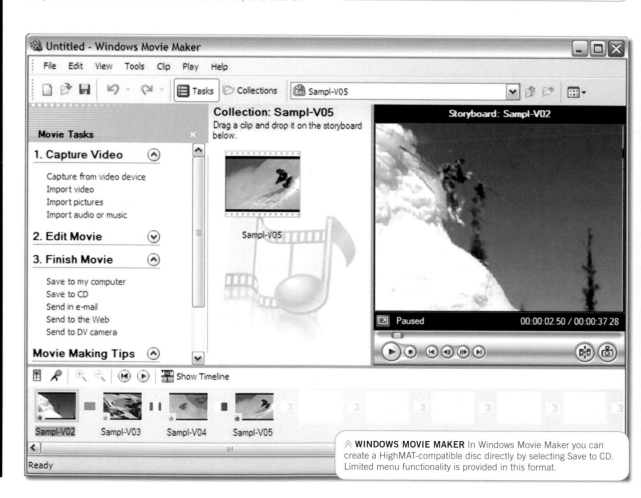

⋀ **WINDOWS MOVIE MAKER** In Windows Movie Maker you can create a HighMAT-compatible disc directly by selecting Save to CD. Limited menu functionality is provided in this format.

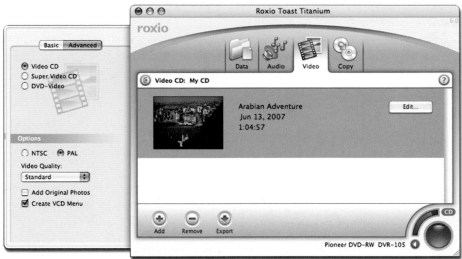

HIGHMAT HighMAT-compatible media and devices sport this logo.

standalone VCD players. These tend to be very common in Asia but less so elsewhere, as VCD is a commonly used format for movie distribution in Asia.

Why would you want to create a VCD? Cost and expediency are the key drivers. VCDs are easier to make, largely because they offer more limited functionality.

## Super Video CDs

An evolution of the VCD propounded originally by the Chinese Recording Standards Committee (as a counterblast to the DVD and as a solution that didn't require the same investment in hardware), the SVCD offers recording in the

VIDEO CDS They may not have all the interactive features of a DVD, but Video CDs are simple to create. They are ideal for a preview disc or for movies that don't justify the full DVD treatment.

higher-quality MPEG2 format like DVDs. The trade-off is that you can't accommodate much more than half an hour's video on a single disc. These discs are also less compatible with standard DVD players.

## Creating Video CDs and Super Video CDs

With their simple structure, there is no need for constructional software applications such as you might use for DVD projects. Using an application such as Roxio's Toast, you just drag and drop your movie files (most formats are accommodated) to the software window. The control you have amounts to creating a menu if required (this will let you select individual recordings if more than one movie is burned to disc) and selecting a quality – standard or high. For high quality, encoding takes longer and the duration that can be encoded will be shorter.

## The HighMAT solution

HighMAT is a relatively new solution championed by Microsoft and some leading consumer electronics companies. It is aimed at addressing potential incompatibilities between media burned on disc and devices designed to replay them.

The HighMAT system creates CDs or DVDs that can be replayed on computer and compatible consumer electronic devices as diverse as DVD players, media players and portable devices. If you have been using Windows Movie Maker you can create a HighMAT disc by selecting Save to CD from the Finish Movie menu in Movie Tasks.

## INFO

# DIVX

Touted as MP3 for movies, DivX is a format designed to compress DVD-quality movies and movie lengths into something that can fit on a CD. It achieves this by using MPEG4 compression, rather than MPEG2, which can reduce file sizes by up to 80 per cent. You can encode your movies into DivX format using encoders available from the DivX website and replayed on many DVD players (and other devices) branded with the DivX logo.

DIVX This distinctive logo is an easy way to identify equipment compatible with the DivX format, and to recognize any material produced using it.

127

# MOVIES ON THE INTERNET

≫Thanks to the impact of delivery systems such as iTunes, many of us are eschewing the purchase of physical products such as CDs and DVDs and gathering resources directly from the web. This suits the aspirations of many filmmakers keen to attract a worldwide audience for their masterpieces. So how do you exploit the Internet for your movie ambitions?

The Internet offers several options for showcasing your movie, including:

- Sharing it as an email attachment.
- Posting it to a personal website.
- Sharing it on a dedicated movie website.

## Sharing as an email attachment

One way of sharing a movie over the web is to attach the file to an email, as you might attach a document or a photo. In technical terms, this is probably the least satisfactory, yet can be the most expedient for a video clip or a short movie. If you want to share an event quickly and personally with distant friends and relatives, this option comes into its own.

This is the perhaps the least satisfactory method as it is not a quick-click solution. You can't just attach your new movie to an email and send it, because movie files are just too large. You will need to compress your files – or rather a copy of them – especially for email use. All the main video-editing applications allow you to do this. When you select that option, you will be given an indication of the ultimate file size so you can assess how viable it will be to send.

For example, a six-minute video that would be well over 1GB in native form will be compressed by a factor of around 100 to under 10MB. Heavy compression, of course, comes at a cost. Check the information panel and you will see that

> ⩔ **EMAIL MOVIES** The parameters for an emailable movie mean quality will be poor (certainly compared with the original), but still sufficient for memories to be shared quickly.

# DOWNLOADING AND STREAMING

If you have accessed movies on the Internet you may have discovered that some movies are described as 'downloaded' while others are called 'streamed'. What's the difference? Downloading is precisely that. You download a copy of a file via the Internet from a server (which could, of course, be anywhere in the world). This gives you your own copy of the file that you can then play to your heart's content using appropriate player software.

You will probably have discovered when you have downloaded a video that it can take some time: attempt to download a big movie file (and movie files are invariably big) and you could be in for a long wait.

Streamed movies are also delivered via the Internet to a viewer's computer, but the data is delivered to special streaming software installed on that computer. No data is stored on the computer's hard disc. Instead, the stream of data is buffered (that is, a certain amount of data is stored in memory to allow the movie to be replayed without interruption) and then played while the download continues. Save for a few seconds when the buffer is filled, the playing of the movie begins immediately.

the resulting movie will be presented at only 10 frames per second (rather than 25 or 30), will be a small 160 x 120 pixels (compared with 640 x 480 in the original) and will have average-quality mono sound (versus good-quality stereo).

At this quality, the movie is probably not something to store for posterity, but that's not really the point: the aim is to send the movie to someone quickly. You can follow up with a CD or DVD later.

## Posting to a personal website

Another problem with sharing a movie by email is that it is restricted to the people that you send it to. If you want more people to access your movie you could post it to a website instead. Then anyone who visits the website can have the

Broadcast Yourself™

Search

| Videos | Categories | Channels | Community |

 **Upload Videos**

## Videos

My Videos - Favorites - Playlists - Inbox - Subscriptions

### Most Viewed (Today)

**Browse**
Most Recent
● **Most Viewed**
Top Rated
Most Discussed
Top Favorites
Most Linked
Recently Featured
Watch on Mobile [NEW]

**Time**
● Today
This Week
This Month
All Time

**Category**
● All
Arts & Animation
Autos & Vehicles
Comedy
Entertainment
Music
News & Blogs
People
Pets & Animals
Science & Technology

**DJ OZMA**
04:27
Added: 2 days ago
From: miranca
Views: 204,826
★★☆☆☆
283 ratings

**Gnarls Barkley 'Crazy' Live**
04:48
Added: 1 day ago
From: AtlanticVideos
Views: 167,882
★★★★☆
747 ratings

**NHK 紅白歌合戦 DJ OZMA**
03:54
Added: 1 day ago
From: Thirjapan
Views: 166,102
★★★☆☆
86 ratings

**my resolution...finally!**
01:27
Added: 1 day ago
From: wilkojunior86
Views: 165,385
★★★☆☆
1509 ratings

**ZIDANE a new way to solve problems..**
01:00
Added: 2 weeks ago
From: maeox
Views: 3,112,118
★★★★☆
7536 ratings

**Happy New Year**
01:27
Added: 1 day ago
From: Zipster08
Views: 163,408
★★★★☆
773 ratings

**cutie costume**
02:28
Added: 1 day ago
From: OmankoYaro
Views: 151,014
★★★★☆
346 ratings

**Have a Kick Ass New Year!**
00:33
Added: 1 day ago
From: futurethought
Views: 128,100
★★★☆☆
943 ratings

**Seattle- Space Needle fireworks display: 2007**
00:25
Added: 1 day ago
From: osbaldoh90
Views: 118,123
★★★☆☆
327 ratings

**Entradas de Materazzi**
03:09
Added: 1 month ago
From: Elpenalti
Views: 1,001,679
★★★★☆

---

⌃ **MOVIE WEBSITES** Movie websites such as YouTube provide the means to publish your movies to the world, no matter how abstract or weird! There are some technical conditions, but you will find out how easy it is to add your own masterpiece by visiting the site.

opportunity to download it. All you need do is email your prospective recipients and advise them of the web address to visit. Often you can save larger files (offering stereo sound and perhaps four times the resolution of an emailed file) and give your viewers the option of storing the file to disc.

Applications such as V2F will help you convert a file and create the entire necessary HTML required to paste your compressed video into your webpages. If you are an iLife user, things are even simpler: you can output a movie directly from iMovie into your iWeb webpage.

### Posting to a movie website

Posting a movie to a personal website is a very good way to let friends, family and colleagues see your work. But it still doesn't achieve the ultimate in exposure: access to everyone. Though in principle anyone could visit your website, unless

your site and its content are widely publicized and can be found by anyone attempting a casual search using a search engine, your hard work will still be overlooked.

Movie websites overcome this hurdle by providing a forum for everyone who wants to post movies and anyone who likes to watch an eclectic mix of productions. You can think of these rather like photo databases. There are huge numbers of movies in each, but visitors will have their own preferences and reasons for visiting. They can filter out all the movies that have no interest to them and concentrate their attentions on those – including yours – that meet their criteria.

Like many open forums, there is a mixed range of material on show. Some are crafted movies, others simple documentaries, still more are crude videos designed to make a political or moral point. But the great thing is that there are no rules or restrictions, apart from sensible ones on taste and decency. These sites can be an inspiring place to pick up ideas and techniques too. Pay a visit to YouTube (www.youtube.com) and take a look at one of the most popular of these forums.

129

## INFO

# VIEWING INTERNET-DELIVERED MOVIES

Playing a movie on your desktop requires a media player. There are three main types: QuickTime, RealPlayer and Windows Media Player. Each of these is available for both Windows PCs and Macintosh computers. All three tend to have common characteristics (rather in the manner of video-editing software) but differ in the details.

QuickTime was the first of the media players to surface, originally only available on Macs. Now it is a cross-platform application and is possibly the most robust of all the players. It is characterized, in usual Apple form, by a simple and intuitive interface, and offers very good playback quality from a wide range of files and sources. The Pro version offers advanced editing and saving features in exchange for a very modest fee.

RealPlayer is an evolution of the audio player that has been a feature of most Windows PCs for some time. Its key strength is in handling streaming media files (which it does very well). However, it doesn't have the most friendly of interfaces and has the tendency to drop little files on to your computer for each video replayed, which can be annoying.

Windows Media Player is, in true Microsoft form, a Jack-of-all-trades and master of none. It is capable of producing very high-quality video playback, but, like RealPlayer, doesn't have the best of interfaces. Optional skins can let you personalize the look of the player, but this doesn't really improve matters.

It is worth noting that all three players are available as free downloads. As a video producer, it is worthwhile having all three on your computer (for replay and testing purposes), even if your standard work is all done in one format. If you plan to distribute your movies over the web, it is important that you can check that the media player your recipients are likely to have are suitable for your production.

In their latest forms, all three players also support high-definition content.

**MEDIA PLAYERS**
❶ QuickTime Player – the original and best,
❷ RealPlayer – handles well but less user-friendly,
❸ Windows Media Player – a jack-of-all-trades.

# VIDEO PODCASTS

Another contribution from the ubiquitous iTunes has been the video podcast. iTunes didn't invent the genre, but it has made it something accessible, as recipient or deliverer, to us all.

Video podcasts are videos that are downloaded to your computer, stored within iTunes (or a similar service) and then copied across to an iPod Video for a viewer to watch. Apple has conceived some useful tools that make it possible to create a video podcast and publish it to an iWeb website (where any potential viewer can download it) in a single

strike. Windows users have similar packages, although they tend to lack the integrated approach of iMovie and iWeb.

Video podcasts tend to be of greater quality than an emailed video: iMovie's publishing regime offers a full frame rate (25 or 30 frames per second) at 320 x 240 pixels. That's about one-quarter of the lowest conventional resolution, but quite sufficient for the diminutive screens of media players. Sound quality is similar to that delivered by an iPod for medium-quality stereo.

**VIDEO PODCASTS** Not just for broadcasters and the TV industry; video podcasts are a great way to disseminate family news and events.

# DELIVERING HIGH DEFINITION

≫High-definition video is the future, albeit one that is already here to some degree. By virtue of HDV we have seen the advent of high definition in compact affordable camcorders. Video-editing applications allow us to edit the resulting footage. Now, how do we share those superb-quality movies?

The problem with high-definition video is that its recording generates a huge amount of data, which needs first to be manipulated in your video-editing software and then stored in some form so that you can share it. So, if you are lucky enough to have a high-definition system, what are your options? There are several:

• Record to high-capacity disc (Blu-ray Disc or HD DVD).
• Record the completed movie back to the originating HDV device.
• Record shorter productions to conventional DVD.
• Down-convert to standard definition.
• Use a compression utility to compress video files to allow distribution over the Internet.

  Let's look at the pros and cons of each approach:

### Record to high-capacity disc
The ultimate solution (for the present) is to record to high-capacity discs such as Blu-ray Disc or HD DVD. These successors to the DVD offer sufficient capacity to store feature-length movies.

• Pros: allows easy storage and copies to be made economically.
• Cons: computers require a Blu-ray Disc or HD DVD drive, and viewers need corresponding players to view on TV.

### Record the back to the originating HDV device
This was the solution offered in the early days of DV video, before DVD recording became widespread. After completing your movie, you can send it back to the camcorder and, with a fresh tape, record the completed video back on to tape.

• Pros: it is easy to do, and useful for backing up productions.
• Cons: video can only be shared with others with HDV-compatible camcorders or players.

∨ **MASTERING HD MOVIES** HD DVD and Blu-ray Disc burners are appearing in both desktop and laptop models.

∨ **PLAYSTATION 3** If you plan to distribute Blu-ray Disc HD movies, Sony's PlayStation 3 is probably the most widely available player – even if gaming is its principal use.

>> **HD DVD** Compatible with DVDs and CDs, Blu-ray Disc and HD DVD players are becoming increasingly common, providing another outlet for your movies.

## Record shorter movies to DVD

If your production isn't of titanic length, you can record it to DVD. It is rather like creating a MiniDVD using a recordable CD with standard-definition video footage.

- Pros: possible with any computer with recordable DVD drive; media costs are low.
- Cons: resulting recordings are compatible only with other DVD drives. Special software is required to produce recordings compatible with HD output on Blu-ray Disc or HD DVD players.

## Down-convert to standard definition

This is perhaps something of a cop-out, but you can convert your high-definition movies to standard definition. You will lose the quality of your original, so this option should be considered only in addition to another if you want to preserve the original quality.

- Pros: this is ideal for sharing with friends or family who don't have high-definition equipment; down-converted movies can then be shared via the web, CD, DVD or even conventional videotape.
- Cons: high-definition quality is lost.

## Use a compression utility

Just as any other movie format can be compressed, so you can compress high-definition originals. When you compress standard-definition video you often trade quality for file size. For high definition, maintaining quality is paramount, so compression routines have to be very effective if there is to be negligible loss of quality.

- Pros: there is very little loss in quality; compact file sizes; can be replayed on almost any computer available; compression is possible using QuickTime, Windows Media HD and DivX HD.
- Cons: limited replay possible on disc players attached to television sets.

---

### INFO

# DIVX HD

DivX provides one of the most effective and universal high-definition compression systems. Compressing a movie requires a reasonably powerful computer. However, if you have already been editing and processing HDV video on the same computer, you will probably have sufficient resources at hand.

Once you have encoded a movie on your computer, you can transfer it to DVD or, depending on its length, CD.

One of the benefits of DivX is that compressed movies can be replayed using certified HD DVD players; no additional hardware or software is required.

Perhaps more importantly, you can send DivX HD movies over the web and, thanks to a compact DivX web player, anyone you choose can receive and enjoy your high-definition productions.

**HIGHLY COMPATIBLE** Platform independent, the DivX HD is – at present – perhaps the most compatible way to distribute HD video.

133

# PORTABLE MOVIES

>> Throughout the history of filmmaking, the goal has been to make movies of the highest creative and technical quality. HDTV has been the most recent demonstration of technical excellence. But the last few years have seen a shift in viewers' expectations, too. Our life on the move has spawned a desire to take movies on the road too, paired with portable devices.

Your movie might equally well be enjoyed by an audience playing it on an iPod or PlayStation Portable (PSP) on the way home from the office as in a darkened room surrounded by state-of-the-art speakers. So, how do you create a movie that can be downloaded easily to any of the portable media devices available on the market?

The stalwart QuickTime Pro is the immediate answer. However, no doubt buoyed by the meteoric rise of the iPod, PSP and their rivals, software companies have been swift to produce applications designed to make the process simpler, more flexible and intuitive.

The process of reducing a movie file in size to fit a portable device is simple and straightforward. The skill comes in producing a file small enough to fit on the portable device but large enough to offer the best possible quality.

> **MOVIES ON A GAMES STATION** A PlayStation Portable is just as viable as a movie player as it is a gaming device.

PART FIVE: PUBLISHING YOUR MOVIE

## MOVIES ON PSP

The aptly named Movies on PSP from X-oom Software is a great package for converting movies for use on a PSP. You can produce a movie to watch on a PSP very quickly using default settings, or you can dive into the controls and settings if you need to download longer movies or want to change the replay quality.

**SIMPLE CONTROLS** Movies on PSP is a great way to convert your movies for use on the go. The clear interface makes it simple to review the progress of the conversion.

# Remastering a movie for a portable device

You could use QuickTime Pro to convert the movie quickly, directly for your portable device. QuickTime Pro is preconfigured to output to iPods and generic MPEG4, but applications such as Magix's Movies2go, shown above, makes the whole process much more straightforward and supports a number of different portable devices.

Movies2go is more than a video format converter; it is also a fully fledged editor that can directly import your raw movie footage and even handle analogue video. In fact, you could use an application such as this in place of your standard video editor if you were looking to master video and movies only for use on portable devices.

Here's how to use Movies2go to produce mobile video:

## 1 Import video
This could be the aforementioned raw footage or your completed movie.

## 2 Edit
Most, if not all, of the actions you perform in your favourite video-editing application are available.

## 3 Cut and embellish
Assemble your movie and pull in additional resources such as images and music that you may want to include.

> ⌃ **MOVIES2GO** This Magix software is highly versatile, with both video editing and format conversion capabilities.

## 4 Convert and transfer
Converts your original movie into the precise format needed for downloading to your portable device.

You're now free to enjoy and share those precious memories or once-in-a-lifetime events wherever you are!

> ⌄ **IPOD MOVIES** You can share photos via your iPod, so why not movies too? An iPod is ideal for showing off your favourite clips.

# MOVIES ON YOUR MOBILE PHONE

>> Mobile phones rarely feature anything more than a modest-sized screen. But what they lose in stature they gain by virtue of being a device that – unlike media players – we almost always carry with us. So what better device to use for sharing those great moments that you've committed to movie?

The delivery of movies to mobile phones can be achieved in a number of different ways. It might simply involve using the phone as a video playback device: replaying movies stored on memory cards. Or it can be used as a client device, receiving movies from a mobile Internet site. Or, used in a more traditional mode, telephonically speaking, it can be used to receive movies from another handset, across the mobile telephone network.

Whatever means of delivery you choose, you need to remaster your movie in a format compatible with phone handsets and, should you want to send it over a mobile phone network, also compatible with the network.

A great tool for prepping movies – of almost any original format – for delivery to mobile phones is QuickTime. In fact, for this you will need QuickTime Pro, the modestly priced elder sibling.

## Creating a 3G mobile-compatible movie

Creating a copy of your movies compatible with mobile phones requires you to export the movie to a format compatible with 3G mobile phones. Here's how you can configure your system to produce movies:

**①** Select Export from the File menu (we're using the Mac version here, but the Windows version is identical). In the dialog box, choose Movie to 3G from the export options.

**②** Next, select the Use Drop Down and select the most appropriate settings: 3GPP formats are compatible with widely used GSM networks; 3GPP2 with CDMA networks.

The additional options are for specific networks. If you are not sure which configuration your network operates, contact the network or try using the Default Settings option.

**③** Now click on the Options button to open the Options dialog. Here you can customize your movie to ensure it looks good on your chosen mobile handset.

**④** Video settings: as a good starting point, select MPEG4 for the video format and a data rate of 80 kbits/second. The image size depends on the intended download device. If you're not sure, 176 x 144 QCIF is a good compromise.

Pay special attention to the option 'Preserve aspect ratio using'. You will need to set this to either Letterbox or Crop. These settings are equivalent to those found on some TV and digiboxes. The original format of the movie will be retained, displayed as a letterbox or with the edges cropped respectively. If you don't check this box, your movie will be scaled and transformed to fit the window size and shape selected in Image Size.

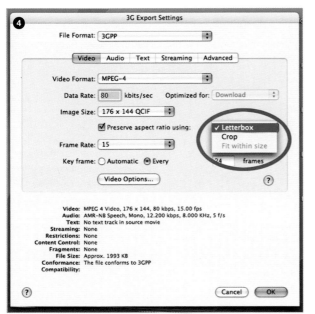

**⌃ MOVIES BY PHONE** More than just a communications device, mobile phones can be a great way to share movies.

That's it. Now you can encode the movie. This process can take some time, but, as you are reducing the file size quite substantially, not as long as some of the transcoding algorithms can take. As for quality – don't expect scaled-down high-definition! Movies compressed for putting on a memory card offer good quality, but the greater compression required for transmission via the phone network will show obvious compression artefacts – rather like those you see if you make a video call by mobile.

**❺** Frame rate: your source movie will probably be recorded at 25 or 30 frames per second. You will get a better result if you specify a rate that is divisible by this. Select 10 or 15 as a basis, but be mindful that the more frames, the more data that will be recorded and the larger the file sizes. Try a few different settings and check which gives the best compromise between quality (and smoothness of video playback) and file size. You can often get away with a lower frame rate on devices that have small screen sizes.

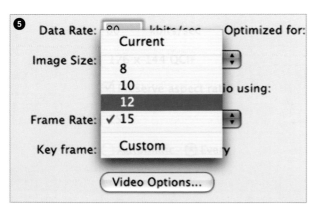

**⌃ SHARING MOVIES** Websites like YouTube are a great place to share your movies (not just phone movies) with the world.

# PART SIX: ADVENTURES IN MOVIEMAKING

Making movies. That's what this book is all about. Now let's get out there and start recording! In this section, we'll look at the most popular of moviemaking genres and examine techniques, ideas and tips for each.

Someone once said everyone has at least one novel in his or her head waiting to get out. No doubt by now you have more than one movie idea waiting to make that break for freedom. Let's help each on its way.

>> Whether you are a sun-seeker or a devotee of winter sports, a holiday is a great opportunity to make a fun movie. Holidays vie with important social occasions for the title of most popular event for video-camera use.

I've said it before and I'll have to say it again: the basis of a good movie – and a holiday movie especially – is planning. Very often holiday movies disappoint us and have the potential to bore anyone we share them with. Why is this? Because time and again vacation movies are merely a collection of disjointed shots that fail to deliver the true atmosphere of our holiday destination or provide a flavour of the holiday itself.

With the excitement that so often accompanies holidays, we tend to forget all we have learned about making great movies and use the video camera much as we would a stills camera, shooting a collection of pseudo-still shots of the landscape and key locations. You would get a better impression of the place by investing in an illustrated guide.

So, how is it possible to make a more dynamic and engaging holiday movie? From the moment you leave to your arrival back home, you need to factor in elements from every part of the holiday. Think of your movie as a grand video diary centred on your family and its adventures and discoveries rather than simply being a travelogue focused on the landscape.

Here are a few episodes that you might like to consider including, with some suggestions about how to make them more memorable.

>> **PEOPLE AND LANDMARKS** Shooting landmarks by themselves can lead to boring shots, but link them with a member of the party staring incredulously or interacting in some way and you will have a much better shot.

## Preparations for departure

- Excited children being woken up on the day of departure.
- Packing suitcases and bags. How about mum having to sit on her case to get it to close?
- Loading up the car. This time dad can't close the boot because mum's bag is close to bursting!

## En route

- Sitting around in the airport/port/train station (don't forget to include an establishing shot to show that this is an airport or station).
- Shot of the departures board.
- Dad struggling with an overloaded trolley.
- Children enjoying movies on the plane; mum or dad asleep with headphones on – a good way to suggest a long-haul journey.
- Struggling to get luggage off the carousel.

## On location

- Establishing shots of the location and the hotel or villa and surroundings.
- Try to get a title shot of the location too.
- Shots of the family exploring locations. Link these with the tourist shots of landmarks and so on. For example, precede a shot of a tall building with a shot of children looking upwards.
- Local colour: don't forget that people are generally the most important and most colourful parts of the landscape. With due deference to any local customs or sensitivities, try to film as many as possible.
- Festivals: whether a real event or something more contrived (as you might see at a theme park) these make great interludes, with colour, music and movement. Shoot lots and trim later.
- Details: Meals, shops and souvenirs aren't obvious subjects for movies but all add to the atmosphere and can also be used as cutaways.

## Last day and the journey home

- Saying goodbyes – even checking out of a hotel – is a good way to start the closing scenes.
- Every member of the party trying to close their bags – complete with gifts and souvenirs. Mum needs two people to sit on her bag!
- Try some documentary footage at the airport or station. Ask the children what their favourite bits of the holiday were. Later you can cut this with scenes from their favourite bits as a useful 'summary'.
- Everyone asleep on the journey home.
- Arriving home to a pile of post on the doormat.
  Note how we've used a theme here (mum's over-packed case) to link scenes together. Also, some elements, such as the arrival home and the interviews could be staged later, if everyone is getting sick of travelling and filming.

**EXPERT TIP**

Check your insurance before undertaking any major travels. Digital moviemaking equipment may never have been so affordable, but that will be little comfort to you when you have to buy all your kit again from scratch thanks to an accident, loss or theft.

141

# WEDDINGS

>> After holidays and vacations, weddings are the most popular use for video cameras. Your average wedding is an ideal subject for a video: it's like a stage show where we know the words, we know the cast (although this may be their stage debut), and there is lots of emotion to provide visual excitement.

There are two ways you might approach wedding video photography. The first is an informal, personal approach. You are there because friends or family members are involved and you want to record your own memories of the day. The second is more official: you have been asked to provide the official record of the day.

### The informal memories-of-the-day video

With an informal wedding video, you are attempting to record personal memories of the day rather than the set list of expected highlights. Incidents that happen along the way – emotional meetings with friends, melancholy mothers – are more important to us personally than some of the prescribed events of the day. Of course, you will record the key highlights too, but the end result will always be a very personal movie. It doesn't matter if you miss something. The fact that you failed to record a single shot with the groom's father will be of little consequence ultimately.

### The official wedding video

If the bride and groom have entrusted you with the official recording of the event, they will expect you to deliver! You should approach the event in the manner of a documentary filmmaker. You need to put together a shooting script and think of all the stages that should be included. The good

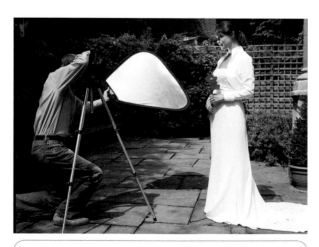

^ **ANOTHER VIEW** Rather than a static shot of the bride, the painstaking attention to detail shown by the official photographer makes for a better composition and more memorable scenes.

---

### INFO

## WEDDING ASSIGNMENT TOP TIPS

• **Know your locations**
Visit the location of the wedding – whether a church, temple, registry office or dedicated venue – in advance. Become familiar with the layout and establish some good camera angles. Keep an eagle eye open for possible difficulties: poor lighting areas, acoustics and blind spots.

• **Know your subject**
Even if you have been to many weddings, you may not be sufficiently aware of what happens when. Even if you have got to know your location, you need to be equally well versed in the timetable of events. This is particularly important when the wedding service is a religious one of a faith that you are not familiar with.

• **Edit tightly**
There is a tendency at weddings to ignore the rules about tight editing and include virtually every aspect of the event. You can end up with a movie that is so long and so onerous it successfully catches every aspect but does not make for a good record. As ever shoot long, edit short.

• **Don't be a stills photographer**
Try to avoid shooting static scenes of guests staring at the camera. Leave these to the stills photographer.

• **Liaise with the official photographer**
You both have a job to do, and you have both been commissioned by the happy couple. A quick introduction and discussion can ensure that you can successfully work together.

• **Make sure you know the key people attending**
You need to pay special attention to the in-laws and parents to make sure you have recorded them all. On more than one occasion, a comprehensive and otherwise brilliant wedding video has managed to exclude the mother of the bride entirely!

• **Draw up a checklist of essential shots**
Refer to your list regularly to ensure you have not missed any vital shots.

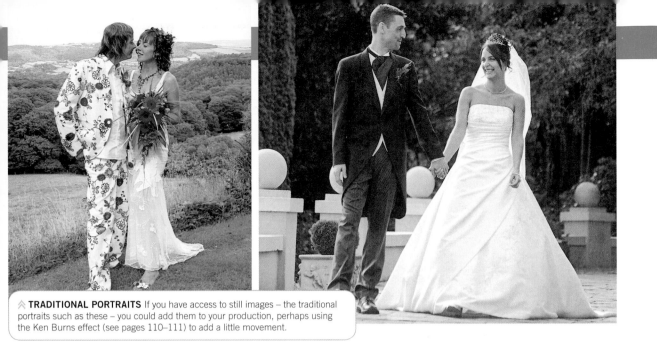

**TRADITIONAL PORTRAITS** If you have access to still images – the traditional portraits such as these – you could add them to your production, perhaps using the Ken Burns effect (see pages 110–111) to add a little movement.

news is that once you've done this for your first wedding you can use it – with appropriate modifications – for any others. Here are just a few of the areas you will need to cover.

### Before the wedding
- The bride getting ready.
- Bridesmaids, pages and companions getting ready.
- Pep talks from family and in-laws.
- Some vox-pop pieces to camera of assembled friends and family expressing their thoughts of the day.
- Waiting for the cars to arrive.

**EXPERT TIP**

Here's a tip for shooting groups of guests but avoiding clichéd shots of them standing, facing your camera: shoot the wedding photographer shooting the guests. Scenes of the photographer organizing groups, with a shot of a group or two over his or her shoulder, will be much more interesting.

**WEDDING SPEECHES** Wedding speeches can be interminably long, so make sure you shoot cutaways that can be used to trim away superfluous material.

143

- Think too whether you want any footage of the groom through the same train of events.
- Departure for the service venue.

### The wedding itself

- Arrival of the guests (take care not to make these static shots).
- Cutaways of the venue to use later.
- People taking their seats and chatting.
- Arrival of the groom.
- Arrival of the bride (some nimble footwork will be required if you are using a single camera and want to film the departure from home too).
- The entrance of the bride into the venue.
- The start of the service.
- The main exchange of vows.
- Any special features (perhaps a soloist's song, or incidents specific to particular faiths).

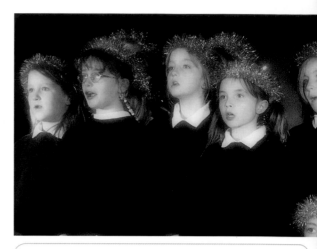

⌃ **KEY EVENTS** Often there is something special at a wedding, such as a musical performance. You will need to liaise fully with your wedding party to make sure you know what is happening and when.

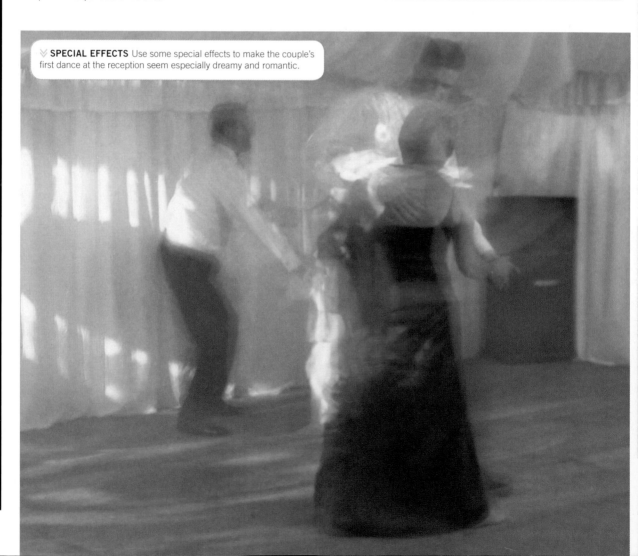

⌄ **SPECIAL EFFECTS** Use some special effects to make the couple's first dance at the reception seem especially dreamy and romantic.

# DON'T BE INVASIVE

There's a risk that an over-zealous approach can turn a wedding video into a movie drama. Rather than being a record of the day's events, you become part of the event, as you call for retakes and stage-manage every move of the wedding party for visual or compositional reasons. You will quickly lose the good will of all involved.

Often, the official stills photography does just this, and a wedding that notionally takes just half an hour lasts many times as long as parades of relatives are lined up for the obligatory groupings, with the bride and groom left standing around for interminable periods.

- The bride and groom kissing.
- More cutaways of people listening to the service.
- Cutaways of children misbehaving.
- The bride and groom walking down the aisle or leaving the venue (keep the camera rolling to capture everyone who follows).
- The bride and groom coming outside with confetti being thrown.
- Random shots of chatting groups outside, concentrating on the bride and groom.
- Shots of the wedding photographer shooting the obligatory groupings.

⌃ **SETTING THE SCENE** Shooting exterior shots of the place where the wedding service will take place can make for vibrant establishing shots, as in the case of this lavishly decorated Hindu temple.

## The reception
- Guests arriving, welcomed by the bride and groom (good insurance for any guests missed earlier in the day).
- The speeches.
- Cutaways of guests listening to speeches to allow trimming later.
- Cutting the cake.
- The bride and groom leading the dancing.

There are probably many more scenes that you can think of, and some weddings, especially those from Asian cultures, will feature many more episodes. Don't worry if the shooting list outlined here seems long: it is important to get as much material to begin with so you have the greatest choice for editing later. With so many people involved in even a modest wedding, it is easy to overlook some people altogether; reduce the risk of this by shooting as much as possible.

An important question to ask yourself is whether you can cover the event with just one camera. In the run of events outlined above, there will be some situations where you need to be in two places at once. Do you, for example, shoot the final stages of the bride's preparations or the guests arriving at the venue? You may need a hand from someone who can shoot some scenes for you to be edited in later.

⌃ **INCLUDE CUTAWAYS** A few cutaways of the venue are a great way to allow more freedom when editing, particularly if the original recording of the service has been a long one!

# A MULTIMEDIA FAMILY ALBUM

≫In only a few years, traditional photo albums have been superseded by their digital equivalent, letting us create far more exciting and visual albums. Take that a step further and we can produce true multimedia albums that can incorporate video and even music.

So many things make up our family memories that it seems a shame to limit those memories to images. A child's first steps, a birthday party, a graduation day, and many more events are much more powerful when you can watch them unfold in video too. By combining old photographs, digital photos, cine film, analogue video and digital video, you can produce a detailed and affectionate family record to keep for posterity or produce as a gift for a loved one.

### Gather your material
You will need to begin by gathering together all those images and movies. Where those assets are analogue – old photos, cine film or analogue video – you will need to digitize them (see pages 92–95). Old photographs, negatives or transparencies (slides) can be digitized using a scanner.

### Compile the album
When you come to compile your album, you will probably find yourself spoilt for choice. With so much material where do you start? How much do you include? Where do you stop? Think of your production as a modest DVD movie. This provides sufficient capacity to store some good video

⌃ **ANIMATED TITLES** Tools in your video-editing application let you combine video clips and still images and, in many cases, use selected resources to build dynamic, animated titles.

footage and a substantial number of images and certainly an appropriate amount to digest and enjoy in a single sitting. If you have far too much material for a single DVD, you could consider making several, each containing a phase of your family history – your children as youngsters, as

≫ **MULTIFUNCTION PRINTER** A multifunction printer is a great addition to your arsenal. Models like this allow you to download memory cards and print photo-quality prints as well as offering normal printing services. They also let you scan old photos, both paper-based and negatives or transparencies.

## INFO

# ALBUM TIPS

- Try to annotate your album as much as possible with dates; it is surprising how quickly we forget what happened when.
- Your movie is designed for your family so it has to please them, but don't use this as an excuse for less comprehensive editing than you would apply to any other movie.
- You can further enhance your albums by adding interviews: you could interview family members (close and more distant) for comments relating to past years, and get them to reminisce. This is a useful technique for linking events and for adding dates and place details; you could get your interviewee to say 'Remember when we went diving in Cornwall, in the summer of 2008?'

Beginning • Spring: Cornwall • April: New York
June: Skydiving • August: Kite Festival • September: Diving

Scenes 1-6

Scenes 1-6

Beginning • April: New York • June: Skydiving • Spring: Cornwall • August: Kite Festival • September: Diving

Scenes 1-6

Beginning • April: New York • June: Skydiving • Spring: Cornwall • August: Kite Festival • September: Diving

⩘ **MENU ANIMATION** You can get creative and make animated menus for your album with the tools offered by your DVD software.

teenagers, and so on. For each phase you can put together video footage of all those important events and include a digital slideshow of additional photos. You can prevent the slideshow becoming the poor relation of the video footage by using the Ken Burns effect (see pages 110–111) to add some dynamism to the imagery.

Because this is a multimedia disc, and one intended for family consumption rather than wider broadcasting, you could also incorporate some meaningful music relevant to you, your family and the year.

# SELF-CONTAINED RESOURCES

You can make each of your albums more self-contained by including the original digital images that comprised your slideshow. As well as a useful back-up for your principal photo library, this will enable you to find and print images for that year quickly. You will need to make sure that the original images are added to the resources to be burned to the DVD (usually you will find a checkbox in the Preferences for your DVD-burning software).

**EXTRAS** Selecting 'Always add originals' will ensure that any original images are copied to the DVD and are then available for any recipients to copy and print.

## Burning your DVD album

Once you have gathered together your resources – video, images and music – you can burn them to a DVD just like any other project. You can create menus and submenus too, to make it easy to find your way to a particular event. Finish off by producing an insert, perhaps using some of the photos you have featured to slip into your DVD case.

⩗ **STILLS AND MOVIES** The great thing about family multimedia albums is that you can combine still shots and movies at will. The results can be more comprehensive than a video album or photo album alone.

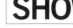

# SHOWS AND CONCERTS

≫Stage productions and concerts make for powerful video footage, but getting the best from live performances can be problematic. A little planning, and perhaps some help from a video camera-equipped friend, can pay dividends.

A problem with recording concerts and stage shows is that with one camera you are limited to the angle from which you can shoot. Unless there are frequent breaks you can't reposition the camera to provide your audiences with the level of visual variety they will be accustomed to on television.

You can provide some interest by using cutaways. These might be audience shots (not necessarily filmed during the performance) of laughter, for example, that can be dropped into any humorous passages. Alternatively, details of props can be used as cutaways if you need to trim the footage.

### Use an additional camera

To obtain optimum results, you will need more than one camera to film the event. Apart from the extra camera, you don't need much else – often not even a second cameraman.

≫ **COLOUR BALANCE** If you work with a friend, make sure you get the colour balance right on both cameras: here, one camera was set to auto and the other to daylight. There is an obvious imbalance.

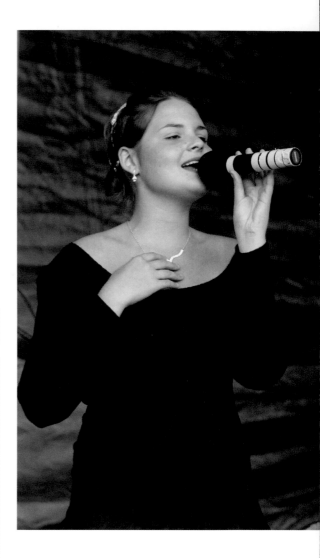

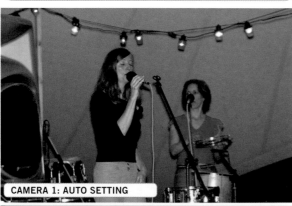

CAMERA 1: AUTO SETTING

CAMERA 2: DAYLIGHT SETTING

## INFO

# COLOUR BALANCE

Your use of two cameras can be betrayed if the colour balance of each is slightly different. You can make some corrections in the software as you compile your movie, but try to minimize the need for this by getting the best match as you shoot. Make a white balance setting off a white or grey card using both cameras in the setting of the event. It won't give a precise match, but it will be sufficient for most purposes. You need then only make minor changes later.

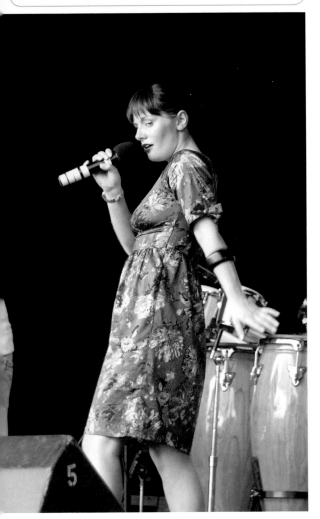

**ADD CLOSE-UPS** If you can get close, or have a good zoom, get some close-ups of the performers to capture the emotion.

## Tackling sound recording

Sound recording needs to be considered in advance. Hooking up to the sound system in the auditorium is probably the best solution. Otherwise, a high-quality microphone on the static camera will be best.

The trick to getting a great movie is to edit the two individual recordings as if they were one. So long as you don't expect frame-perfect cuts, you should find the process relatively simple. Avoid synchronization problems by not cutting from one camera to another at a crucial point – for example, as an actor is speaking his or her line. You may be lucky and get an exact match, but often a single frame's error will be sufficient for your audience to notice.

It is better to use the second camera for cutaways and for cutting to reactions on actors' faces (at a drama performance) or to support and backing musicians (at a concert). In the case of the actors, a cut from the general scene (where the audience's attention will be focused on the main actor) to the reaction on the co-star's face can be very powerful.

**CORRECT EXPOSURE** It is important to get the exposure right when shooting stage performances. Bright subjects and dark backgrounds can be problematic.

So how do you shoot with two cameras but only one cameraman? Set one camera to record the event from the back of the auditorium, taking in the whole stage. Then, with the second, you can rove around (physically, or by using the zoom lens) concentrating on the action or performance.

Having one camera operator is often better than having two as you learn the craft. If there are two cameramen, you might both film the same action from a similar perspective or, worse, you will both concentrate on peripheral action. As your skills at event video photography improve, you might be able to employ a second cameraman but will need to work to a tight script as to who shoots what and when.

# SPORTING ACTION

≫Sporting events can be a gift to the digital moviemaker. The chaotic parade of colour and action coupled with intense emotion from participants and spectators gives you plenty of dynamic material. By the same token, it can be difficult to record effectively: you could feel overwhelmed and point the camera in every direction in a frenzied attempt to record everything.

### The limitations of one camera

When you shoot a sports event, you have to accept that there will be some limitations to what you can do if you are shooting alone with a single camera. You can't be everywhere at once and you will not be able to cover all aspects of the action. Be mindful of why you are at the event. It could be because you are shooting a family member's first appearance in a competitive event; or maybe your favourite team is on the pitch and you have the opportunity to catch your heroes in full flight. Or perhaps your golfing dad needs to enhance his technique and figures that video will be the best way to improve. It might even be because the team – or an individual sportsperson – has asked you to make a record of the game. Focus on the reason why you are recording the event and shoot accordingly.

### Getting the best position

You will also face limitations because of the venue. Unless you have a privileged position or a press pass, your shots are not likely to be taken from the best of positions. You will have to make best use of a zoom and be prepared for excited fans to periodically intrude into your field of view. It is best to accept this is going to happen and build it into your movie. It can sometimes even help cover up your camera being in the wrong place at the wrong time: your commentary can say 'the crowd went wild at the goal…' when all you were able to shoot were some silhouetted heads!

Each scenario will have a different approach but, as ever, your movie must ultimately tell a story. If you are shooting a stadium-based event, include some establishing shots of the venue, inside and out; include wide shots of the field as well as close-ups of the action.

| INFO |
| --- |

## RECORDING SOUND AT SPORTS EVENTS

Getting great visuals can be so problematic at sporting events that we can fail to recognize that sound too can be a problem. At a major event, the sound can range from the near silent to the ear-splitting in seconds. This can cause problems as you edit because you may find yourself abutting two clips, one loud, one silent. Use sound effects to even up the sound (with applause or judiciously placed roar from the crowd), or apply a good musical soundtrack and hope that your lucid commentary will divert attention.

Cutaways (which you will now be shooting as a matter of course) will be more important than ever, as they will allow you to trim away monotonous stages of play and link together some of the more compelling action. When the play on the pitch becomes a little stilted and it is apparent that nothing momentous is about to happen, you can turn your camera towards the crowd and shoot a few seconds' footage of the expectant spectators.

**EXPERT TIP**

If you have lineside, trackside or ringside access, get some close-up action shots. They work well when intercut with more conventional shots from a distance. The different angle can help break up a sequence of shots otherwise filmed from a similar distance and perspective.

≫ **FRAME-FILLING ACTION** Use your zoom to get frame-filling action from a safe distance. (Courtesy MCIA.)

## Shooting extreme sports

Extreme sports push cameras and camerawork to the limits, although some are easier to film than others. Consider aerial sports such as parachuting and paragliding. The action takes place almost exclusively in the air, so you won't have to deal with crowd problems. And suddenly that 20x zoom becomes useful as you trace the diminutive figures high in the sky and record them all the way to a successful touchdown.

With parachutists and, to a lesser degree, paragliders and hang gliders, much of the action is up high and relatively fixed in the sky, making a tripod or steady support feasible. However, when they come close to the ground, relative speeds increase and you quickly need to cut your zoom ratio and be prepared for some fast close-up action.

> ⌄ **STRONG VISUALS** Road racing offers good opportunities for eye-catching visuals: the extensive roadside locations let you get really close. This shot is of Team Lampre/Caffita during the TT Team stage of the Tour de France. (Courtesy Rudy Project.)

> ⌃ **ZOOM LENS** Large venues mean that you will need to use your zoom lens to get close – make sure you have a steady support to avoid camera shake.

# DOCUMENTARIES

≫ Most of us think of documentaries as highbrow productions that tackle pertinent or controversial issues of the day. Documentaries can also be much more accessible. A documentary is simply an informative, non-fiction production that explores or investigates a subject. A wedding video would not really qualify, but a travelogue, taken on your last summer holiday, might well do.

Let's consider a documentary that you might make about local issues: for example, building new houses on green-field sites, or the impact of a new road or airport expansion. Documentaries of this type are not only useful for your community but also provide an excellent training ground for your movie skills. You will need to be rigorous in setting objectives, working towards them and producing a video that remains faithful to them. You will also need to pull together your creative, technical and editing skills to see the production through from vision to execution.

### Planning a documentary

Your first decision needs to be the duration of the documentary. This will depend on the subject matter, the complexity of the presentation and the aims and objectives.

⌃ **LOCAL CHARACTER** Local people talking adds necessary interest to local issues.

As a rule of thumb, base your project on a ten-minute duration. You can increase or decrease later as you begin to establish the content and criteria.

First, you need to ask some key questions. Who is the intended audience for the documentary? What is the aim or objective of the movie? These questions will shape every aspect of the production.

Imagine a hypothetical case. A new road is to be built around a couple of small towns, and you are going to document the process. Now start asking pertinent questions. Who is this documentary aimed at? What is the age of the audience? Their education level? Income? Some of these questions may seem a little obscure, but are crucial. If your documentary welcomes the way the new road will push up property prices, this may alienate the part of the audience who live in rented housing or are struggling to save for a new home.

Your documentary needs to reflect those issues appropriately. You may want to present problems like this in a purely factual way ('The new road is expected to raise property values by 15 per cent in 18 months') or, if your documentary is supportive of these problems, it might be more partisan ('Younger members of the community will really struggle with the inflated house prices.') It might even be that your presentation aims to take a personal view, or a controversial one: 'We favour the road because it will make our house even more valuable.'

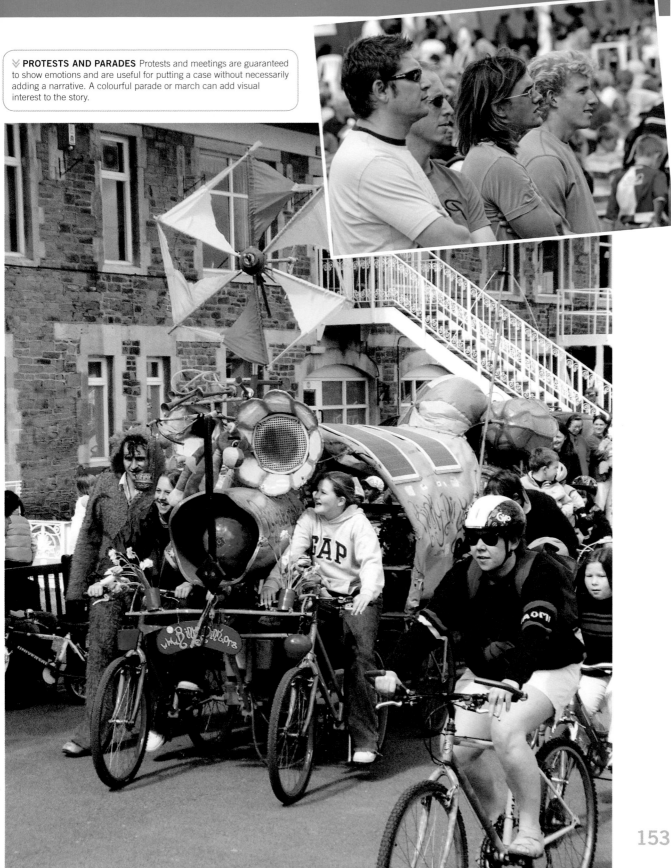

**PROTESTS AND PARADES** Protests and meetings are guaranteed to show emotions and are useful for putting a case without necessarily adding a narrative. A colourful parade or march can add visual interest to the story.

153

One story, so many different approaches! That's why it is crucial to define the production at the outset. You don't need anything too detailed at this point, something like:

**Proposal:** Effects of a new ring road around Everytown and Anywhere.
**Aims:** To show the benefits and drawbacks on the community of the bypass.
To present the cases proposed by the town council in favour of the bypass, and the rural pressure groups against the proposal.
To investigate the impact on schools and children.
**Audience:** Residents of the town, the neighbouring villages and any local interested parties.

Of course, you can add further details to this later.

## Scripts and storylines

Once you have established the rationale for your production, you will need to produce a shooting script. Scripting is crucial in documentaries because through this you define not only the story that you tell but also how you tell it.

Structure is important in any movie but especially so in a documentary. Think of it like the case presented by a lawyer at court. You need an opening discussion that will advise viewers of the documentary's aims and viewpoint. You can then present your evidence. Again, this must be in a structured, logical way. Finally, in the manner of a summing-up speech, you can wrap up the points raised in relation to your initial proposals. Whether this closing scene is left open to let viewers make up their own mind on the information presented, or designed to influence them into your way of thinking will depend upon your original aims.

The script will comprise the actual words that will provide your commentary, along with details of the conversations and interviews that will be incorporated. For a documentary, both apparently informal conversations and more formal interviews should be scripted as far as possible; you will need to discuss with the parties ahead of shooting what they want to say and how they should say it. Don't put words in their mouths, but make them aware of the needs and aims of the production. And remember, when it comes to shooting, take plenty of cutaways to let you edit out any unwanted, confusing or repeated comments.

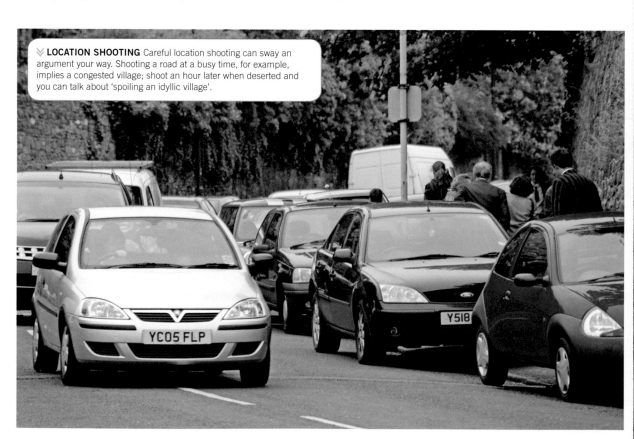

**⩒ LOCATION SHOOTING** Careful location shooting can sway an argument your way. Shooting a road at a busy time, for example, implies a congested village; shoot an hour later when deserted and you can talk about 'spoiling an idyllic village'.

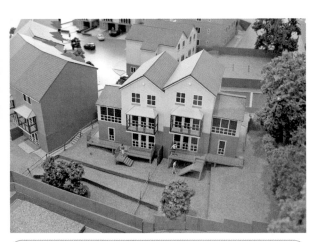

⌃ **MODEL SHOTS** Close-up shots such as this image of developers' planning models can be used to vary the pace of the documentary.

⌃ **ESTABLISHING SHOTS** Location shots such as these might work well as an effective establishing shot for the documentary, helping to set the scene from the outset.

Some shots, for impact, may need to be shot in a certain way. For our example, you might want to shoot a pretty cottage from a certain angle to show looming road works overshadowing it. Or, conversely, you might want to shoot from the opposing angle so that you give the impression of tranquil country life. This is where your storyboard will come to your aid. As well as rigorously defining all your shots, it makes you think about the best ways to shoot them, not only in terms of composition but also with regards to the story and points you are trying to promote.

## Shooting the documentary

Now you are all set to shoot. Equipped with a detailed storyboard, you know the shots that you need to get and can set about collecting them. They don't have to be shot in order, but you do need to keep good notes to ensure you have everything you need.

The nature of documentaries means that some shots can be handheld if necessary. Audiences are more tolerant of this technique in reportage-type situations; in fact, some documentary-makers have a personal style that concentrates on using a handheld camera.

Similarly you can get away with sound that wouldn't make the mark elsewhere. That's not an excuse for bad camera and sound work, or sloppy approaches – it's more a recognition that in some situations you won't have the time or opportunity to set up an exemplar sound system. Your audience will recognize this and be more concerned with the content of any conversations.

## Critical acclaim?

Once you have finished your documentary you need to lay it before a critical audience. Present it first to some friends or family members closely related to the project. They will probably not be too critical (for fear of offending you), but they can point out any glaring errors that might have escaped your attention.

Next, present it to some of the group involved with your case. They will be more critical, sometimes to the point of wanting you to make the documentary more pointed with regard to the aims and objectives. You have then to use your judgment and, perhaps, discuss at length to ensure that any points you take on board with regard to a final edit don't leave the documentary too opinionated.

Once you have thrashed out any necessary changes and implemented them into the movie, you can go on and publish your documentary.

**EXPERT TIP**

Wobbly camerawork is the trademark of many documentaries, but this is not something you should emulate. Documentaries are serious and the subject matter of premier importance, so ensure that your camera work does your subject justice.

# STOP-FRAME ANIMATION

≫So you have produced a great movie. Need a new challenge? Or maybe directing real actors is not your forte. This is another moviemaking opportunity to try!

Stop-frame animation is a technique as old as cinema itself. It harks back to the days of zoetropes and the like, when it was realized that presenting a set of still images in rapid succession produces the effect of motion.

## Equipment for stop-frame animation

The great thing about stop-frame animation is that you don't need any special cameras or equipment; your digital video camera, connected directly to your computer, with the requisite software running, is sufficient. In fact, because you are capturing still images, many digital stills cameras are suitable also. If you are using a DV camera, you will need to check with the software publisher that your camera does provide a direct feed through, so that you can capture directly with the software. Most do, but some don't.

## Software for stop-frame animation

The software you will need is pretty simple (see box): it is designed to grab a still shot on demand and then store these shots sequentially to build up a movie. Depending on whether you are using the European PAL or North American NTSC-based television standards, you will have to shoot 25 or 30 frames for each second of high-grade animation. However, when you start creating animations, you can shoot fewer frames (perhaps 12 or 15) per second to see the results faster. Some animation software will interpolate motion at these low frame rates to produce smooth motion.

⌃ **CLAYMATION** More sophisticated than we might achieve, but Aardman's animations show what can be done with clay.

---

**INFO**

# CREATING A STOP-FRAME ANIMATION

**1** With a tool like iStopmotion, creating an animation from a clay model or even some posable toys is simple.

**2** The key to success is to make each frame flow logically from the one before. Displaying the current frame and previous frames makes it simple to adjust the positions.

**3** You can also modify individual frames to correct any shortcomings. For example, in iStopmotion you can use an image editor (such as Photoshop, here) to adjust frames.

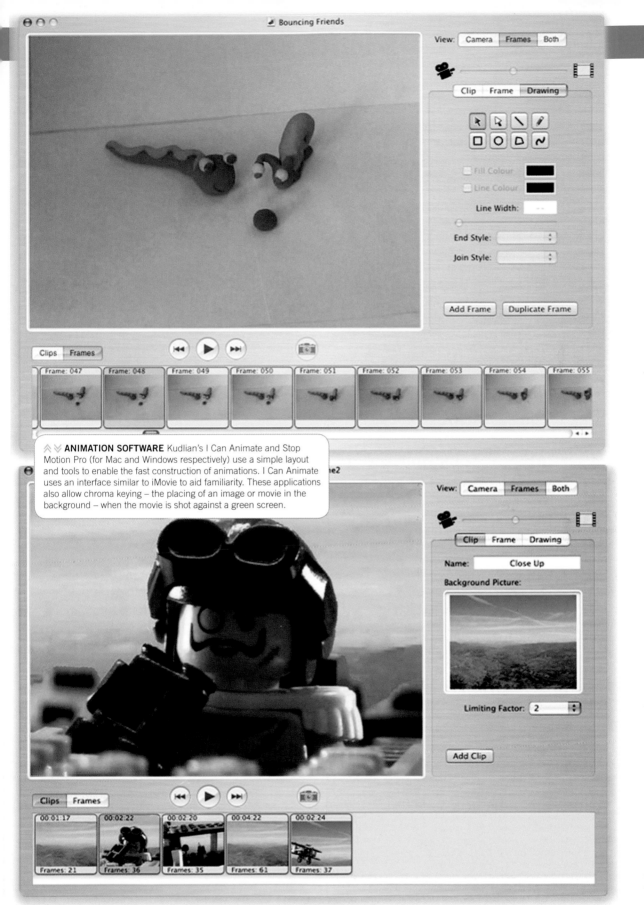

**ANIMATION SOFTWARE** Kudlian's I Can Animate and Stop Motion Pro (for Mac and Windows respectively) use a simple layout and tools to enable the fast construction of animations. I Can Animate uses an interface similar to iMovie to aid familiarity. These applications also allow chroma keying – the placing of an image or movie in the background – when the movie is shot against a green screen.

# GLOSSARY

**Analogue** A description of information presented electronically as a continuously varying signal, rather than a precise numerical code, as in digital data.

**Analogue video** Video, and video systems, that record data in an analogue form (compare with Digital Video).

**Aperture** The 'hole' at the centre of a camera lens through which light can enter. When this hole is enlarged more light can enter; when reduced, less light. An iris, similar to that in the human eye, adjusts the size of the aperture. The aperture and shutter speed can be adjusted for correct exposure and also for creative effects.

**Aspect ratio** The ratio of a television or video picture, expressed as a ratio of the width to the height. Conventional format television is 4:3, whereas widescreen broadcasts are 16:9.

**Blu-ray Disc** An evolution of the DVD used, in video, to store larger amounts of video data (for example, high-definition movies). It uses a blue laser rather than a red one to read data from the disc, which allows a greater density of data on a disc similarly sized to a DVD.

**Broadcast quality** An imprecise term often used to describe camcorders that can offer image quality that is similar (but not identical) to that of standard broadcast television.

**Charge-coupled device (CCD)** An electronic chip comprising a matrix of light-sensitive pixels upon which the scenes can be focused by the camera lens. The data from the CCD is read several times a second and recorded to produce a video recording. Cameras typically have a single CCD but, for greater image quality, some may have three, each optimized for imaging a specific colour.

**Chroma** That part of the video signal that contains the colour information; compare with Luminance, which contains the brightness information.

**CMOS (Complementary Metal-Oxide Semiconductor)** An alternative imaging chip to the CCD that is favoured in some applications because it uses lower power.

**Codec** Short for COmpressor/DECompressor, a computer process used to compress video (for example, to store on tape or disc) and subsequently expand it to its original form.

**Colour temperature** A measure of the colour or tint of a light source. It is measured on the Kelvin scale, which relates the colour to that of a 'perfect radiator' heated to the equivalent temperature. Daylight is approximately 5500K on this scale.

**Component video** A method of handling a video signal in which special cable delivers individual colours separately to a display. This may be Red, Green and Blue or YCbCr, which is Luminance (brightness), Chroma (colour) minus Blue, and Chroma minus Red. Separating colours and information into separate channels produces a better-quality picture because the chance of data from one channel interfering with another is reduced.

**Composite video** A video signal in which all the data – colour, brightness and any other data – is carried in a single channel and a single cable. It is a less robust system than Component video but often cheaper to implement.

**Compression** The process of squeezing data into a smaller space to allow more to be stored on a given amount of tape or disc. This compression can result in loss of data (resulting in a slightly degraded image when uncompressed) or lossless. Lossy compression regimes often allow for a greater degree of compression than lossless.

**Control-L** An editing system used with analogue video. Comparatively crude (and incapable of editing with frame accuracy), sockets for Control-L (or LANC as it is sometimes known) can still be found on some video recorders.

**Cut** Description of splitting a video scene into two, or the 'jump' from one scene to another.

**Cutaway** Specially shot scene used in compiling a video to link two scenes where there would otherwise be an uncomfortable (in visual terms) break.

**Data rate** Usually measured in bytes/second, the data rate is the amount of data that can be transferred in a given time. Used to describe, for example, the amount of video data transferred from a camera to a computer when video is downloaded.

**Depth of field** The amount of a scene that is in focus in front of and behind any subject that the camera has focused on. The greater the depth of field, the larger this amount.

**Digital** Information or data that is recorded as a numerical code rather than a continuously varying signal. Has the benefit, for the purposes of digital video, of preserving quality when copied, compared with analogue, which loses quality on copying.

**Digital zoom** A feature of most digital video cameras that creates a zoom effect by recording a progressively smaller area of the CCD sensor as the camera zooms in. This results in high zoom ratios but image degradation that is proportional to the amount of zoom. Optical zooms are always to be preferred.

**Digitizer** A piece of hardware (that can be built into a computer, or be standalone) used to convert an analogue signal to digital. A digitizer is used to convert analogue video to digital. Sometimes called an Analogue to Digital Converter, or A to D converter.

**Digitizing** The process of converting an analogue signal to a digital one, such as converting analogue video to digital using a digitizer.

**Dissolve** A transition where one scene fades seamlessly into the next.

**DV (Digital Video)** Abbreviation and description of a commonly used digital video format.

**DVD (Digital Versatile Disc)** Disc-based format used for data storage including, as DVD Video, movie and video recordings.

**Electronic image stabilization (EIS)** An electronic process whereby vibration and camera shake can be electronically removed from a video image. Compare with Optical image stabilization, which often gives superior results.

**Exposure** The total amount of light allowed to fall on the CCD of a camera; a result of the aperture and shutter speed.

**f-ratio** A description of the aperture of a lens as the ratio of the diameter of the aperture to the focal length. Larger f-ratios mean smaller apertures. Sometimes called f-stop.

**Fade-in** A scene that fades in from a black scene, usually at the start of a movie or a section of a movie. A fade-out is the reverse, usually used at the end of a major scene or the whole movie.

**Field** see Frame.

**Filters (1)** Glass (or optical resin) attachments used to modify the light entering a cameras lens (such as polarizers or coloured glass).

**Filters (2)** Software modules found in image-editing and video-editing applications that modify the images in a similar way, and are also capable of more extreme image modifications.

**FireWire** The generally used term of IEEE-1394 connections, the high-speed communications system that can be used to attach DV cameras, hard disc drives and some other peripherals to a computer. The term was coined by Apple Computer. Also known as iLink.

**Focal length** In digital movie cameras, the distance between the centre of the lens and the CCD sensor. In general, the longer the focal length the more an image is magnified. Long focal length lenses record a smaller area and are known as telephoto. Short focal lengths record a wider view and are known as wide-angles. Zoom lenses can offer a range of focal lengths.

**FPS (frames per second)** The number of frames, or discrete images, recorded per second. Conventional movie film and PAL video plays at 25fps; NTSC video at slightly under 30fps. The number of frames displayed or recorded per second is sometimes called the frame rate.

**Frame** A recorded video image. Can comprise a single image or two fields, each comprising the odd and even lines that make up a video image.

**Frame rate** see FPS.

**Hard cut** The default transition between two shots or scenes in which one shot ends and the next begins on the following frame.

**HDV** High-definition video format that uses MPEG2 video compression and DV video tape. Used in increasing numbers of high-end consumer digital video cameras.

**High-definition TV (HDTV)** Television and video that records higher definition pictures than conventional, standard definition TV. Rather than 625 lines (PAL) or 525 lines (NTSC), high definition offers 720 or 1080 lines, which equates to up to four times the picture resolution. HDTV also offers better-quality audio.

**IEEE-1394** see FireWire.

**iLink** see FireWire.

**In point** In video editing, the starting point of an edit. The corresponding end point is known as the Out point.

**Insert edit** An edit in which new material is inserted between existing shots. Subsequent shots are moved along the timeline.

**Interlaced scan** Method of creating a frame of video. That frame comprises two fields, the first comprising all the odd-numbered lines, and the other comprising all the even-numbered lines. These are interlaced to produce a single frame comprising all lines.

**LANC** see Control-L.

**LCD** In digital video cameras, the technology (and colloquial name) for the flip-out viewing screen. Secondary displays (those showing camera settings and so on) are also LCD-based.

**Letterboxing** The result of showing the entirety of a widescreen (16:9 aspect ration) movie or broadcast on a conventional (4:3) TV. Black bars appear above and below the video. See also Pillarboxing.

**Lossless/Lossy** see Compression.

**Luminance** The component of a video signal that contains the data information that relates to the brightness of a scene and which needs to be combined with the colour (chrominance) information to produce a complete video signal.

**Lux** The metric measurement of visible light levels (1Lux – 1lumen/square metre).

**MiniDV** Alternative name for the DV video format, so called because MiniDV used the same format but on mini tapes as compared with professional full-sized DV.

**MPEG (Motion Pictures Expert Group)** Name of a standards organization and a series of lossy compression CODECs devised by them. MPEG1 is a low-quality format used for the Video CDs; MPEG2 is used for DVD, some digital television and HDV; MPEG4 is also used for digital television and is a scaleable format (suitable for small handheld devices through to HDTV).

**NTSC (National Television Standards Committee)** The broadcast video standard for North America, Japan and dependencies that offers pictures with 525 horizontal lines and a frame rate of around 30fps (actually 29.97).

**Optical image stabilization** A special lens system comprising prisms and gyroscopes that helps eradicate or reduce vibration and shake in video images. Unlike Electronic image stabilization, this system does not degrade images but, due to its complexity, can be more bulky and more expensive.

**Out point** see In point.

**Overexposure** Any images recorded when too much light is hitting the CCD. Although it can be used creatively, it is often the result of incorrect camera settings or shooting when the light levels are greater than the camera can accommodate.

**PAL (Phase Alternate by Line)** The television standard used in most of Europe and Australasia and parts of Africa. Offers 625 lines of resolution and a frame rate of 25.

**Pillarboxing** The result of showing a full frame of standard aspect ratio video (4:3) on a widescreen television. Black bars are shown to the left and right of the video.

**Pixel** Short for PICture ELement, this is the basic unit from which a video image is produced. The CCD sensor may comprise several million pixels in a grid or matrix formation; in the final video each pixel provides information on the colour and brightness at that point in the image.

**Polarizer** A lens filter that polarizes the light coming into the lens. Can be used to increase saturation and to eliminate reflections in glass or water.

**Progressive scan** A method of producing a video frame where each horizontal line is scanned from top to bottom in a single field, rather than interlacing odd and even scans in the case of an interlaced scan.

**QuickTime** A video file format and viewing technology introduced on the Macintosh but now available for all platforms.

**Real Media** An alternate format to QuickTime that can be used to replay stored video and video streamed 'live' across the Internet.

**S-video** A method of delivering a video signal (from a camera to a TV, for example) in which the brightness and colour signals are carried separately (Y/C video). This is one of the methods employed in S-VHS and Hi8 analogue video to offer better picture quality than VHS and Video 8.

**SECAM (Sequential Colour a Memoire)** The broadcast television standard in France, Russia and their dependencies, along with, in modified form, part of the Middle East.

**Shutter** A mechanical 'window' in a camera that opens to allow light through to the CCD. The duration that the shutter is open can be varied, along with the aperture, to achieve correct exposure.

**Single-chip** see CCD.

**Special effects** Visual effects applied to a movie (normally) during the editing stage.

**Standard definition** The description of conventional television, compared with High Definition TV.

**Streaming video** Video delivered over the Internet that can be replayed while the downloading is still in progress.

**Telephoto lens** see Focal length.

**Three-chip** see CCD.

**Timecode** A system that adds a unique time-based identifier to each frame of a video to enable accurate editing and location of frames.

**Timeline** A representation of a movie used in video-editing systems. Clips and scenes are presented as thumbnails or bars along a time-based axis.

**Transition** A method of linking two scenes both visually and audibly.

**USB (Universal Serial Bus)** A standard connection system used on computers for keyboards and other peripherals. The faster USB2 (compatible with USB) provides sufficiently fast data transfer rates to allow video data transfers.

**VCD (Video Compact Disc)** A format that uses MPEG1 to store around an hour of VHS-quality video on a standard compact disc.

**White balance** Camera control that adjusts the colour balance of the recorded signal (either manually or automatically) to ensure that there is no colour cast and that white (or neutral-coloured) objects are faithfully recorded.

**Widescreen** see Aspect ratio.

**Y/C video** see S-video.

**Zoom lens** A lens whose focal length can be varied to change from wide-angle through to telephoto.

# INDEX